MASTERS OF THE WILD

R O B E R T
ABBETT

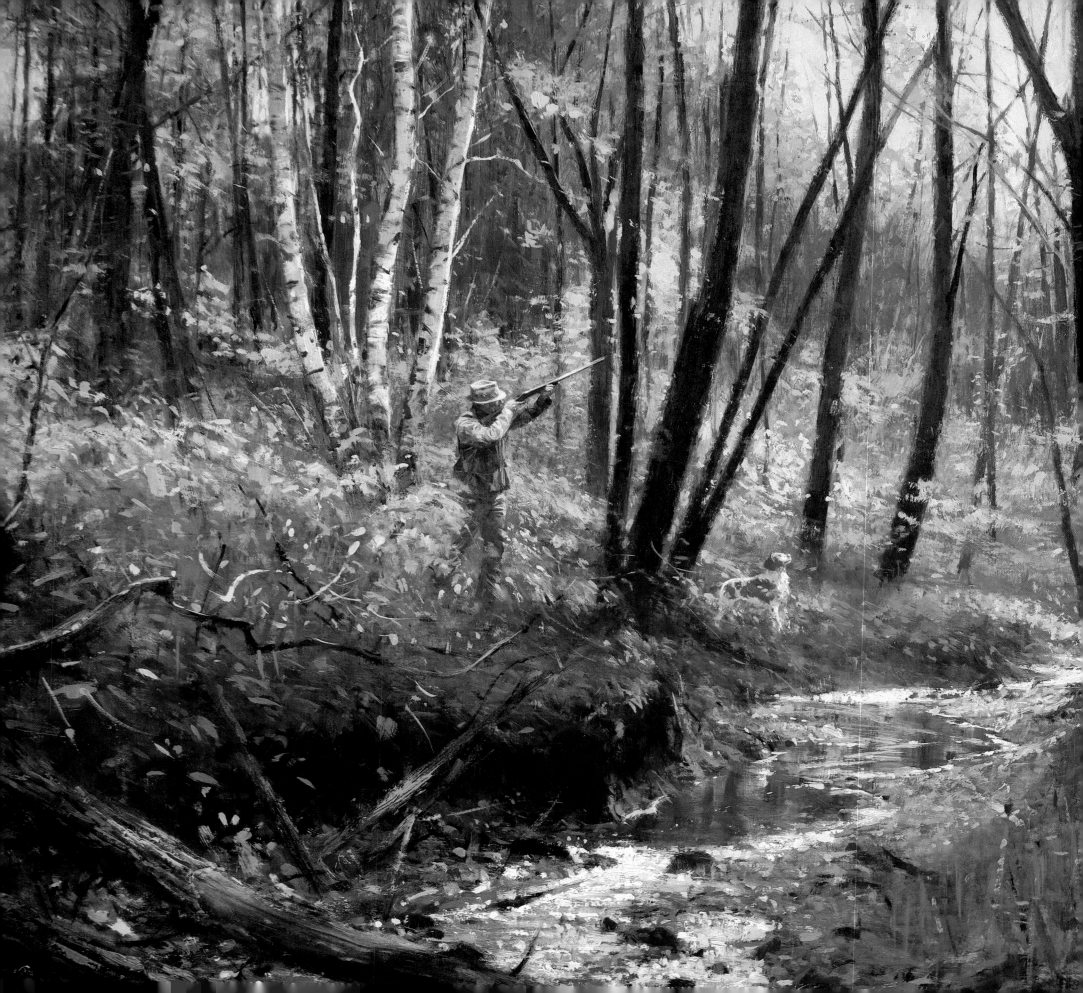

TEXT BY MICHAEL McINTOSH

R O B E R T

ABBETT

BRIAR PATCH PRESS
CAMDEN, SOUTH CAROLINA

This book and other volumes in *Masters of the Wild*
are produced by Briar Patch Press, Inc., P.O. Box
1017, Camden, SC 29020.

Briar Patch Press, Inc.

John Culler, *Publisher*
Charles A. Wechsler, *Editor*
Kay K. Jackson, *Art Director/Designer*
Liz Strohl, *Design Associate*

Printed in Spain

ISBN 0-922724-04-0

Previous page:
Late Day Woodcock, Oil, 24 X 36, 1978

*F*ew artists work alone, and so I dedicate this book to my wife Marilyn, who for these many years has constantly worked alongside me and made my goals her own, and who, like our children Rob and Lindy, kept a faith in my work which often exceeded my own. I must also thank my mom and dad who long ago opened the doors of art for me at the Chicago Art Institute, as well as the countless helpful people – friends, family, clients and associates – who have given me a nod, written a good word, showed me a field or a dog, or just smiled at a painting.

ROBERT ABBETT

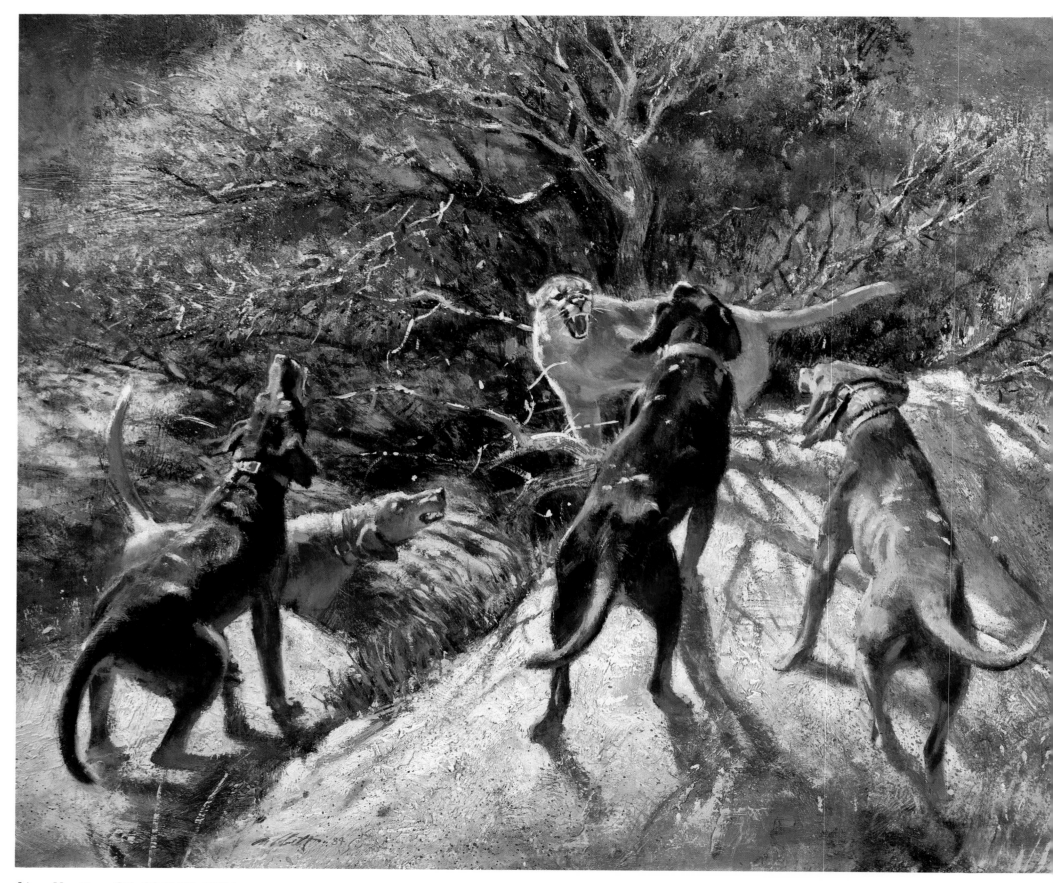

Lion Hunting, Oil, 20 X 32, 1984

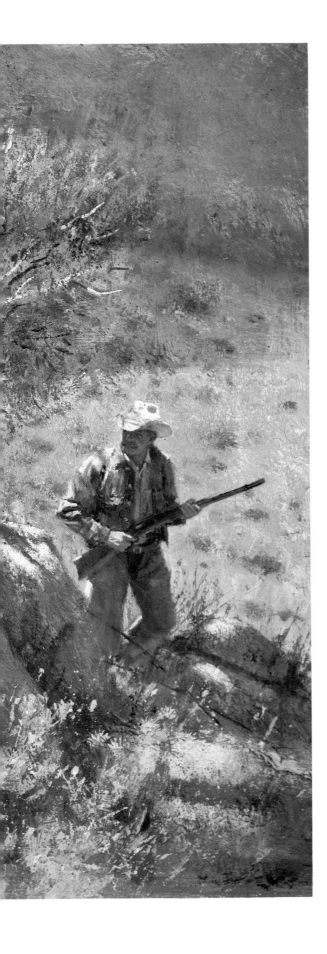

Books have always played an important and enjoyable part in our family, partly I suppose, because my father was once a teacher, and in my own life because so much of what I've learned about art has come from them. Since part of painting is communication, the marriage of art and publishing is twice blessed.

An earlier book of my work, published in 1976, let people know that I did paintings of more than just dogs. "I didn't realize you did Western art," they'd say, or horses, or flyfishing, or whatever they hadn't seen. So I'm pleased that this book will likewise show you a wide selection of my paintings, many not previously reproduced.

I confessed to Michael McIntosh that in the presence of writers, I rarely feel I'm giving them enough crisp and meaningful information to create their work. I'm sure most artists feel some of this; we're convinced our art is driven by marvelous and unique philosophies, the articulation of which seems altogether evasive at that crucial moment.

But more important was Michael's visit to Oakdale Farm where these pictures started. He hiked the fields I've hiked and saw our skies and worked with our dogs. And he sensed the loneliness of a painting's evolution.

To me every painting is something special; a very precious possession while it is in my care. Something like raising a child, my artist's responsibility is to do each one with honesty, treat it as it deserves to be treated in its own right, and know when to let it go.

Each is a perfect piece of art until that moment when I begin to work on it. That is to say, my mental image of a picture suffers none of the realities of common difficulty until it is begun. But such is the challenge of my art: hopefully to conquer each technical or pictorial problem as it arises and to permit nothing to block the expression of my honest emotions.

When I see the shimmer of a pointing dog flashing to a point or the sparkle of a trout stream, my inspiration is the scene's overwhelming presence. I do these paintings because I have to, because some inner force urges me to show you what I've seen and enjoyed. When you and I meet somewhere inside my picture and share our common experience, then this circle of communication is complete. Well, at least for the moment, until the next picture starts to focus in my mind.

———

ROBERT ABBETT

INTRODUCTION

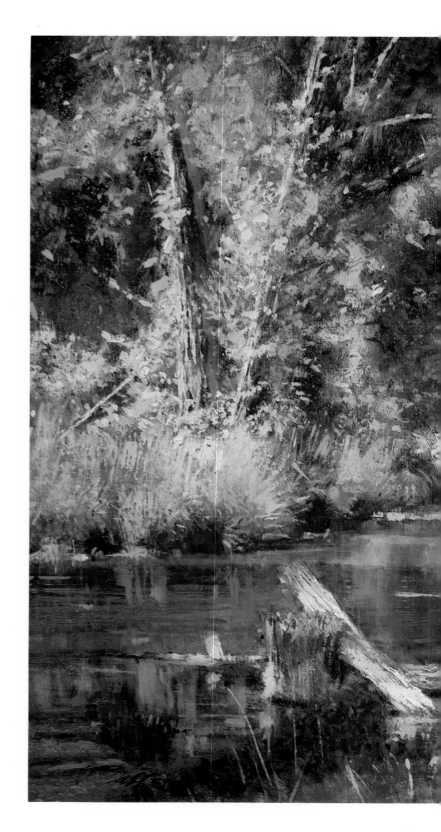

The opening scene of Guy de Maupassant's *Bel-Ami* is an artist's studio in Paris, aromatic with the bouquet of turpentine and oils, unforgettable to a man who has lived with it. The crimson drapes at the tall studio window are partially drawn back admitting a beam of light — not sunlight, for studio windows always face north. Dust motes in the streak of cold light float and spin like atoms in arrested energy, and in this room where an artist has struggled with his soul and talent, there is a palpable substance in the cubic space that bespeaks achievement, a sense of quiet rest after a piece of work has been completed, the flame after the substance that fed it is consumed. It doesn't come easily. I know, for I've been there.

Studying a Robert Abbett painting, there is an awareness of this thing I'm talking about, a conviction that this man has given himself to this painting in front of you, that it didn't just happen, the way a dilettante splashes paint and stands back, delighted with the accident.

Abbett is a painter's painter. His pictures have form and light and shadows; there are depth and space and thickness of air, and this air is the cold wind and warm sunshine of an autumn day in The Season. I can recognize his paintings from a distance before I see the subject.

Abbett color is an overall golden nut-brown tone of days in coverts. And there are dogs.

If you love dogs as I do, you feast on Abbett's intense ribby pointers, his setters of the soulful eyes and flowing feather, serious Labradors and retrievers, vizslas and German shorthairs with rippling musculature under shining coats so convincing you can feel and smell them. And you know Abbett has felt and smelled them with you.

The modern color camera has done much for today's sporting painters, but some wildlife artists abuse it, painting merely colored photographs. The old Chinese chestnut about a picture and a thousand words can end up pretty dull if the artist attempts to spell out all those words in paint. Good painting is like good writing: *show*, don't *tell*. Abbett has the taste and skill to use a photograph as a model with the advantage of captured action, an aid Edmund Osthaus didn't have in the days when he had his pointer and setter subjects held on leash while he made studies of them, singly or as a group.

A.J. Munnings, who painted the British racing and fox hunting scene, painted his subjects from life. As a fox hunting man he knew the action so thoroughly he had it in his mind, and his grand brushwork convinced

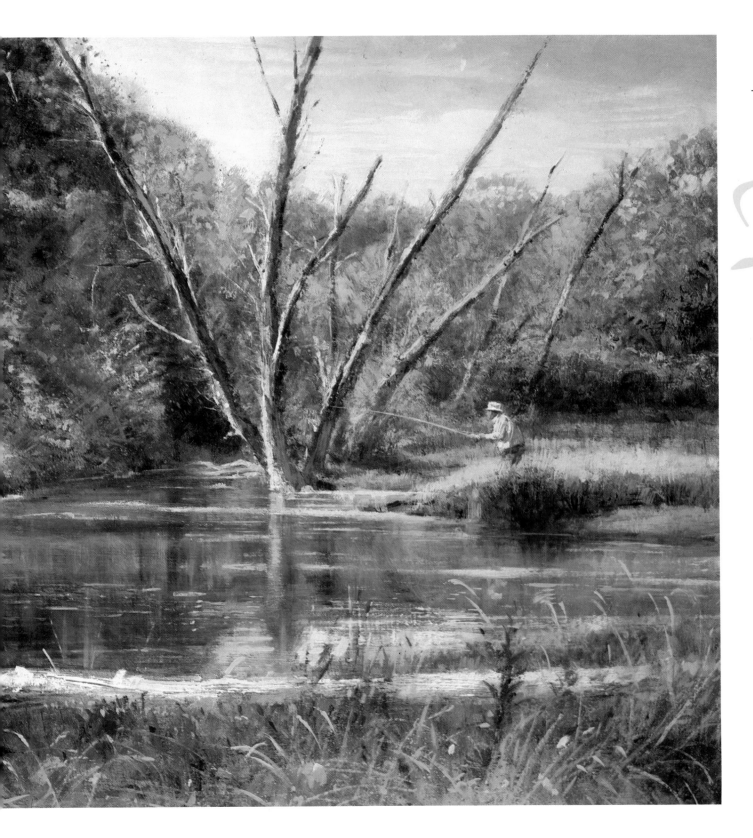

you that the horse flesh and dog muscle would quiver under the hand if spanked.

Robert Abbett gets this in his paintings. In addition he, like Munnings, can paint people, something lacking in a lot of sporting art. His shooters are *in* the picture, small scale as part of the landscape, yet activating it. They are real men with real guns walking up to pointing dogs, or about to shoot at a bursting covey of bobs on a Southland plantation with a tenant cabin in the background under live oaks draped with Spanish moss — Archibald Rutledge's *the grieving loveliness that live-oaks wear*. Others of his gunners are in New England coverts ("covers" to the Yankee), part of the bird/dog/man triad so beautifully done in his *Late Day Woodcock*, a charming painting of a gunner about to shoot over a Brittany looking skyward at a woodcock topping out along the line of pointing from the shooter's gun. There is a cold light from what certainly is a watery November sky spilling through nearly bare trees, with the far cover already gathering mist.

The Letort,
Oil, 20 X 30, 1978

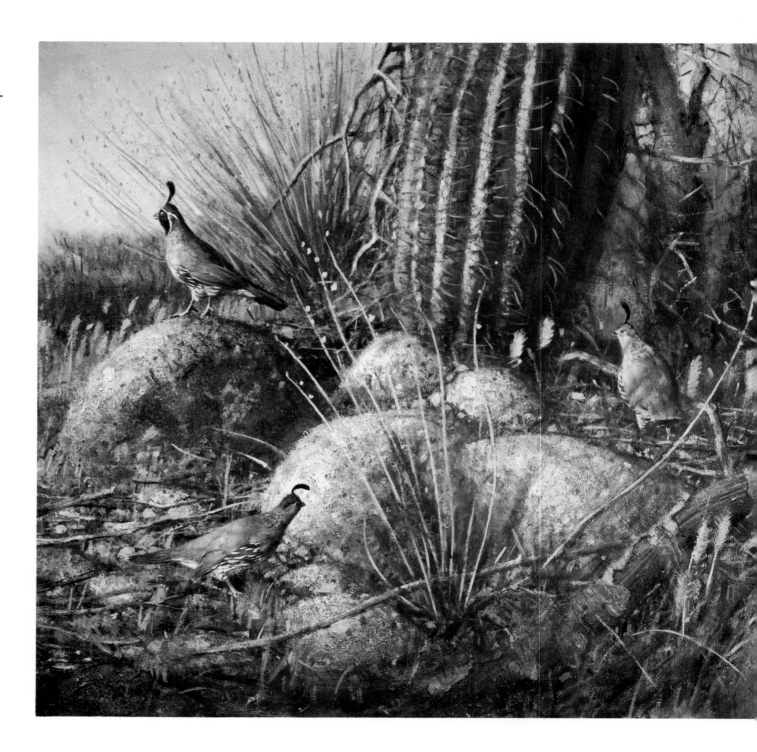

iving a shooting man who spent his early years as a painter this assignment to write about Robert Abbett's paintings is to give him the pleasure a Methodist would consider sinful. Abbett's rusty-roofed, sagging old barns are my old barns on abandoned farms I gun; his distances are the distant ridges I see in my Allegheny Mountains; his Indian summer haze is my haze, his air is the air I smell and feel. One of his fishing pictures has two anglers on a stream bank stooping over in stealthy scrutiny of a distant trout rise just downstream from a covered bridge whose faded paint is a pink tone that is a painter's delight.

Realism in "wildlife art," a term that makes me flinch, is too often counted by the feather, the hair, the leaf. Take away the plumage and there is nothing there. Robert Abbett's paintings have detail but it is telling detail or the mere impression of it — the prick of small golden leaves, a suggestion of twigs and branches. He lets your eye call it real without forcing it upon you.

The development of fine color printing has given sporting paintings to the shooting public, opening a market for prints of artists' work that never could reach such numbers as originals. Not all original art will reproduce well, as any painter who has had his work converted to

graphic form can tell you. Abbett is fortunate in that his paintings "go down" effectively. It derives from his values, a magic word to painters, as well as *chiaroscuro*, the play of light and shade.

If you want to see what an engraver and a printer can do to two reproductions of the same painting, compare the Abbett cover on the Premiere issue of *Gray's Sporting Journal*, Fall 1975, with the reproduction of the same painting on the last page of that magazine. They are similar plates photographed from the identical painting; the difference lies in the strength of the plates and/ or the inking of the red and yellow.

In the hurried process of publishing a magazine, an illustrator rarely has the opportunity to correct engraver's proofs of his work before it appears. Fortunately, he can do this while producing a good print, sometimes in more than one step, in order to achieve a faithful reproduction of his painting.

As a man for whom grouse gunning has been a way of life, I find Abbett's treatment of game birds refreshing. He doesn't toss up handfuls of grouse in a picture — I don't believe in large chunks of

———

Desert Quail,
Oil, 18 X 24, 1985

———

grouse, nor do my dogs — and he doesn't paint game birds that look suspended on wires in the front of his composition. His grouse are where you have to look for them, following the gaze of the dog, who in turn is led by the stream of scent.

I especially like Abbett's painting of his German shorthair Schatz ("treasure"). It is pleasing with its richness of early golden woods, and there is the feeling that somewhere under that large log, just beyond the pointing dog, there might be a second grouse ready to go up any moment. The fallen snag leading into the picture gives depth, as does the glimpse of a small brook in the background. The gold of the trees repeated in the golden lights on the coat of the liver-colored bitch, the rather cold October sunshine — all of it is there and you can feel Autumn. I have seen this painting reproduced in reverse — "flopped," to use printer's jargon.

ith some artists I am almost sorry that I have seen their early work, feeling it not quite fair to them to have seen them before they grew up. I don't feel that way about Robert Abbett. Perhaps I didn't know his work during the immature stage, or perhaps he had the good sense not to make his paintings public until he was ready. Some of his 1970s things are among

my favorites. *Split Rail Bobs* is of that period. It takes me back to a late October afternoon, its superb color tones creating Indian summer for me. And yet, I have seen Robert Abbett grow as a painter.

He paints in oil, a hellishly difficult medium to handle well, painting on gesso on board, which creates a plasterlike surface with varying texture, depending upon how the artist applies it. His paintings are usually about 20 x 30 inches, sometimes larger.

ou rarely find blue, real blue, in an Abbett painting, and he refrains from garish reds, but he brings autumns to you with his controlled palette. One thing you notice and I particularly like in the Abbett pictures is a varying sense of weather and time of year. A.B. Frost's paintings were usually a brown, late-October, leaf-thinning season, as if Time stood still, and unless the subject was wildfowl or rail shooting, they appeared to be in Massachusetts woodland. Lassell Ripley's New England autumns had more leaf color, and almost always the accent of the brutal silhouettes of black-dark white pines.

Robert Abbett's days change. He will give you October at its blazing peak, as in his back-lighted *Hillside Woodcock*, which throbs with glowing color of Vermont. There is Indian summer haze in certain of his

paintings, a warm atmosphere among the trees, becoming violet between you and distance, more dense as the leaves thin. There are his characteristic browns of November, and there are windy, cloudy days, for not all good shooting days are sunny and frost-sweet.

ipley's and Frost's gunners were New Englanders. Abbett paints gunners in different lands — the Carolinas, Georgia, Arkansas, Texas, as well as in his Connecticut coverts. Like those other painters, Robert Abbett limits his grouse shooting in paint to gentlemanly October and November days, never putting pressure on late-season birds. His shooters gun over good dogs and dress with decent taste. He sees no need for hunters to look as though they had just finished a six-pack (his words, and mine).

Robert Abbett studied at the Chicago Academy of Fine Arts, and knew Chicago, as I did in my student days. The difference lay in the period; I finished at the Art Institute School in 1927, the year Lindbergh flew the Atlantic, when Abbett was one year old.

There is a parallel between Robert Abbett and Lassell Ripley — neither started to paint sporting subjects until after they had been painting for years. Ripley was in his late thirties, Abbett in his forties;

both had been doing landscapes that needed only gunners and anglers to give them the personal meaning their paintings hold for sportsmen.

For Abbett, this new field began when he and his wife, a singer, bought their place in Connecticut and moved there in 1970. Their setter Duke is the son of Tom and Martha Sweeny's Luke, one of his first dog subjects. At present the Abbett's maintain a second home and studio in Arizona.

Abbett shoots, but much of his time in coverts is with a camera, photographing the setting, the actions and other gunners, accumulating material for his shooting pictures.

n artist doesn't need a biographer; his paintings tell of the man better than words, speaking of the dogs he knew, the kind of cover he thinks looks good, the sort of men he likes to gun with, situations that hold adventure for him.

There is expectancy in good sporting art, action we all yearn for about to happen. Yet they hold it back, these painter/gunners, the good ones, tantalizing us with pleasure not quite consummated, the birds still flying, never falling. It is a nice way to enjoy those lovely quail and grouse and 'cock, like taking a trout on a fly and then returning it.

But if such a thing should happen

to you or me that Lady Luck turns unkind and the day should come when we must only sit and remember, the paintings of Robert Abbett can keep it for us — bird dogs forever pointing, grouse and bobwhites and woodcock always rising, men still vibrant with the joy of living the shooting life.

I have more than once walked with my gun into thinning autumn woods behind my setters, and devouring the beauty around me have thought: *That's just how Robert Abbett would paint it.* For an artist, that is *paradiso.*

———

GEORGE BIRD EVANS

CONTENTS

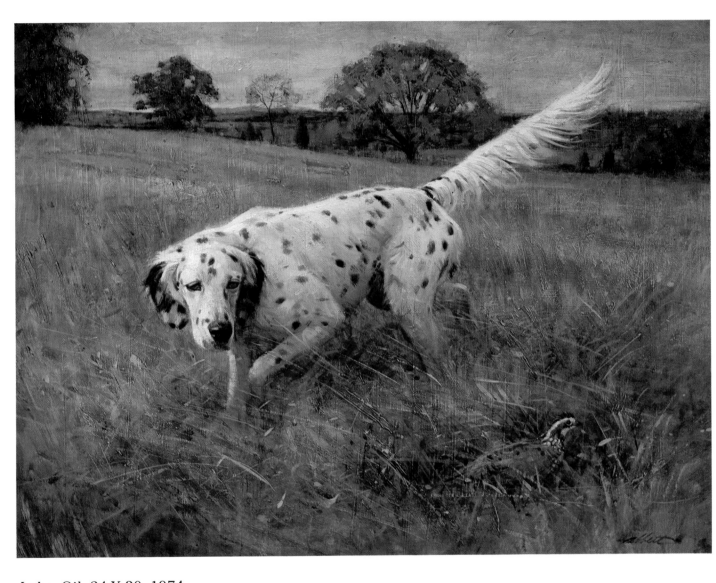

Luke, Oil, 24 X 30, 1974

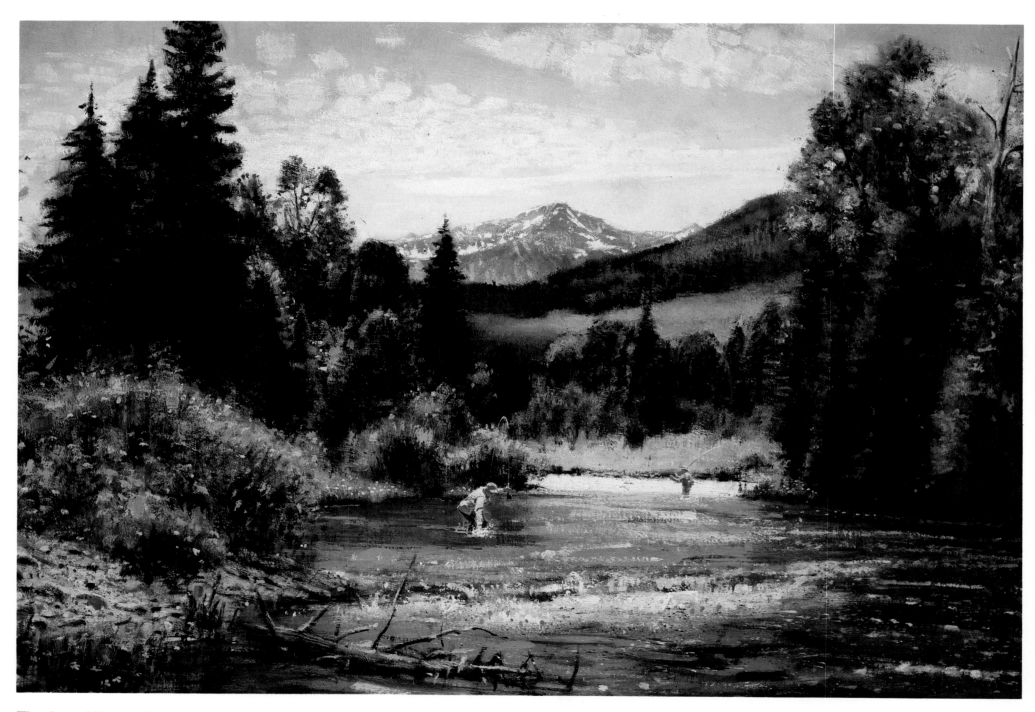

The Joy of Peace, Oil, 20 X 30, 1987

PLACES ALONG THE RIVER

The Housatonic River begins at Pontoosuc Lake in the Berkshire Hills of western Massachusetts, at a place I've never seen. It ends at Long Island Sound on the southwestern Connecticut coast, dividing Stratford from Milford, bisecting the corridor of expensive, crowded real estate that sprawls along the water from New York City to New Haven — a place that wouldn't break my heart if I never saw it again.

You can't see the Housatonic from the hill in Bridgewater, Connecticut, where Bob Abbett lives, but it's there, a short way downslope to the west. From the broad windows on that side of the house, you can see the tall, beetling ridge above the river's west bank and, at the horizon farther west, the softly rounded face of New York State.

Here, the Housatonic flows quietly, slowed and doubled back upon itself by a dam a few miles downstream. The map calls this stretch of river Lake Lillinonah. It has no sense of lake about it. In this country, the hills shoulder close to one another, and the river has no choice but to remain a river, to come from somewhere else and move on to some place out of sight.

Bob Abbett, too, came here from somewhere else, by way of Chicago and New York and points between, moving, like a river in reverse, from the fretful crush of an urban landscape to this hilltop washed with light and peaceful, open space. Where he's going is out of sight only in time.

Rivers — and some highways — lead to discovery. From the airport at Windsor Locks, herding a rented Ford, I drove south along the Connecticut River, turned southwest at Hartford. At the end of October, the New England forest is past its scenic prime. The stuff of picture postcards is shedding away like tarnished scales, showing a leaner, sterner undercoat of grays and browns. Birches here and there show traces of a former gold among pines and leathery-leaved oaks, but now it's their bark that catches the eye, gleaming white like old bones.

Still following the placemat-sized map the Avis people gave me, I crossed the Housatonic just east of Sandy Hook and, eight miles beyond, left the interstate at Hawleyville. From there, I navigated by a Bob Abbett original — two colors of felt-tip on typing paper. Bearing east from Brookfield Center, I crossed the Housatonic again, fatter now in its Lake Lillinonah mode, and turned north to Bridgewater.

Brookfield Center looks larger than the 14,500 souls assigned to it by

——

"Downtown" Bridgewater and The Village Store where you can buy everything from gas and groceries to a lottery ticket. Right: The Abbetts' Oakdale Farm as seen from nearby Wolfpit Mountain.

——

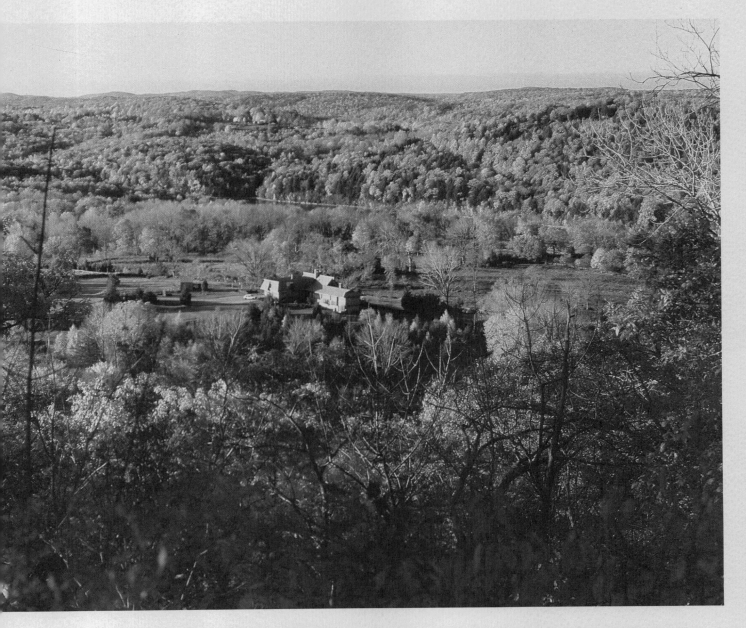

New York City, but it's near enough for country homes and for those whose livelihood requires no more than a once- or twice-weekly trip to the city.

Bridgewater's commercial district occupies a single long, pale-gray frame structure. The oldest portion dates from 1899, from the days when one Charles Thompson did a thriving business in selling soap by mail. Thompson's part of the building now is The Village Store, where you can buy gasoline, groceries, a copy of *The New York Times*, rent a video, buy a lottery ticket, or have a grinder made to order. An addition at the south end houses an office of the New Milford Bank & Trust. Another addition at the north end is the local post office. When we stopped there one afternoon to collect Bob's mail, he mentioned that the postmistress of Bridgewater moonlighted on weekends, performing as a belly dancer at a club in New York State.

Bob's map led me west at the intersection by the business district, down Hatshop Road. A short jog to the north from where Hatshop Road tees into Curtis Road, Henry Sanford Road drops straight west between the hills, eventually to the Housatonic. Midway down, at a steep asphalt driveway on the left, a tiny sign nailed to a tree says simply *Abbett*. Topping the hill, the curving drive ends in a vista washed in light and distance.

the Census Bureau. Bridgewater, on the other hand, looks infinitely smaller than its 1,600 population. In the Midwest, where I live, a village that occupies no more physical space than Bridgewater is likely to show more plywood than window glass, more ragweed than late-blooming marigolds. But this is no farm-country burg withering alongside the now-bloodless artery of a railroad grade. Bridgewater is old trees arching the streets, old wooden houses meticulously kept amid green lawns — all held together by the integument of old money. At eighty miles' distance, Bridgewater is too far away to be an everyday bedroom to

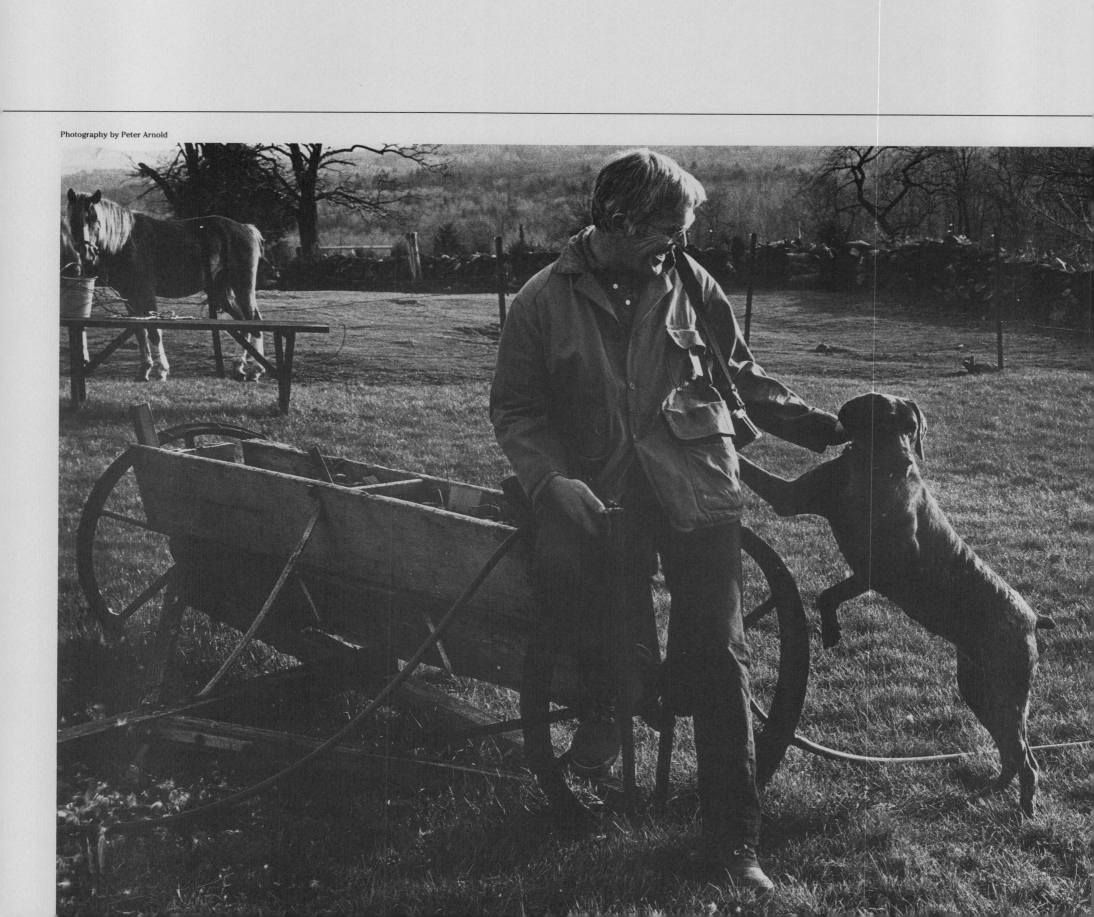

From a kennel attached to a tiny barn on the left, Bojangles barked at me, ninety-eight pounds of coal-black Labrador whose posture and voice carried a hope that I was someone who'd come to play. Marilyn's horse eyed me disinterestedly from the paddock behind the stone wall.

Being one who is by nature not a particularly gregarious man, I find a special pleasure in meeting those rare people to whom I take an instant liking, people whose company feels old and familiar and comfortable from the start. To that moment, Bob Abbett had been a name, a visual presence in paintings and prints, a voice on the telephone. Ten minutes later we were old friends.

Relatively little of Bob Abbett's sixty-two years' mileage really shows — a shock of silvery hair, a respectable set of lines and creases in his face when he smiles. You could say as much for me, and I was born almost twenty years later. Bob Abbett is a trim, fit-looking man of medium height, quiet of voice, calm-mannered in the way of a scholar, self-aware without being self-conscious, in the way of a man who has a genuine gift of magic.

Bob asked about my flight (uneventful), the drive down from Windsor Locks (equally uneventful but with better scenery), whether a

whisky might help me shed the feeling of disbalanced time and space that goes with covering half a continent in less than half a day (indeed) — all the while steering me through the back-door entryway, around the old butcher's block in the middle of the kitchen, across the dining room, past a tall, stone fireplace, and into the living room. The living room is a precise echo in miniature of the feeling you get standing outdoors on Bob Abbett's hill. The vaulted ceiling brings the same sense of open space indoors. The west wall is nearly all glass, and the splendid view of tree-covered hilltops is repeated in form on the opposite side of the room by multiple levels of entryway, staircase landing, architectural lines and angles.

The whole house, with its half-truncated, double-A-frame upper story, is built after a Japanese

concept of rendering interior space in ways that reflect and interact with the environment. The feel is as inviting as a Bob Abbett painting.

Luke, the big English setter who *is* a Bob Abbett painting, almost, ambled into the room and sniffed my pantleg, thereby making a proxy acquaintance with October, my Brittany. Evidently deciding that I was a likely prospect for some pets, he put his chin on my knee and closed his eyes when I found the right spot behind his ear.

Bob and I talked for a while about our different tasks over the next few days: mine to gather material for this book, his to be Bob Abbett. Marilyn was in Illinois visiting her parents, so we and the dogs and the horse had the place to ourselves. It's been my experience that the best time to get an accurate view of a working artist is

21

when he's actually working — not looking over his shoulder in the studio, of course, but being a part of his working day. As it happened, Bob was in the final stages of a painting for Ducks Unlimited, involved, therefore, in the matters of problem-solving that go along with refining a piece whose basic structure is well established. It also happened that our preferences for work time are a good match; we both like to tackle demanding creative work early in the morning, preferring to spend afternoons winding down or just hanging out.

Since I had a room reserved at a bed-and-breakfast inn in the village, we agreed to spend mornings doing our own things, meet at Bob's house about eleven, and follow whatever whims occurred to us for the rest of the day and evening.

The arrangement offered a fine opportunity to follow a particular whim of my own, which is to drive the backroads, to explore without destination, following any road that seems to lead into the heart of the countryside. A powerful sense of place is a key element in Bob Abbett's work, and if I was looking for anything in those early-morning hours among the Litchfield County hills, it was to gather a feel for the environment that appears so often in his paintings.

And I found, nearly everywhere, places I had seen before, through the windows of Abbett's art — hemlocks along the brook, rocky hillsides in scrub oak, thickets of old pine, swift-falling streams banked with moss and fern all in a deep, green shade, mossy logs slowly disappearing into the forest floor as the woods patiently renew themselves. Look into the background of an Abbett painting and you can see far into time, both past and yet to come.

Bob Abbett came late to the world of dogs and guns and game birds that he paints so well. He was past thirty when he did his first hunting, older yet when he owned his first gun dog. It hasn't been a disadvantage. In fact, like falling in love at an age when passion is tempered with the alloy of experience, it has lent a certain maturity to his vision of what the sporting experience really means. Paradoxically, the things we've always known are often the most difficult to understand, and I believe that an important part of Abbett's ability to see the essence of the hunter's world so clearly is the fact that he was a grown man when he saw it first.

Crowded shoulder to shoulder between south Chicago to the west and Gary to the east, Hammond, Indiana, never has offered much by way of outdoor experience. The landscape long ago disappeared under the steady crawl of cities and factories.

When Robert Kennedy Abbett was born in Hammond on January 5, 1926, the air was thick with coal smoke and pungent with the reek of paint factories and stockyards and steel mills.

But if there wasn't any place in Hammond to shoot a quail or watch a deer, it did offer opportunities to come face to face with the work of the world's great artists, and something in Bob Abbett's nature responded.

"My parents took me to Chicago fairly often," he says, "to the Chicago Art Institute and other museums. I can remember standing in front of a canvas that in some ways looked like nothing but a jumble of paint, and yet I could feel myself being drawn into it. The more realistic painters like Winslow Homer seemed extremely powerful to me, but I think I was fascinated most by what I thought of then as the jumbly ones, the French Impressionists. They really invited me in, left lots of room for me to apply my own imagination to what I was seeing. That's shaped my view of art ever since — both in what I like of other artists' work and what I try to do myself."

The decision to try it himself was not without its false starts. Following a wartime stint in the U.S. Navy, Abbett resumed classes at Purdue University, planning a pre-med major, and graduated with a Bachelor's degree in general science. A year

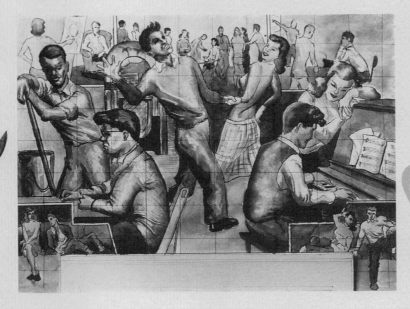

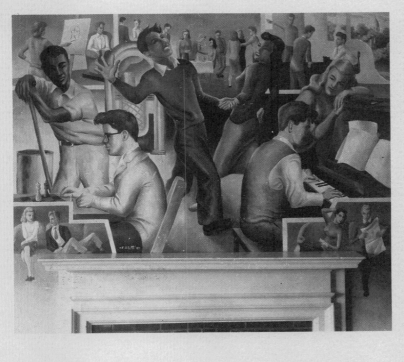

Top: Abbett in 1943, as a senior at Hammond High School in Hammond, Indiana. Right: Working sketch and finished mural for Read Hall at the University of Missouri. Above: Unlike most of us who discovered gun dogs and hunting at an early age, Abbett was 32 when he posed with this brace of cock pheasants, the colorful results of his first hunting experience.

later, he added a B.A. in fine arts from the University of Missouri at Columbia. Then followed two years of night courses at the Chicago Academy of Art, and in the midst of that, in 1948, an apprenticeship at Stevens Gross Studios, purveyors of commercial art.

Despite the academic world's persistence in distinguishing commercial art from "serious" art (the same way it insists upon separating "popular" from "serious" literature and music), the distinction often is a blurry one. It was even less intrinsically distinct from the late 19th century through the 1950s, the period before photography finally took over as the primary means of illustrating magazines and other publications. A substantial number of the people we now consider members of the first great generation of American sporting artists either began their careers or spent virtually their whole working lives as illustrators — William Harndon Foster, Francis Lee Jaques, A.B. Frost, Walter Hinton, P.B. Parsons, Louis Aggasiz Fuertes, Lynn Bogue Hunt, and a host of others.

Bob Abbett sees his early career in illustration as an invaluable apprenticeship.

"We were well aware of the popular attitude that illustrators were somehow third-rate hacks who couldn't make it in the fine-art world.

Abbett at Bielefeld Studios in Chicago, where he illustrated everything from cosmetics to building products. Abbett freelanced for *Playboy* founder Hugh Hefner, creating story illustrations under the assumed name of Mark Smith. "I used that pseudonym because I was also doing a meaningful amount of work for a local religious magazine,"says Abbett.

"On the other hand, we always contended that commercial work forced us to learn craftsmanship to a degree that some kid who went to a progressive art school would never match.

"I don't know if we were right, but I do know that I wouldn't trade the experience of working in the commercial studios for anything. We really had a gamut of things to do and a diversity of subject matter to deal with. And we had to do things realistically. It seems to me that you need to know how to render something realistically before you can successfully approach it some other way.

"Moreover, what we did was only part of a larger process that included the page designer, the typographer, and the printer — and it all had to fit together. The thing about magazine illustration is that it usually was a matter of solving the same problem over and over, and we all tried to do it in different ways. That means learning the craft and learning it thoroughly."

Abbett remained at Stevens Gross Studios until 1952, when he went to work at Bielefeld Studios, also in Chicago. By then, he and Marilyn were married; their son Rob was born in 1953. Chicago was no idle backwater of the art world, but then as now, the hub of it all was New York City, and the Abbetts moved east in 1955. Bob worked at Chaite Studios in New York, their daughter Linda was born in 1956, and the following year he struck off on his own, working as a free-lance illustrator. This, the second phase of his career, would continue for thirteen years.

In the twenty-two years between his first job at Stevens Gross and his exit from commercial art in favor of fine art, Abbett did nearly every sort of work that an illustrator can do: magazine illustrations and covers, movie posters, paperback-book covers, dust-jackets for hardbound books, record-album covers, you name it. Much of it is preserved as tearsheets in scrapbooks the size of cafe tables, stored away in Bob's studio. One afternoon, with Bojangles snoozing on a braided rug in a patch of sunlight and Duke sprawled behind my chair, Bob gave me a page-by-page tour through some of them. It amounted to a tour through the development of an artistic technique second to none.

Bob pointed to a double-truck magazine illustration from a 1950s issue of *True* magazine. One side of the gutter was printed in color, the other side in black and white.

"This was a typical problem, where I'd have to go from full color to black and white or two-color. I tried all sorts of ways of bridging the gap; some worked and some didn't but it was always interesting to try.

I was interested at that time in what we call the separation of form and color. I would draw things in black ink or shades of gray and drape the color over it. That could be done transparently or opaquely, depending upon the effect I wanted. It was also a state of mind, in that things modeled in black and white, with or without color, are going to represent form. Color you think of separately. That seems to work; it certainly worked well for cheap publications, and it certainly taught me some things."

Next page. Two more magazine pieces. "The problem here," Bob said, pointing to one of them, "was how to make a guy look extremely handsome when you don't see his face. Then I remembered the movies and how Cary Grant used to look when they'd photograph him from behind while he was schnurfing Grace Kelly. You could do it. I learned that."

Indeed, he did. The man in the drawing had his back to the viewer,

A 1963 illustration for the *True* magazine story: "He Unlocked Nature's Fort Knox."

but there was something about the set of his shoulders and the shape of his head that left no question: You wouldn't necessarily recognize his face if you saw it, but you'd find it a handsome face.

The other piece shared the page with a column of type, and I wondered if the designers worked around the art or offered guidelines. We didn't always get guidelines," Bob recalled, "but we usually were criticized if we didn't leave some space for type. It really was up to the art directors to tell us if they had specific demands, but I always tried to keep in mind that the artwork was part of something larger. The art directors appreciated that. It made for better working relationships, and it also taught me to think of form in a larger context. The artwork and the larger environment — whether it's a magazine page or a cornfield — interpenetrate and shape one another.

"This piece shows another common problem that illustrators had to deal with — to get some action with an emotional content (tension and fear, in this case) into a narrow space. I really enjoyed doing things like that, especially working in enough background to make it plausible and authentic."

Adventure magazines of the 1950s—*True, Argosy, Bluebook*, and the like—were wonderful stuff, a cross between *Soldier of Fortune* and *Outdoor Life* with a healthy dose of penny-dreadful journalism thrown in. The drawing Bob was talking about went with a story that looked like a dandy; his illustration showed a young woman, pin-up pretty, shrieking in terror from a menacing Indian. I made some wisecrack about immortal literature. Bob laughed.

"We had a little of everything to work with. That one came around every so often: The young girl who gets captured by Indians—and never gets over the experience." He laughed again. " 'Sorry, Jim, you just don't measure up.'

"Some of it was great stuff, great writing, but there was a lot of junk. But we took the illustrations seriously—at least the techniques, if not the subject matter. I learned more by doing that than I could have anywhere else."

Nowadays, a lot of magazine readers seem to make a hobby of finding inaccuracies in both artwork and text. Was that the case of illustrators, too?

"Oh, yeah. That thing really started with Norman Rockwell and *The Saturday Evening Post*. Before the war, the name of the game was "Trip Up Rockwell." He was so realistic that, in a way, he was asking for criticism if he got the buttonholes wrong. That carried over into all illustrations."

Bob turned a few pages to another illustration from *True*, a full-color rendition of the Battle of Casino.

"The effort to take Casino was a joint effort among the Americans, the British, and the Ghurkas. We wanted to be as accurate as possible, so before I started this I did some research on the battle. Then I had to chase down the right uniforms and get some models and learn how all the equipment and weapons should look. We did a lot of research for any period piece. It was a great deal of work, but it needed to look right."

Authenticity and environment. Reality of experience and reality of place. Two key components of Bob Abbett's magic.

Another scrapbook page, another magazine illustration. This one shows a young woman in an indoor setting. The artist's choices of the elements we see and the way we see them point like a signpost toward the future, toward now.

"I really enjoyed doing things like this — to go from a tight kind of realism, here with the girl, into a context where things are a little sketchier, some of them just a hint, and join it all into one piece. I always tried to play loose against tight in paintings.

"And I still do. As you move out from the main subjects in my

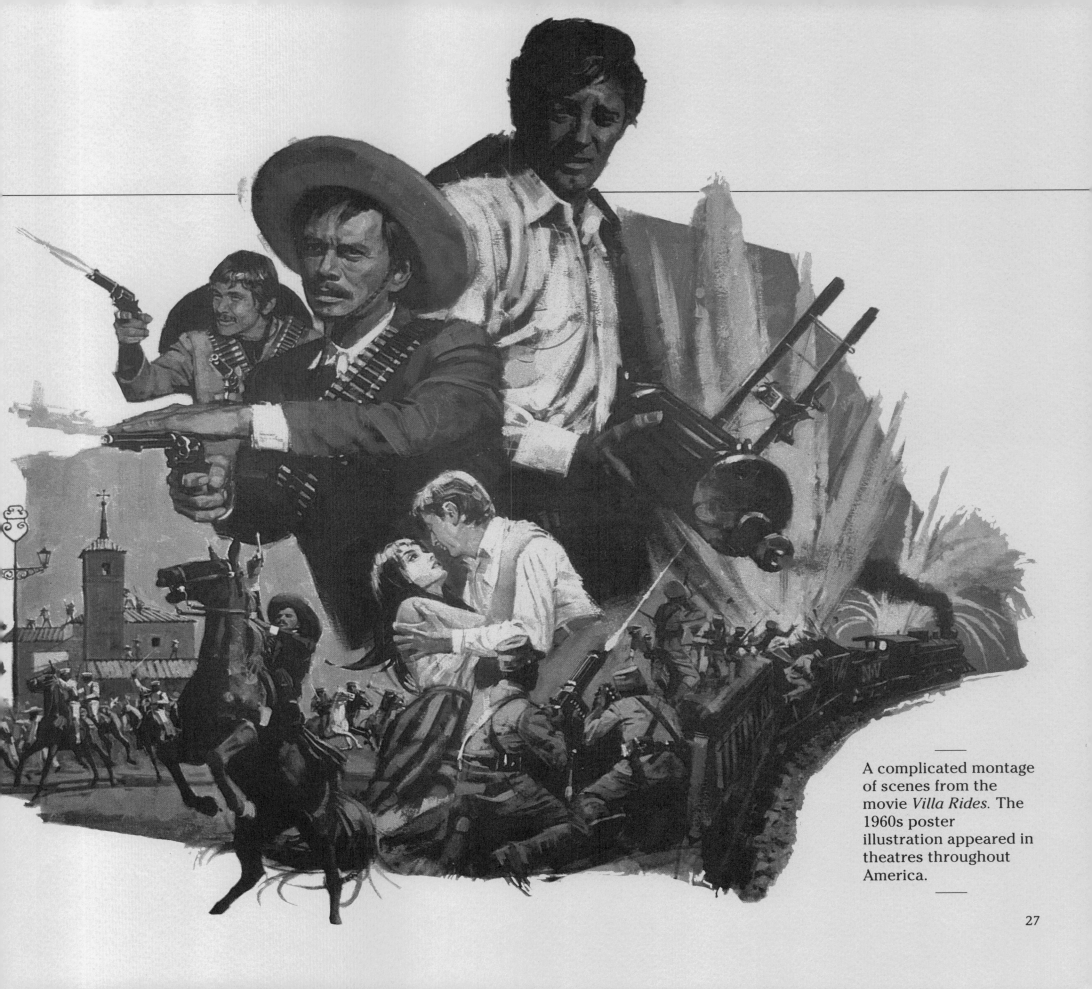

A complicated montage
of scenes from the
movie *Villa Rides*. The
1960s poster
illustration appeared in
theatres throughout
America.

27

Illustration for an early '60s issue of *Cavalier* magazine. "It was typical of the kind of robust, corny illustrations that were popular back then," says Abbett. Opposite: Paperback cover art for *Tarzan and the Madman*, a Ballantine book.

paintings, things get looser, things go out of focus. I do that very deliberately. I try to control the viewer's eye, and one way to do that is to have some things out of focus and relatively uninteresting, which constantly pulls the eye back to where I want.

"It works in any kind of setting, but it's particularly effective in a natural environment. It puts the artist in control of the picture and allows the artist to communicate with the viewer.

"Let's face it: Everything in a natural scene isn't equally interesting, and if you try to make everything equally interesting by painting every blade of grass and every tiny feather, then you're playing games with the viewer. You've painted him right out of the picture.

Hemingway said that if you know your subject, you can omit a lot of details. He was talking about writing, but that's also true for an artist. If an artist really knows what he's painting, he can do it convincingly and spontaneously. If you're painting something you don't know about, you'll try to convince the viewer that you know all about it and overdo it with so much detail that the picture loses its focus.

"What I'm after in a painting is pretty much the same thing a writer is after in a novel or a short story. I'm trying to communicate something of how it feels to hunt quail or ducks, or to watch a dog go about its work. I'm not trying to pass along only specific information. I don't paint *How to Hunt Quail*; I'm trying to paint *How it Feels to Hunt Quail*. I'm looking for whatever there is in quail hunting that makes it quail hunting no matter where you do it or what kind of dog you have.

"To do that, I have to have a setting, because the setting is as important as the quail and the dog. But you can overdo the setting, and one of the most valuable things I learned from all the years I spent as an illustrator is how to suggest a context for a scene.

"One reason I liked to do paperback book covers is that everything had to be in a setting — a minimal one, but a setting nonetheless — and the more I worked at it, the more I discovered how little it takes to imply a whole environment."

Something the scrapbooks show that the sporting art doesn't is the astonishing breadth of work that Bob Abbett has done. Here were National Football League program covers, there the painting of Jacqueline Susann that appeared on the dust jacket of *Valley of the Dolls*, on the cover of the paperback edition, on movie posters, promo material for both the novel and the film—just

about everywhere. I never knew it was an Abbett painting.

"Yeah," Bob said. "They used the hell out of that. It was just a sketch, but they liked the spontaneity of the drawing so much that I never had to do a finished painting."

A few pages farther on, an actress of the 1950s, whose penchant for low-cut gowns earned her the nickname of "The Back." As I remember, a recollection borne out by Bob's drawing, the front wasn't bad, either. I must have muttered something like, "Ah, June Wilkinson."

Bob muttered back: "I see you haven't entirely wasted your life messing around with shotguns."

And a few pages beyond that, I make a discovery: One of the finest sporting artists alive once painted a series of men's fashion pictures for *McCall's* pattern book. Bob smiles at my quizzical look.

"I'd never thought of myself as a fashion artist, but I was an illustrator, and a guy called. He liked my pictures and asked would I be interested . . . well, what the hell?

"The reason he liked my pictures had nothing to do with the clothing. He could get people to do that; the clothing always looked like decals, anyway. But the *McCall's* people wanted the models in settings. I enjoyed doing them, enjoyed building little environments. I didn't enjoy

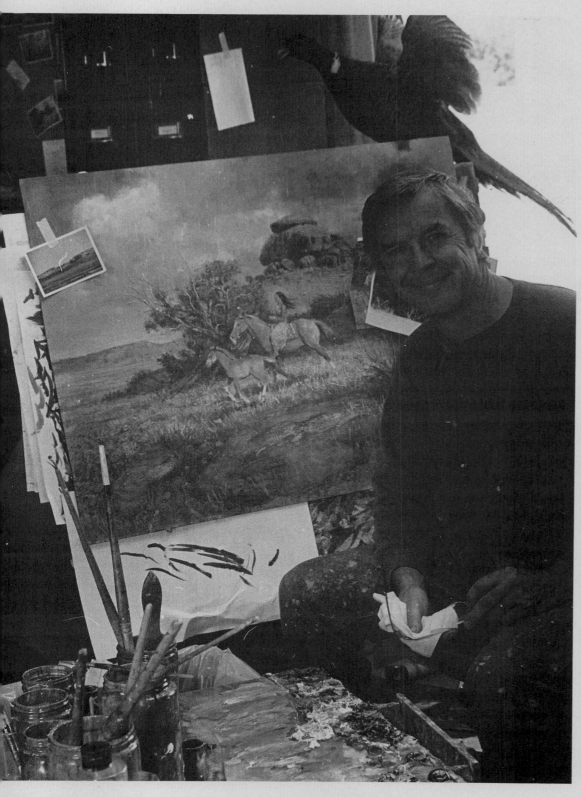

painting plaids, though. Plaids are a bitch."

As the 1960s came to a close, so did Bob Abbett's career as an illustrator. He and Marilyn and the children were living in Wilton, Connecticut, by then. The desire to devote full time to fine art and a love for the New England countryside had grown equally strong. In 1970 they began exploring for a place to call home, a search that led, finally, to the hilltop above the Housatonic.

This is pricey real estate, this corner of the world, and some of the neighbors, like Bob Abbett himself, are names well known. Mike Nichols, film director, owns the farm to the west and raises Arabian horses. To the southeast, Mia Farrow owns a few dozen acres of woods. Bob and I sat on the patio one evening, sweatered against the chill, toasting sundown with smoky-tasting Scots whisky and watching the deer feed out from the woods and graze in the lower pasture.

"The first year after I left commercial art, I spent twelve solid months scared out of my mind," Bob recalled. "I had all the experience, all

———

Robert Abbett in 1974—
a paint-spattered
newcomer to the world
of fine art.

———

the craftsmanship, all the tools. What I didn't know was whether I could find a market for the kind of work I wanted to do.

"I think it was being here that kept me from fretting myself to pieces that year." He looked down the hill at the deer, scarcely more than shadows now in the dusky light. I thought about how it feels to reach into myself day after day for ideas and the words to paint them with, thought about my own few brushy acres of Missouri countryside and how the sun looks when it comes up behind the cedar-grown ridge beyond the ponds, and I knew exactly what he meant.

It was about that time, early in the gallery-painting years, that Bob and Marilyn began travelling in the West, and before long, they owned a second home in Scottsdale, Arizona. Spending winters in the Southwest served both as respite from the bone-chilling New England cold and as an opportunity for Bob to expand the subject matter of his painting.

Not that Western painting was entirely new: "When I started illustrating paperback book covers, Westerns were all over television, and we got to do a lot of covers for Western novels. The funny thing about it was that most of us in the Chicago studios had never been to Arizona — most of us had never been farther west than Cicero Avenue, as a

matter of fact. Yet we were supposed to paint these Western scenes. We couldn't afford to go west, so we'd buy Western-movie magazines... That's where I got started doing Western art."

Even though Bob Abbett still is best known as an Eastern artist, as many as half of the paintings he does in a typical year treat subjects endemic to the Southwest. He is masterfully skillful at painting horses, usually quarter horses and seldom a horse standing still. I know just enough about horses to be convinced that every one of them is secretly out to kill me, but even I can't miss the spirit and vitality of an Abbett horse. What those paintings do for real horse people, I can only imagine. It must be much the same as the dog paintings do for me.

The next afternoon we walked the woods at Oakdale Farm, Duke and Bo and Bob and I.

Some artists have been captivated by the ugly uproar of great

cities, but Bob Abbett's sensibilities are of a far gentler turn, more responsive to the subtle energies of the woods, more quickly touched by the scarp of mountains than by an urban skyline.

"When I was a kid in Hammond, and later, in Chicago and New York, my great dream was to own a piece of land like this," Bob said as we scuffed along through the drift of fallen leaves. "Enough land to walk out of sight on, as they say.

"I've been watching these woods change for almost twenty years now, and I often wonder how they'll look twenty years from now."

Our woods-wandering styles are a good match, not much talk, both of us fond of just poking around, seeing what there is to see. Bob stops often, to look at the slant of the hillside or a peculiar wry-necked curve in the limb of an oak, filing it away for the studio.

"Bob gets caught up in what he sees," Marilyn told me later. "We've had some exciting moments traveling. Bob will notice something, reach for his camera, and try to look, take a picture, and drive, all at the same time. Now I do most of the driving."

31

To walk these woods is to travel as if through a seamless series of Abbett paintings. Here, next to a tiny slough where woodcock had splashed their chalky calling cards, was the same snaggled stump that I'd just seen in the Ducks Unlimited painting on Bob's easel. There was the old stone wall that some Yankee farmer built rock by back-aching rock, where, in another painting, Duke stands frozen in time and the smell of grouse. Over the hill and down to where a stream trickles along the forest floor is *Late Day Woodcock*, my favorite Abbett painting of all. I wished my Brittany were there with me.

As it turned out, we had enough dogs. Duke and Bojangles, true to their particular genetic blueprints, were having a grand time — Duke following his nose through the woods in the sinuous glide of old-style, Eastern setters, Bo frolicking everywhere like a buffalo with a puppy's heart. At some point he managed to harpoon himself on what probably was a broken-off branch, something in any case that gouged a thumb-sized hole into the big muscles of his chest. If Bo even noticed it at the time, he didn't indicate anything, and because the wound was low on his chest, almost under his front leg, neither Bob nor I noticed it until the next morning. By then Bo had licked it clean, but it was a nasty rip that clearly needed a stitch or two.

With Bo in the back of Bob's van, delighted to be going for a ride, we drove to Brookfield Center where Dr. Don Ginand performed the necessary repairs. To keep Bo from nipping the sutures out, Dr. Don used the standard treatment, so the dog spent the next few days wearing a bright-yellow plastic bucket, its bottom cut out, slipped over his ears, and tied to his collar with gauze. He looked like a dog shanghaied into a grade-school pageant and assigned the role of a daffodil.

I drove the van back to Bridgewater, while Bob sat in back to keep Bo, still half-stoned from anesthetic, from rolling around and tearing out the stitches. It reminded me of driving Tobe away from a vet's office in Minnesota after she stuck her nose into the base of a hollow tree, expecting Lord knows what, and found the wrong end of a porcupine. We swapped dog stories for a few miles and concluded that life without dogs would be considerably less trouble but woefully incomplete.

Bo put his chin on Bob's leg. Bob stroked the glossy black coat and said something that started Bo's ballbat-sized tail whacking against the back seat. In the rear-view mirror, I caught a glimpse of Bob Abbett looking at his big dog like a man seeing the depths of some precious mystery.

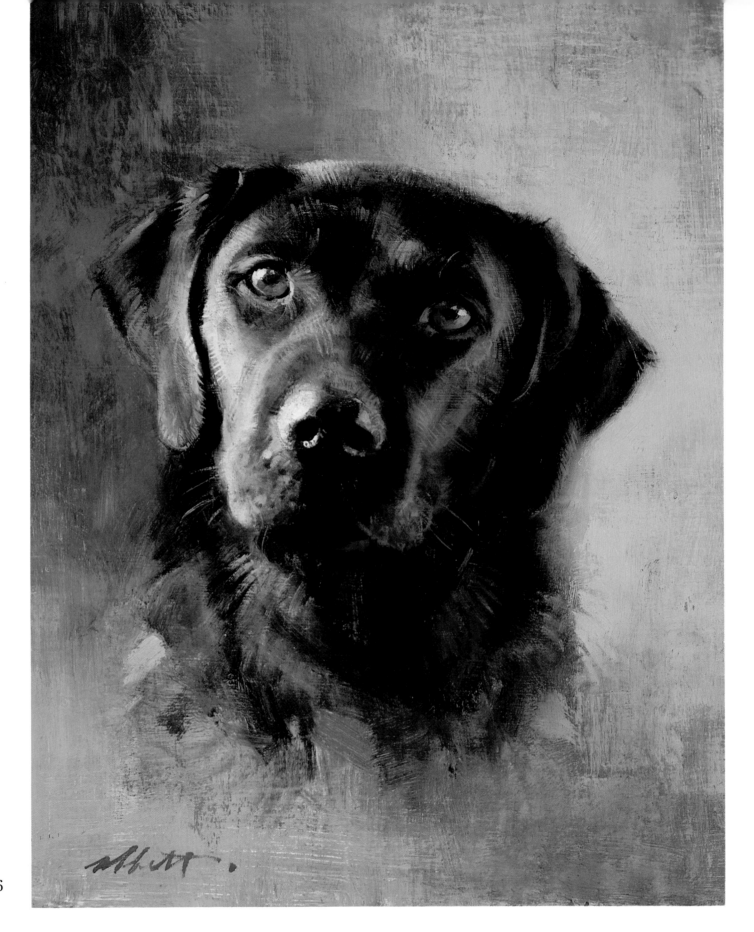

The Lab, Oil, 9 X 12, 1986

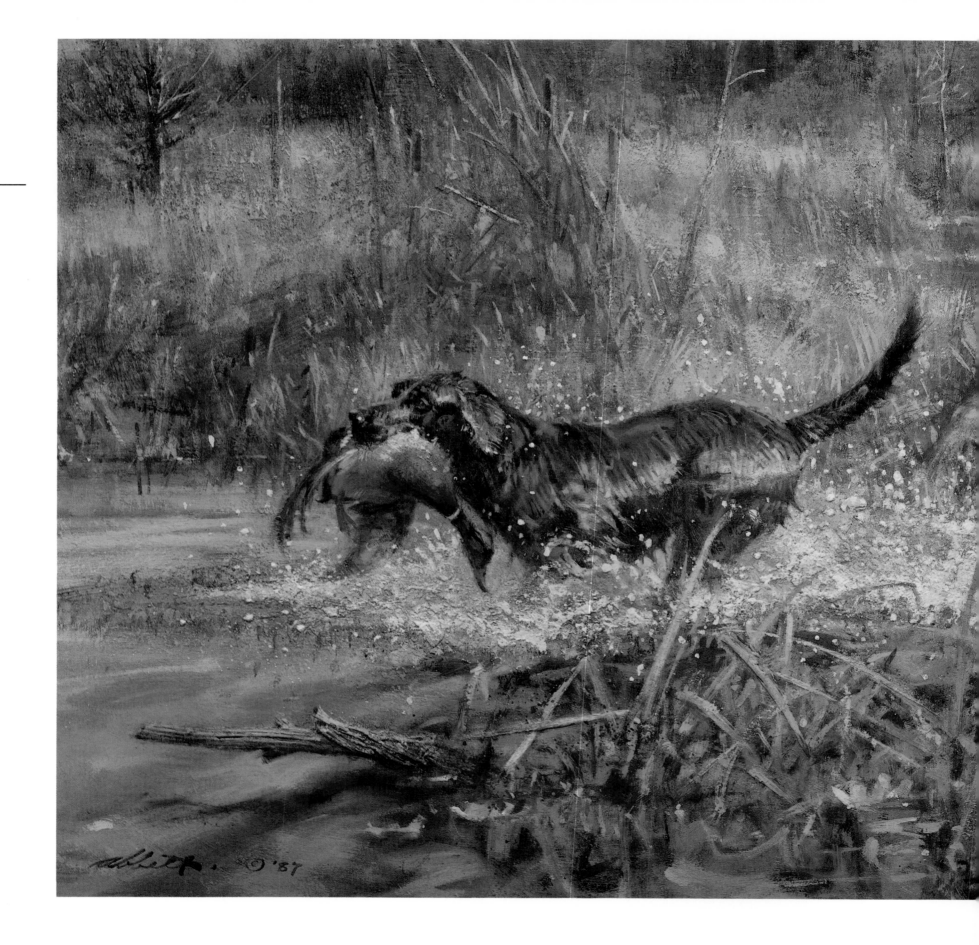

I cranked up my Lab, Bo, for quite a few runs through the water in front of Tom Sweeny's home on Candlewood Lake and merged several local scenes into this setting.

Though a different problem, painting a Lab's wet coat is as tricky as doing a wild turkey's plumage—the sheen has to be just right.

My one argument with the whole duck-hunting scene is the waterfowler's penchant for arising before dawn and hunting in the worst weather ever invented. Gray days make for dull pictures. In this case, however, I was able to enliven the scene by adding a heavily textured wake beneath the dog.

Ducks Unlimited published *Gray Wood Retriever* in a large edition of fund-raising prints in 1987.

Gray Wood Retriever,
Oil, 20 X 30, 1987

orb Lillis lives on a stretch of the Aspetuck River where it meanders through New Milford, Connecticut. The stream isn't mentioned in many flyfishing books, but it's an enviable location all the same.

On one hazy New England afternoon, I tagged along with Norb and his friend, Bob Gant. As they paused a moment to check for fish, this painting began in my mind. Experienced trout fishermen know that seeing and carefully approaching a fish or pool is as important as the choice or presentation of the fly.

I've painted the Aspetuck into quite a few pictures, but for this one I moved in an old covered bridge from Pennsylvania.

———

Stalking the Brown,
Oil, 20 X 30, 1986

———

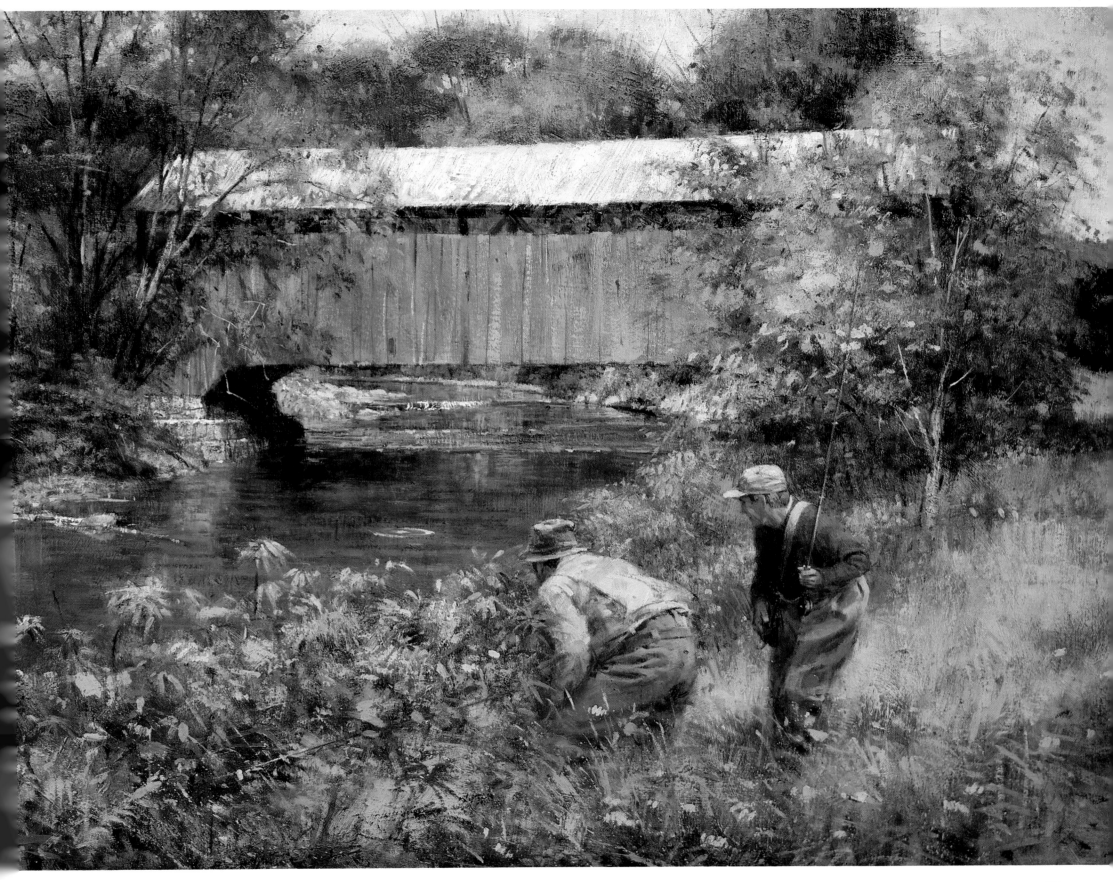

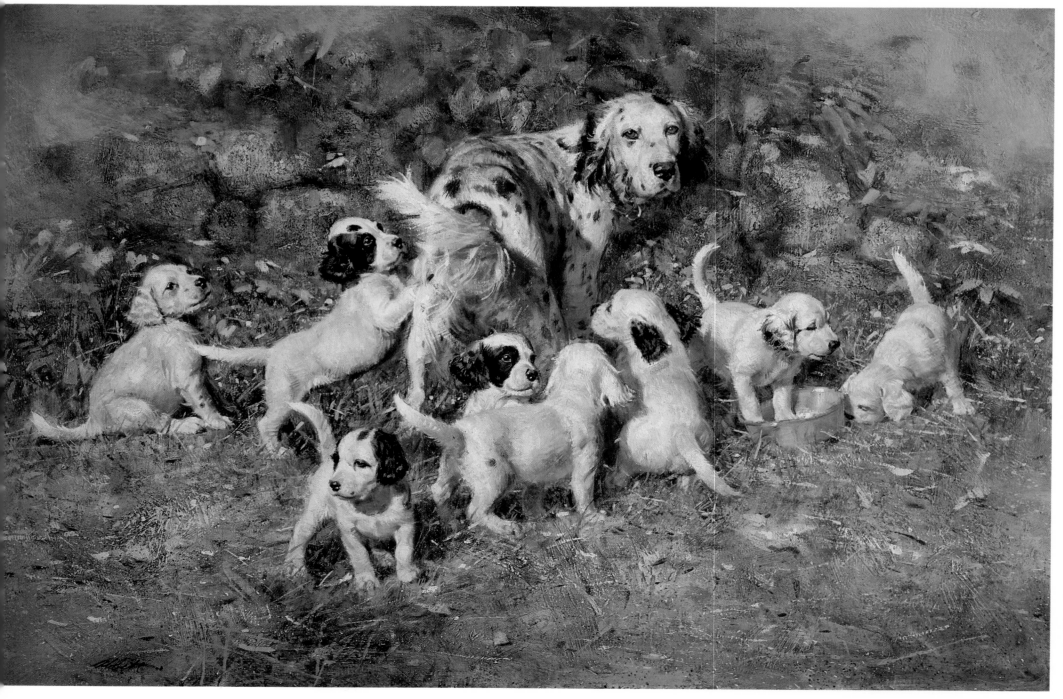

My dog's parents were Luke and Diana, and Diana is shown here with her litter. Duke is the third pup from the right, though I'm not quite sure. I'm conscious that such a painting could label the artist a sentimentalist or a painter of "cute" pictures, but if that is the nature of the subject matter, then so be it. These lively pups deserve to be shown.

Rendering a setter's coat is a challenge, like painting satin or water; knowing when to quit is a virtue, as is not putting down everything you see.

English Setter Pups,
Oil, 24 X 36, 1987

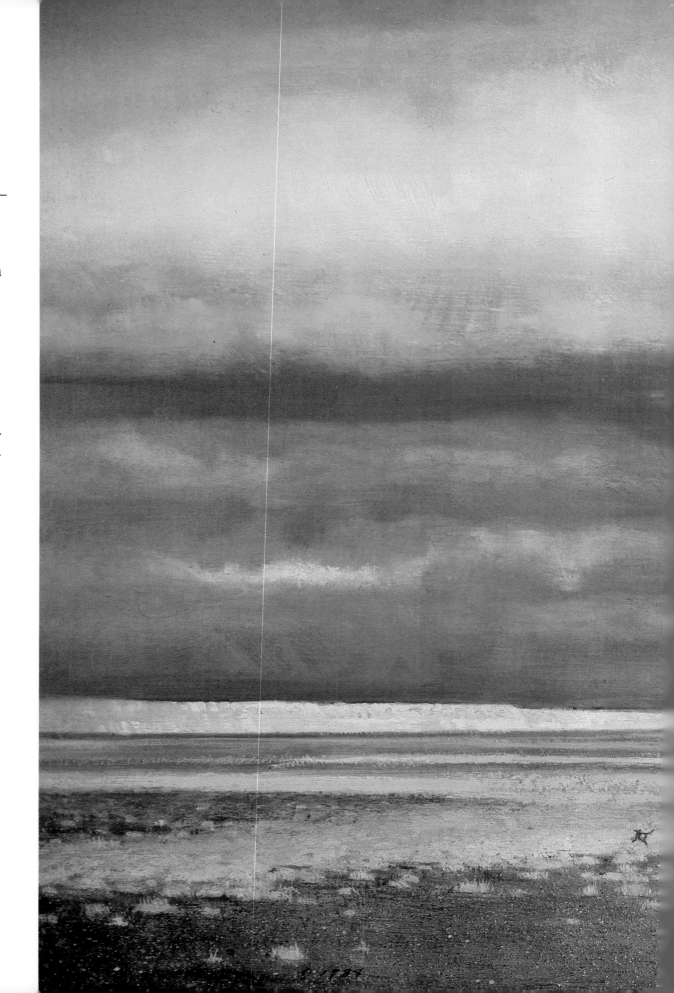

In the '70s I was privileged to travel on Arizona's Navajo Reservation with Troy Murray in the company of Jim Cody, a young Navajo. Aided by Jim's interpreting, we visited and ate with many of his friends and relatives.

What I learned about the Navajo in that limited time was the understandably strong emphasis on nature in their beliefs. And as in this picture, there is no escaping the ever-present awesomeness of its presence. Sometimes the skies seem to follow the landscape; in this case the wide, simple patterns of clouds, grass, and earth created the painting almost automatically.

———

Navajo Pasture,
Oil, 24 X 36, 1984

———

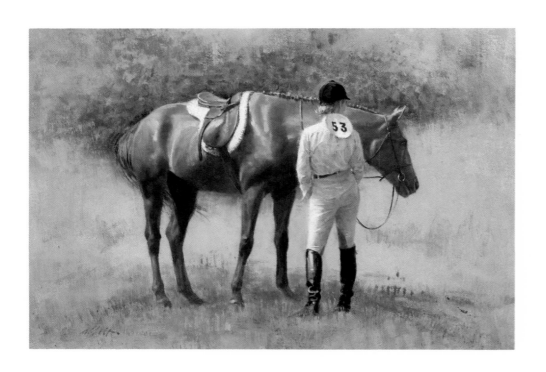

There is something so attractive about good-looking horses, about well-kept tack, and about the people involved, that horse shows almost always suggest painting ideas. As an extra little device, I added a story line in this picture, using the body language of both rider and horse to suggest their day might have been better.

I kept the painting simple, with just some quiet tonal areas to set off the figures.

Maybe Next Time,
Oil, 20 X 30, 1987

I watched the jumping and when I turned around, there was another picture: the contestants waiting their turn to compete and perform. Horse shows have a festive air about them, especially for the spectators, and I'll always seize the chance to paint a bit of that genre, along with its fine animals.

Waiting in the Wings,
Oil, 18 1/2 X 32 1/2, 1979

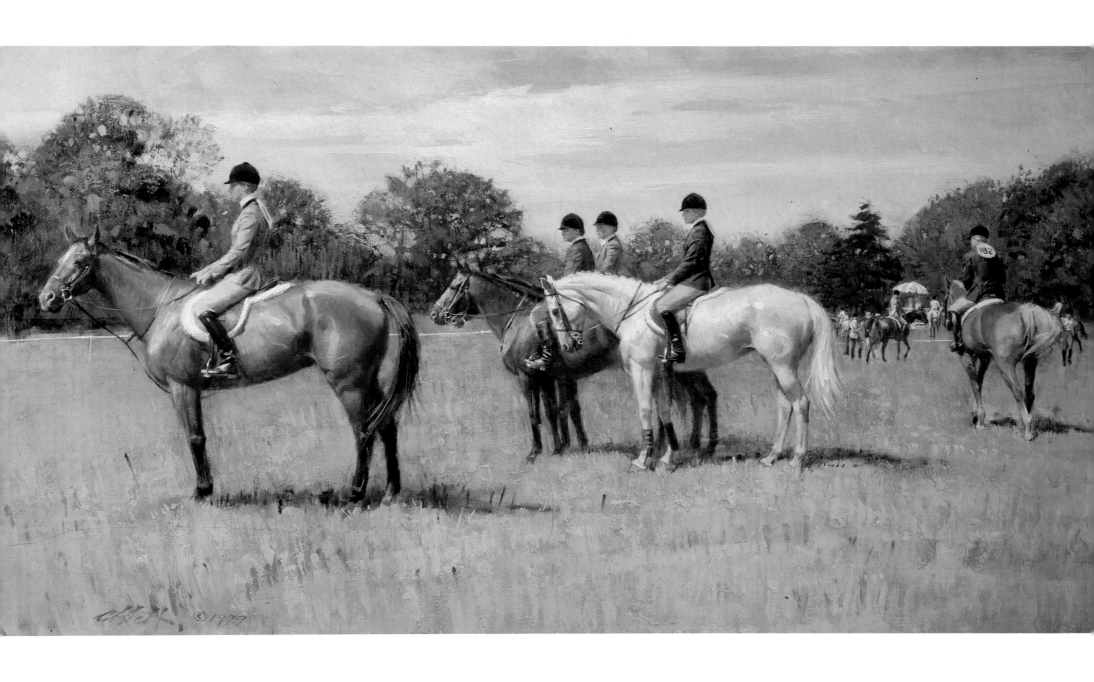

43

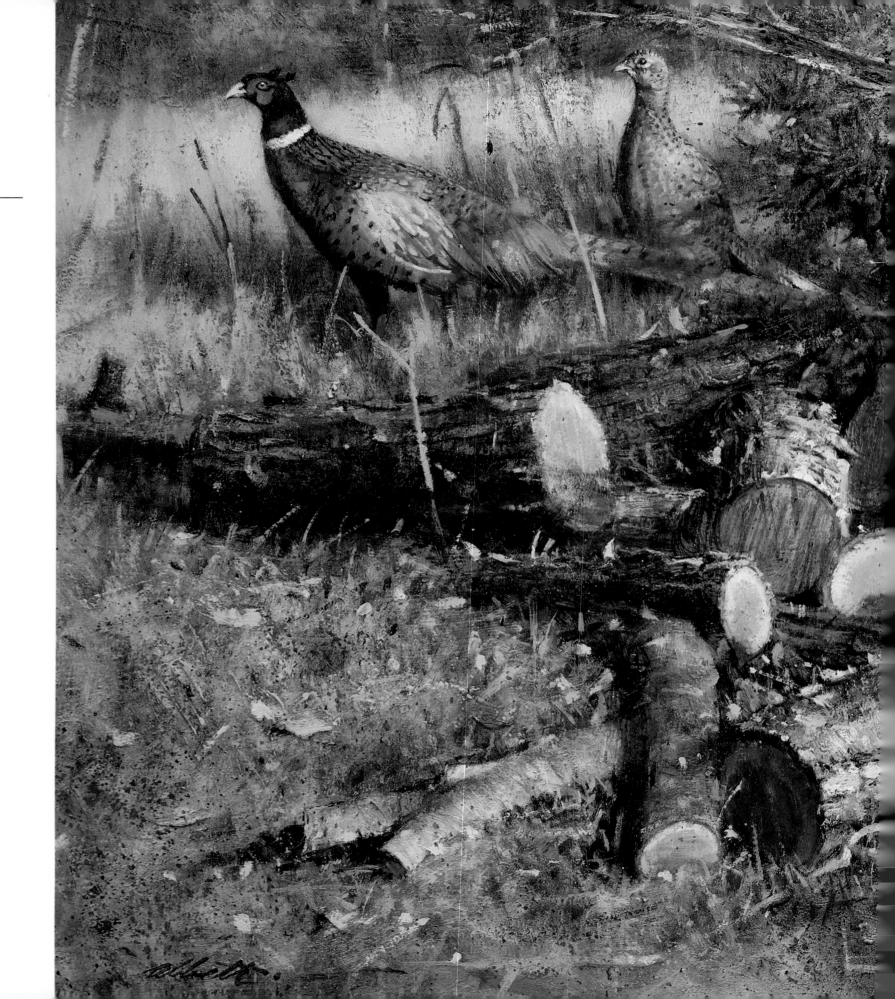

When we cut up a fallen tree on our farm, the wood may remain in the field for some time before I can manage to pick it up. The grass starts to grow up around it, and the logs begin to look "built in" to the landscape. Since pheasants seem relatively at home with us, it was natural to show this relaxed pair of ringnecks picking their way past a logpile.

While I may have gained some expertise at picture making, I'm sure a real woodcutter would criticize my diagonal cuts. He might even notice the signs of a dull chain on the bright ends of several logs.

———

Wood for the Small Stove,
Oil, 18 X 24, 1987

———

45

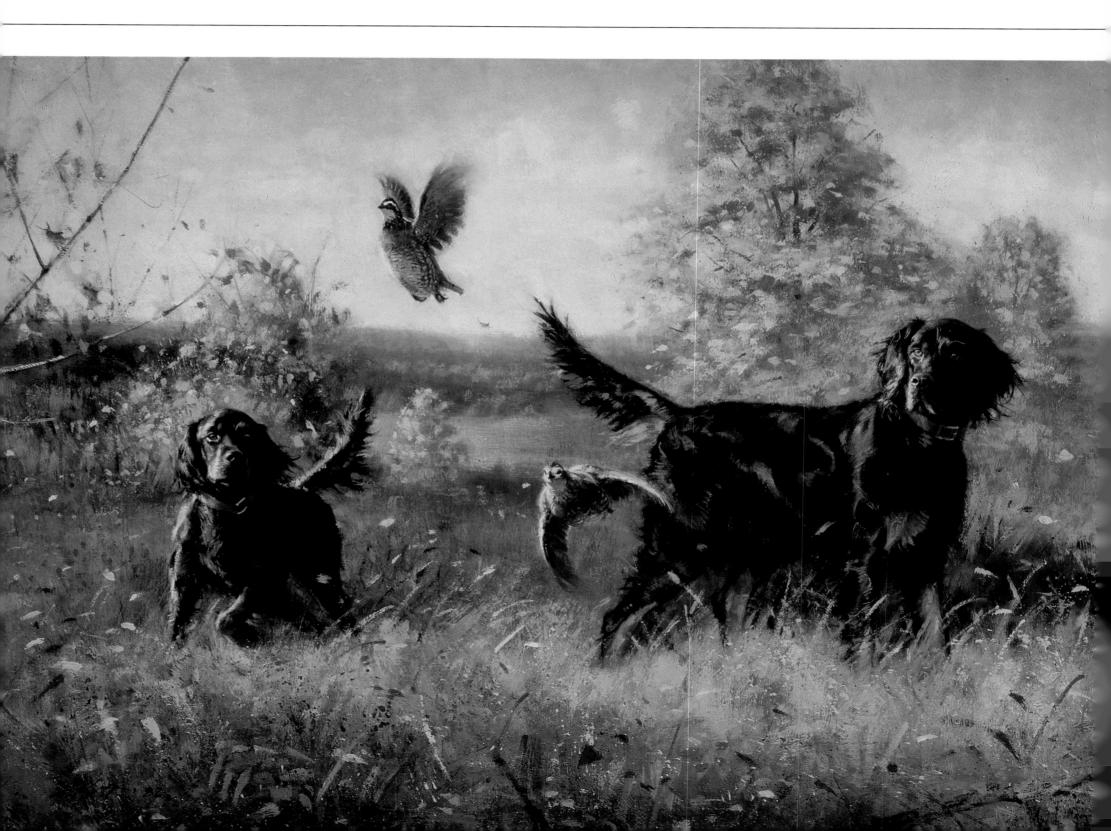

*D*are and Dash were active on the AKC and American field-trial circuits. Each dog won many placements in both open and breed competitions. Gwynne McDevitt, trainer Tom Getler, and I worked the pair at the Setter Club near Medford, New Jersey, for their double portrait.

In 1988 this painting was reproduced in limited edition by Wild Wings, Inc. and the Gordon Setter Club of America, Enfield, Connecticut.

Dare and Dash,
Oil, 24 X 36, 1982.

*D*are was a beautiful example of a Gordon setter, and a fine house dog and favorite of her owner, Mrs. Gwynne McDevitt of Newtown Square, Pennsylvania. Although the breed originated in Scotland, it is historically regarded as *the* New England grouse dog.

Painting black animals can be tough, but the rewards are worthwhile. I think the yellow-and-black color scheme adds a very rich aspect to the picture.

Dare, Oil, 16 X 20, 1983

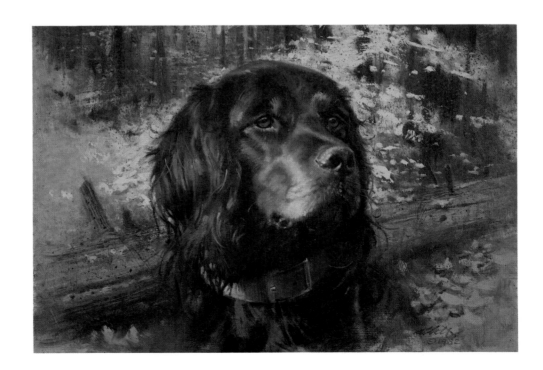

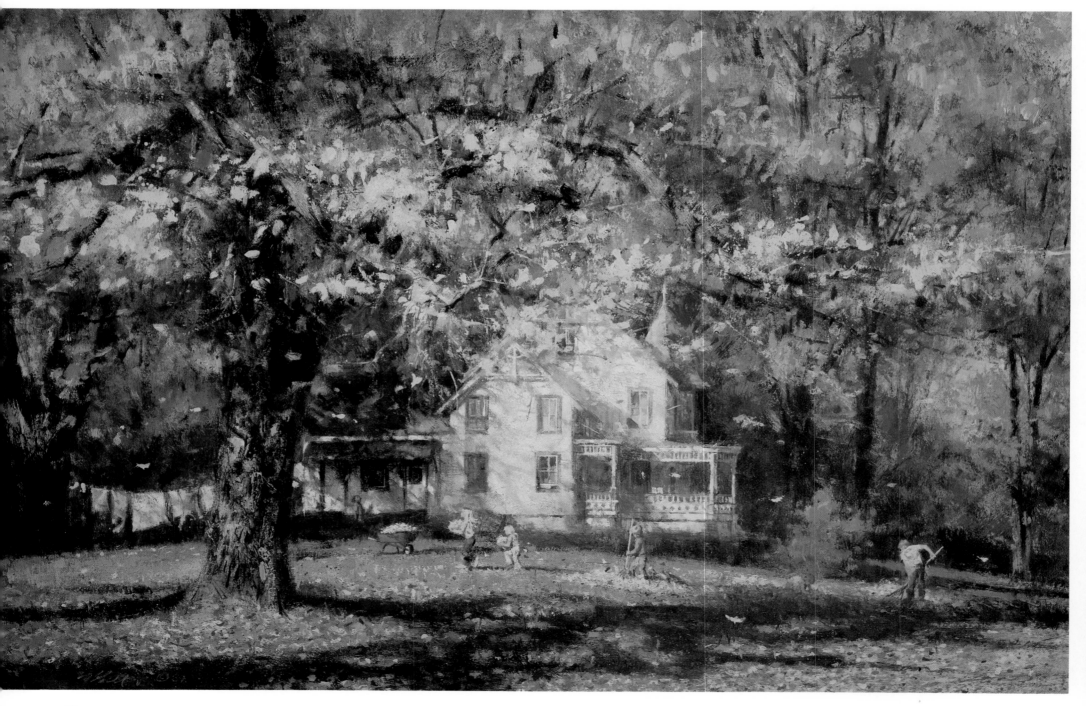

48

Many people have told me they were either raised in a house like this one or wished they had been. Of course, New England has a handy supply of picturesque old homes. Whenever we travel, Marilyn and I enjoy photographing and comparing the differences and similarities of houses across the country. Many of the popular designs were obviously repeated as people moved about.

I found this home in nearby New York State, and though it was a little run down, it had great charm. Using a clear, warm afternoon light and the glory of fall colors, I could breathe some life into the image. The kids were from photographs that I've been collecting for some years.

As with all my recent limited-edition prints, Wild Wing's production man Bill Meyer did his usual magic. It is one of the warmest, most faithful reproductions in his long line of credits.

The same year it was painted, *Saturday Afternoon* was shown at the second Society of American Impressionists Exhibit in Scottsdale, Arizona.

———

Saturday Afternoon,
Oil, 20 X 30, 1984

———

I paint people as well as animals, so I am always pleased to have a portrait or two on my schedule. I'm not sure I would want to do only people, however. Wasn't it John Singer Sargent who tired of the limitations of his specialty and wrote a friend, 'No more *paughtraits*!'?

Frank Rhodes builds fine antique furniture reproductions, and I visited him at his workshop near Chestertown, Maryland. I could think of no better background than one of the pieces in progress—a magnificent lowboy—and several appropriate props from the workship like the Nutting book on furniture, a calendar, and a bottle of the local beer.

I used a kind of split lighting in this picture, highlighting not only his face, but his all-important hands.

———

Frank Rhodes,
Oil, 24 X 30, 1984

———

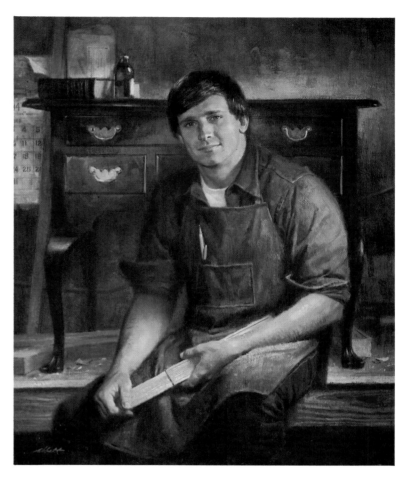

ainted for the 1985 Easton Waterfowl Festival, *First Time Out* was used for the official catalog cover as well as a small edition of Festival prints.

The Maryland show fills several November days with art and photography exhibits, carving demonstrations and displays, parties, some of the country's best goose shooting, and that great Eastern Shore cooking.

This picture reflects yet another go at painting water. The smooth surface enhances the relaxed mood I wished to depict. Here too, I blurred the reflections so they would not compete with the central figures.

Most important, however, *First Time Out* speaks of those quiet moments when a magical connection occurs between a man and his dog. It is a moment that a person who has never owned or hunted with a dog will never fully understand.

First Time Out,
Oil, 19 X 27 1/2, 1985

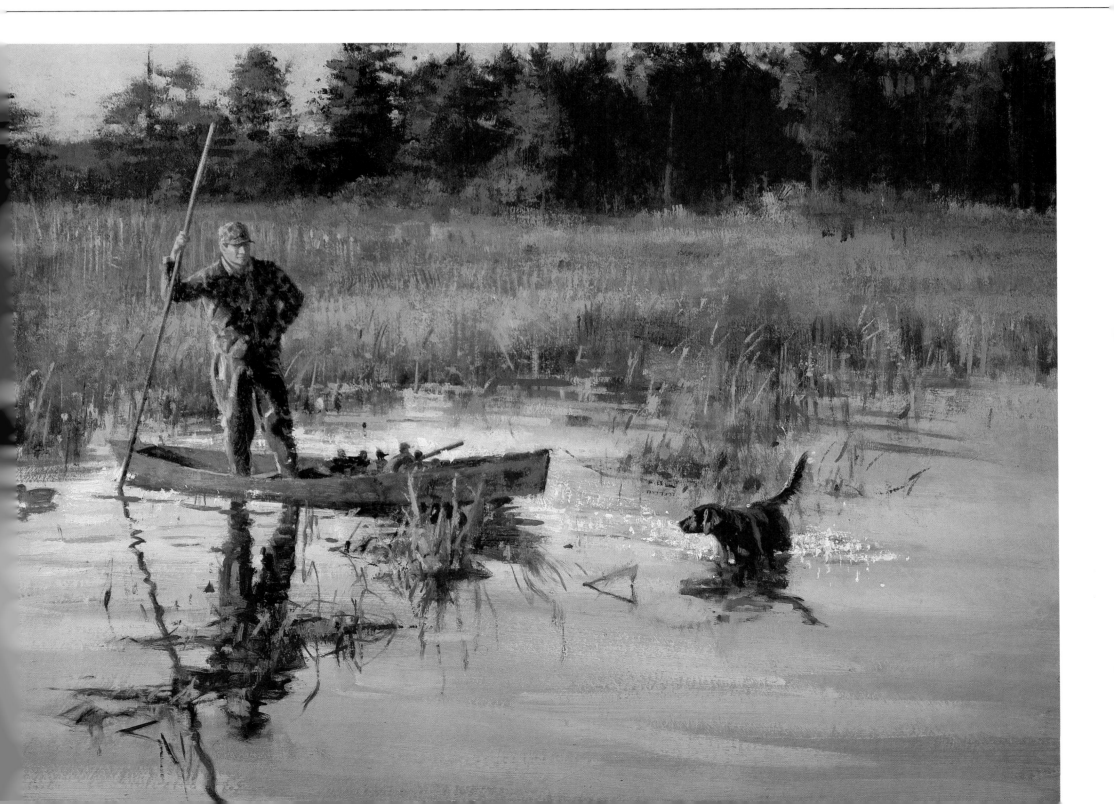

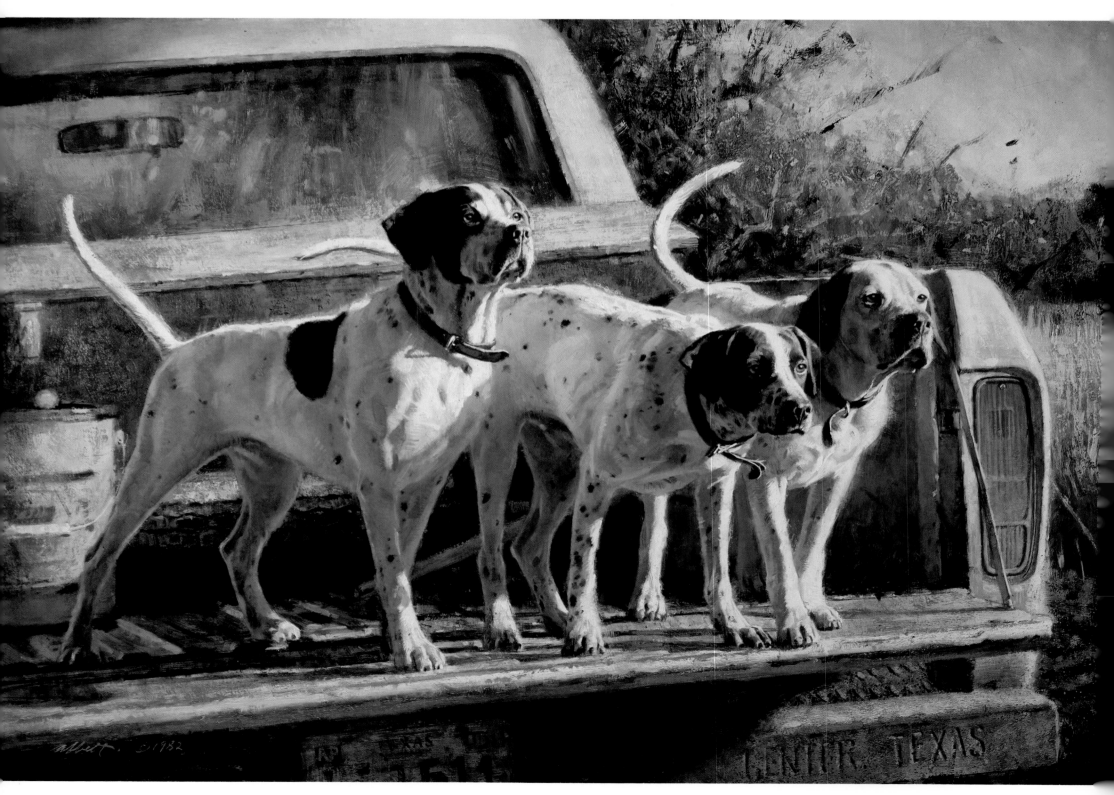

As you might suspect, these pointers at Hawkeye Hunting Club in Center, Texas, were trained to wait in the pickup until their trainer, the late Hoy Thompson, gave them some invisible signal. In the meantime they would not respond to anyone else's command or invitation, no matter how compelling. It wasn't the trick that attracted me to this trio, but their distinct personalities.

This scene, incidentally, violates one of my unwritten laws in painting. While tastes in hunting and fishing apparel change, as does most everything, I like to keep my sportsmen dressed somewhat unspecifically so the painting doesn't look out-of-date by next week. That's one reason I rarely show a car or truck. But the pickup truck is so endemic to the West, that I felt it would serve as an interesting and authentic setting in the picture.

Waiting at Hawkeye, Oil,
36 X 24, 1981

Bob Wehle's Elhew Kennels is to pointers what Rolls Royce is to automobiles. After fifty years in the dog business, Bob thought a commemorative painting would be in order, and so I was summoned. Showing three of his prime dogs, the painting was reproduced in prints and cards for Elhew (that's Wehle spelled backwards, in case you didn't notice).

Bob's brother, Jack Wehle, is owner and director of Genesee Country Museum, which houses one of America's finest sporting and wildlife art collections. The beautiful museum is located at Mumford, near Rochester, New York.

Elhew Pointers, Oil,
20 1/2 X 15, 1987

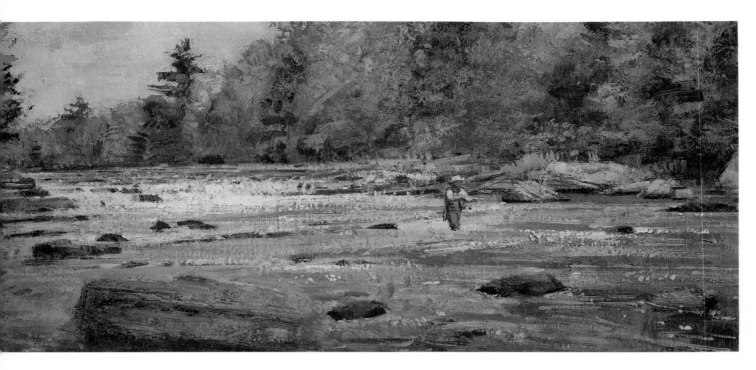

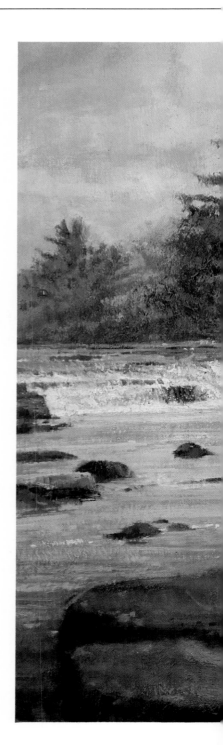

aving agreed to change the season to autumn, this sketch enabled me to work out my color scheme in advance; of course, the surface of the water would also reflect the color.

———

Denton Falls Sketch,
Oil, 6 1/2 X 13, 1988

———

r. Ira Jaffrey of West Nyack, New York, had been trying for some time to get me to one of his fishing beats, where I could work on a painting for him. In the middle of our hottest and driest summer since I've been a Yankee, Ira found that the Neversink had plenty of water.

Neversink is thought to be a Dutch corruption of the name from its original (Iroquois) Leni-Lenape tribe dialect, whose specific meaning has been lost. To the Dutch the suffix "sink" apparently meant stream, like its lesser counterpart "kill," as in Beaverkill.

———

Denton Falls —
The Neversink,
Oil, 18 1/2 X 32 1/2, 1988

———

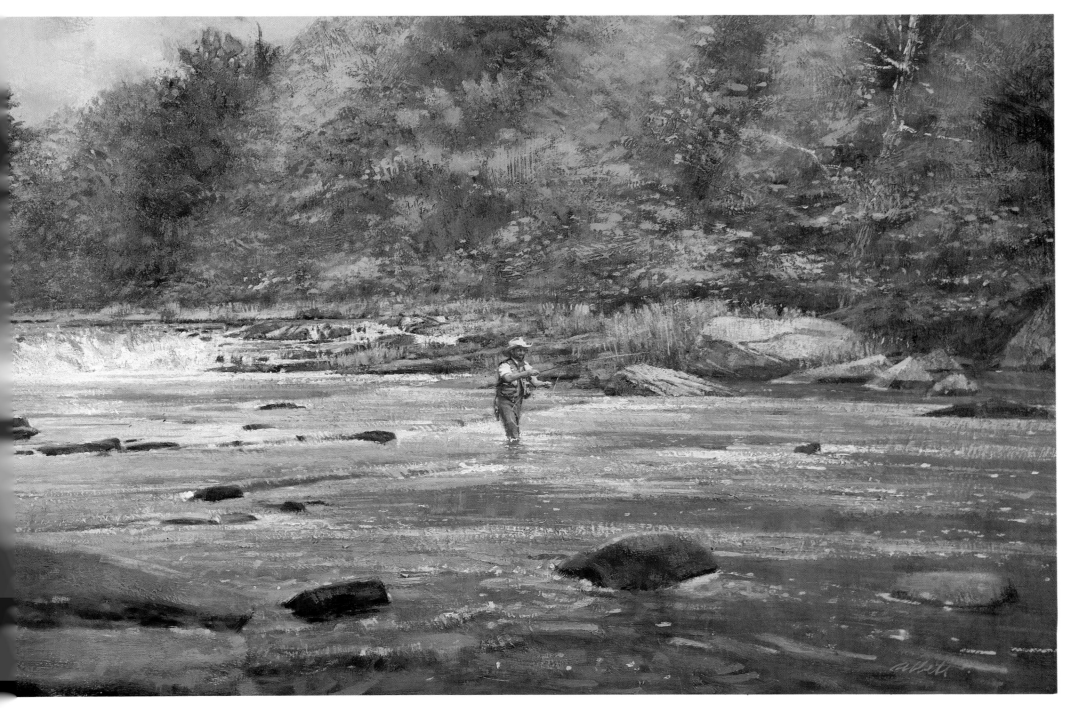

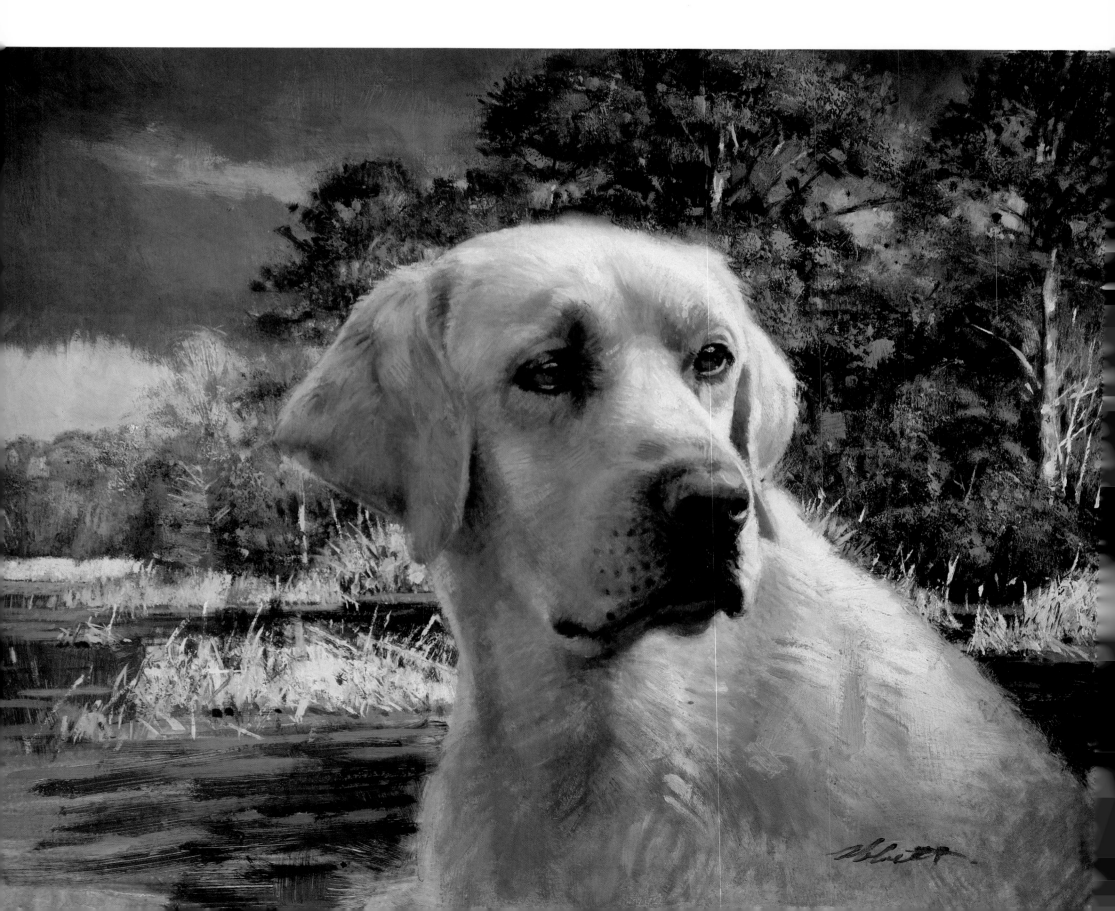

lash's "official" portrait was commissioned by Atlanta sportsman Jim Kennedy. The setting is in front of a duck blind at Clarendon Plantation in wonderful old South Carolina. I've hunted with Jim and Flash on several occasions, and each was a battery charger.

The limited use of color seemed expedient here; Flash and the dried marsh grass are almost the same tone. By massing the foliage of the trees in a value close to that of the dark sky, I created a deep-toned background against which the dog stands out forcefully.

Some artists dislike doing commissions, partly I suppose, for fear of being over-directed. But I've had many good experiences in doing paintings that are very personal to the people involved. I would have hated to miss out on these projects, both for the sake of the picture opportunities as well as the friendships that have resulted.

Flash, Oil, 16 X 20, 1987

ate Boulos turns out marvelously-trained setters at her Florida kennels. In addition to the dogs' sprightly stances, I was interested in giving viewers a taste of Florida's quail habitat — the sabre-like leaves of palmettos, a profusion of oak leaves and pine needles covering the ground, and hinted in the gray background, curtains of Spanish moss.

As opposed to painting dogs or any other subject on a white background, I made up my mind early on to do well-integrated paintings — pictures with subjects that fit comfortably and correctly into their settings or habitats. If I can make the viewer feel the crackle of dried leaves underfoot as he "enters" the painting, then I've accomplished at least part of what is important in my art.

Training at Cedar Ridge,
Oil, 20 X 30, 1986

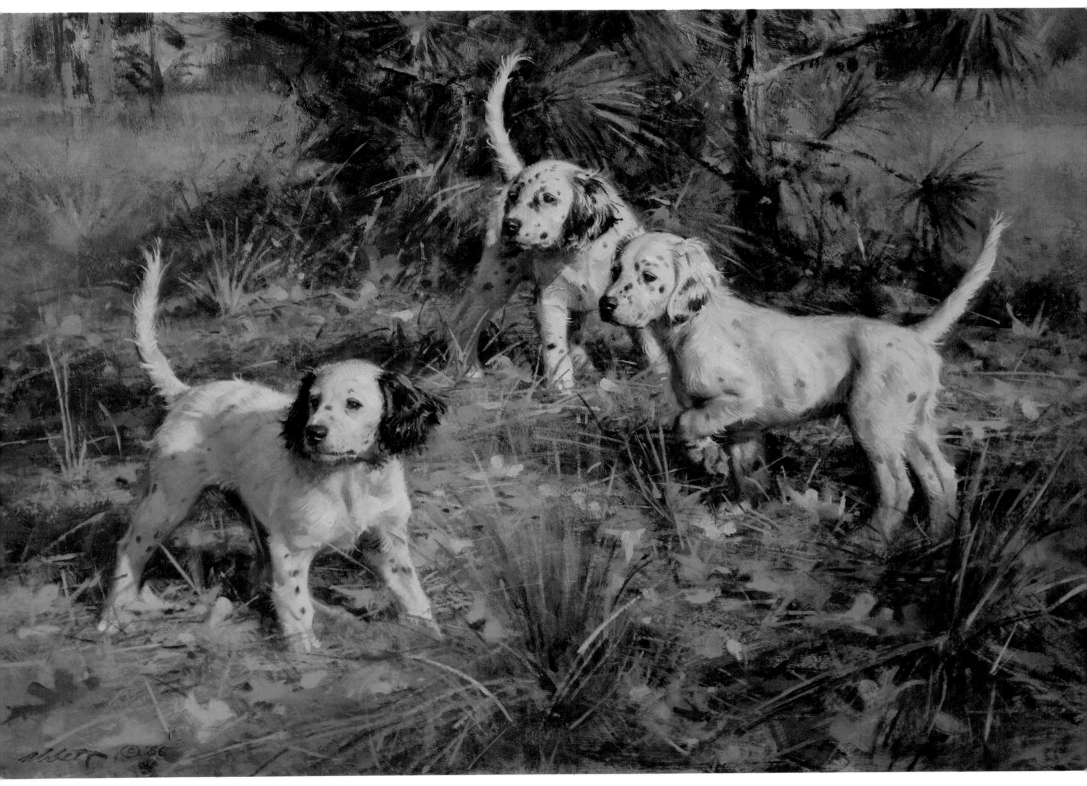

It was a great thrill to be commissioned by the Cowboy Hall of Fame to paint this portrait. It hangs in a gallery of portraits depicting screen celebrities whose works enlightened Americans to their Western heritage. I'd always enjoyed Jimmy's movies and while at his home in Beverly Hills, I learned that he'd been mostly playing himself all those years.

As he donned some old movie garb, Jimmy shared a number of fascinating stories from his film experiences. Then, as he sat down in front of my floodlights, I couldn't help notice that it was "show time," as if he had just walked onto the set at a Hollywood studio.

I finished the painting in my Connecticut studio, where among other things, it fell off the easel onto my palette and was temporarily adorned with splotches of pure tube color, easily removed, of course. These color gobs were reminiscent of a painting Jimmy showed me during the first minutes of my visit. He asked for my opinion of a wildly abstract piece, obviously pulling my leg. He let me suffer only for a moment before revealing the truth. It had been painted by a chimpanzee and was due to be auctioned for a local charity.

A research trip to Arizona's Mount Lemmon furnished the setting; as for the handsome roping horse, I found it in Danbury, Connecticut.

———

Jimmy Stewart,
Oil, 32 X 42, 1976

———

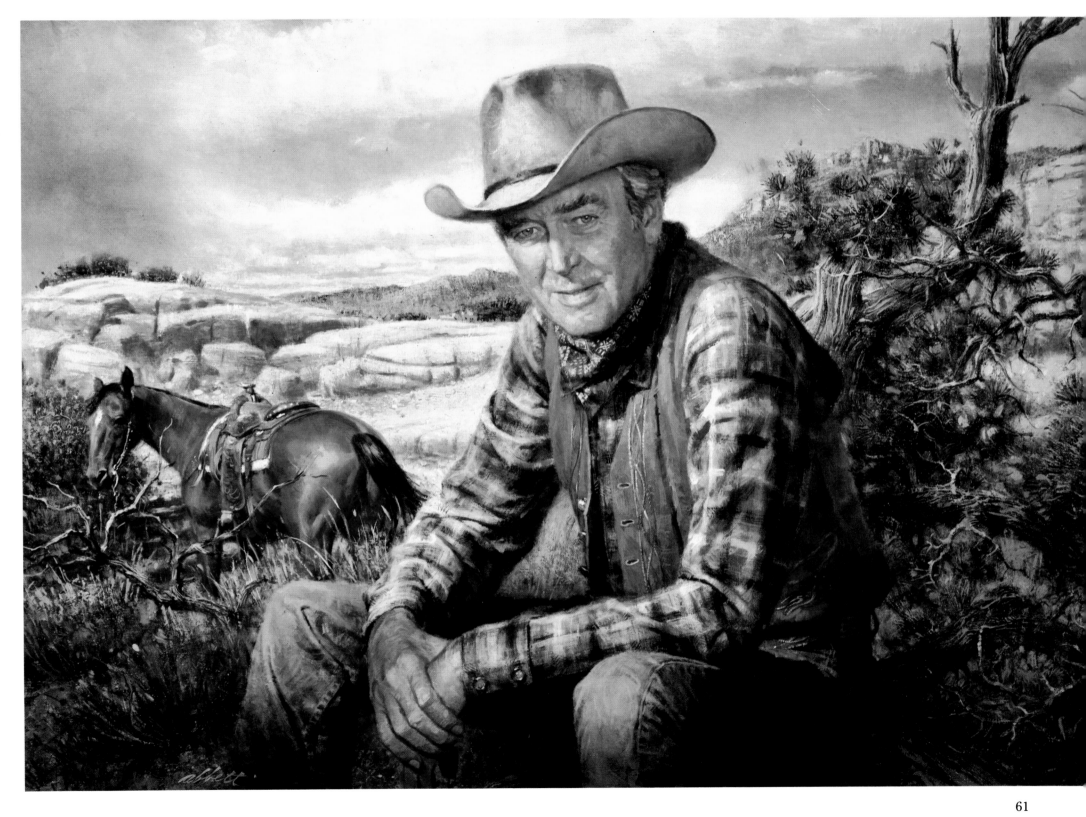

61

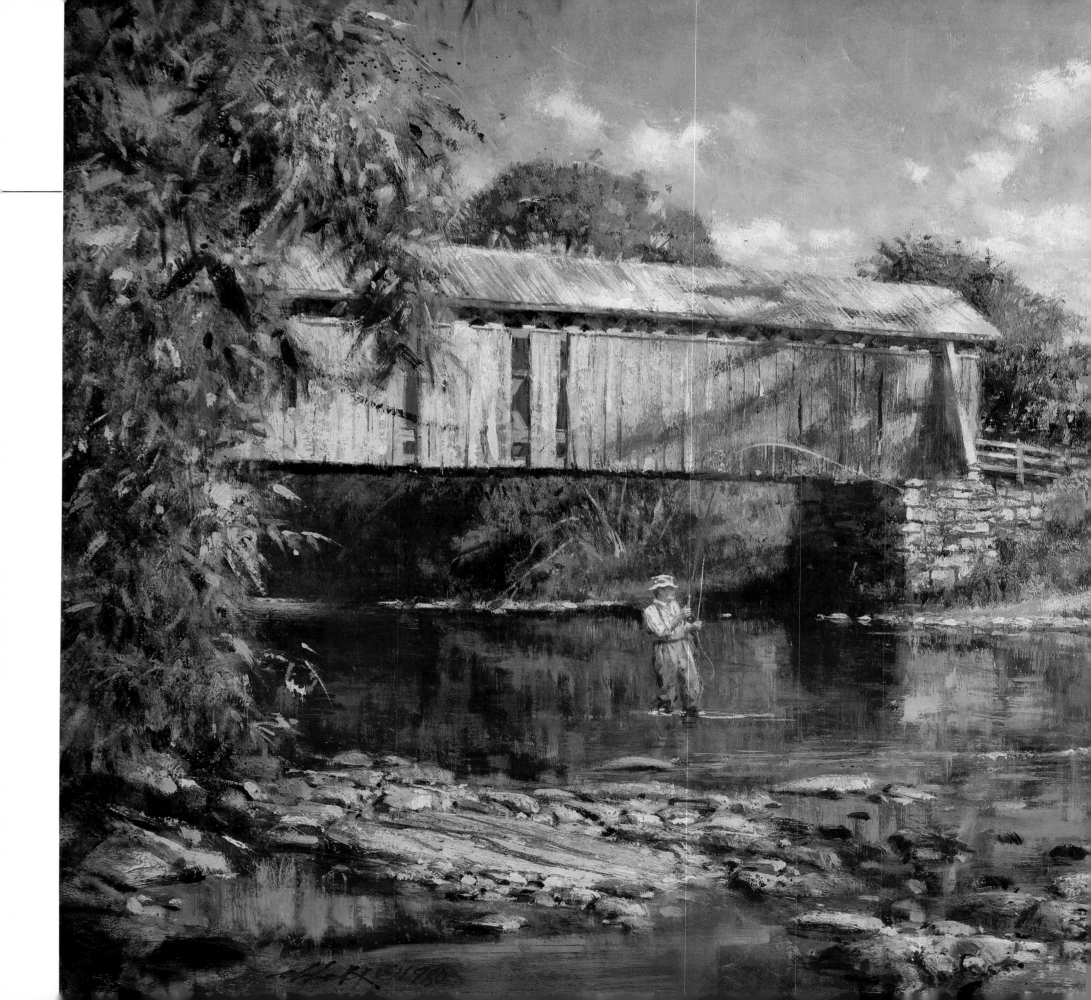

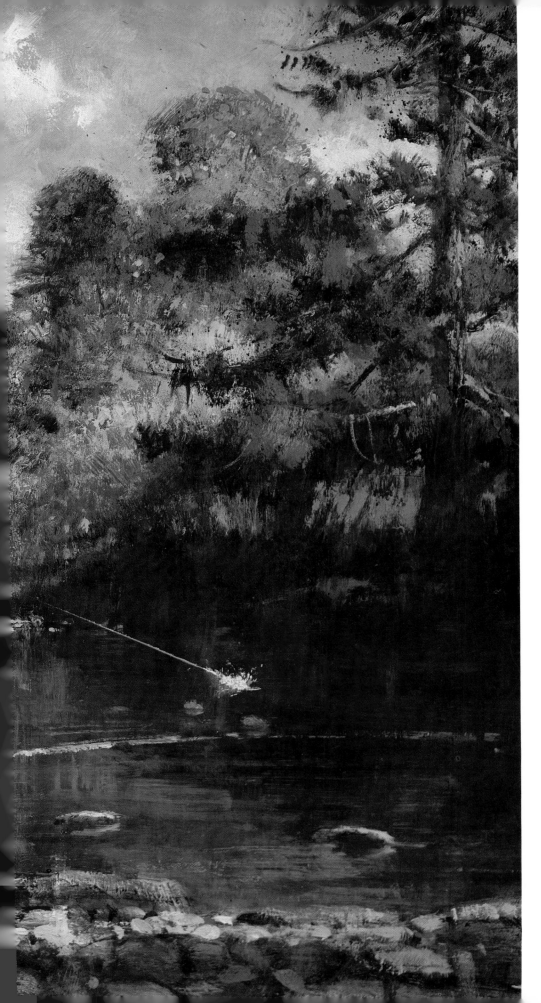

Covered bridges, like old barns and colonial homes, often increase in pictorial value while their actual physical condition is in marked decline. I'm not sure we'd all agree that the human counterpart is valid.

This old structure spans the Willowemac River near Roscoe, New York, and I was as interested in the feel of the ledge rock and river stones as I was in the bridge's rough wood. In doing a painting in which texture is important, I try to select a time of day when the sunlight comes across these surfaces from the side. If they were lighted flatly with the sun at our backs, we'd see much less definition.

Painting it best often calls for a return visit at the right time of day, or maybe a wait of several hours. I've done both, and while waiting is not one of my strong suits, I tell myself that taking things more slowly is not all that bad either.

———

The Bridge Pool,
Oil, 20 X 30, 1980

———

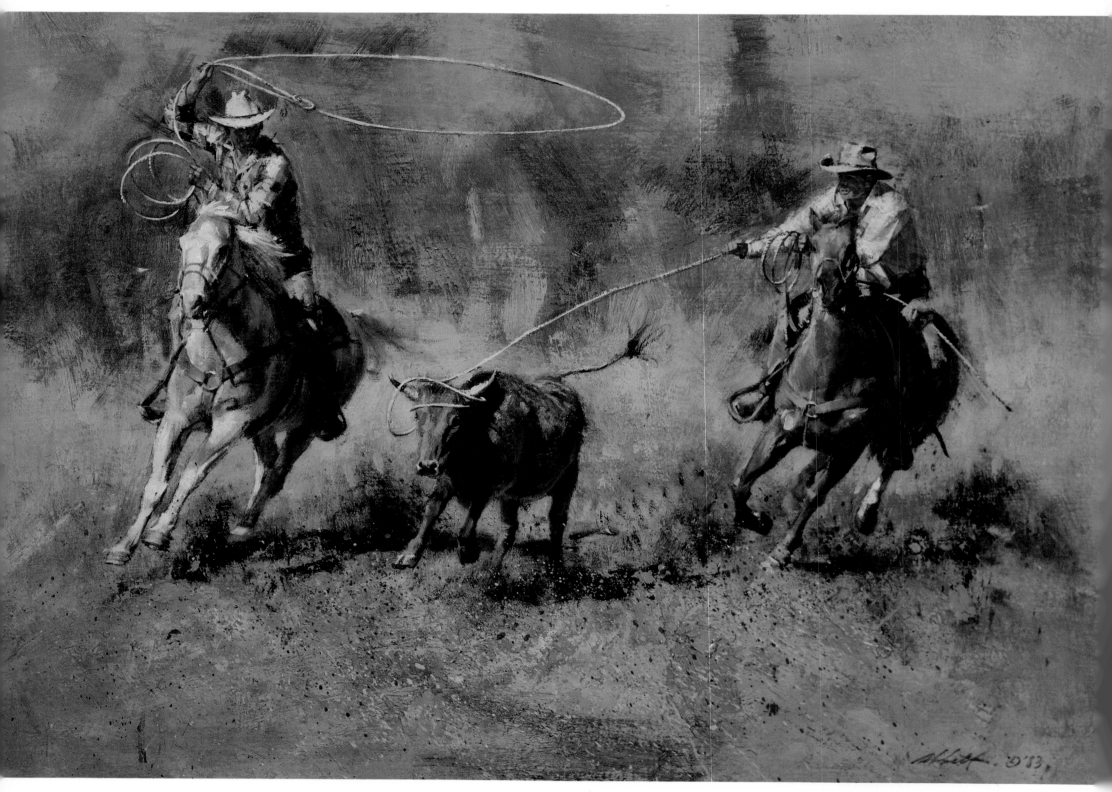

Most rodeo events have grown from normal work-a-day ranch jobs, as in this case where two cowboys team up to separate and immobilize a calf or steer for branding or inoculating. The rodeo equivalent is Team Roping. The header's job is to rope the horns; the heeler's is to place his loop vertically in front of the calf's hind leg where the next step will take it through the rope.

The double loop around the horns is an accident and not what every header hopes for. When this painting was almost complete, Arizona neighbor and former rodeo competitor Ed Honnen informed me that such roping would disqualify a team in competition. I changed the painting and removed the unwanted loop.

The Extra Loop,
Oil, 18 X 24, 1983

———

In rodeo parlance, slack time refers to the elimination rounds of competition. They are run off earlier in the day and not viewed by the general public. Without the accompanying crowds and hubbub, slack time is a good time to hear the thumps and grunts, and to observe some of the incidental moments to which I'm attracted.

One simple little theme—the horse's curiosity, nosing in as the rider picked out his favorite rope—was the seed for this painting. Here, a vignette seemed much more appropriate than a full background. I wanted the stage bare and the spotlight on just these two actors. The early-day, low-angled sunlight coming in from the side helped to define both the cast and their props.

———

A Joint Decision,
Oil, 20 X 30, 1981

———

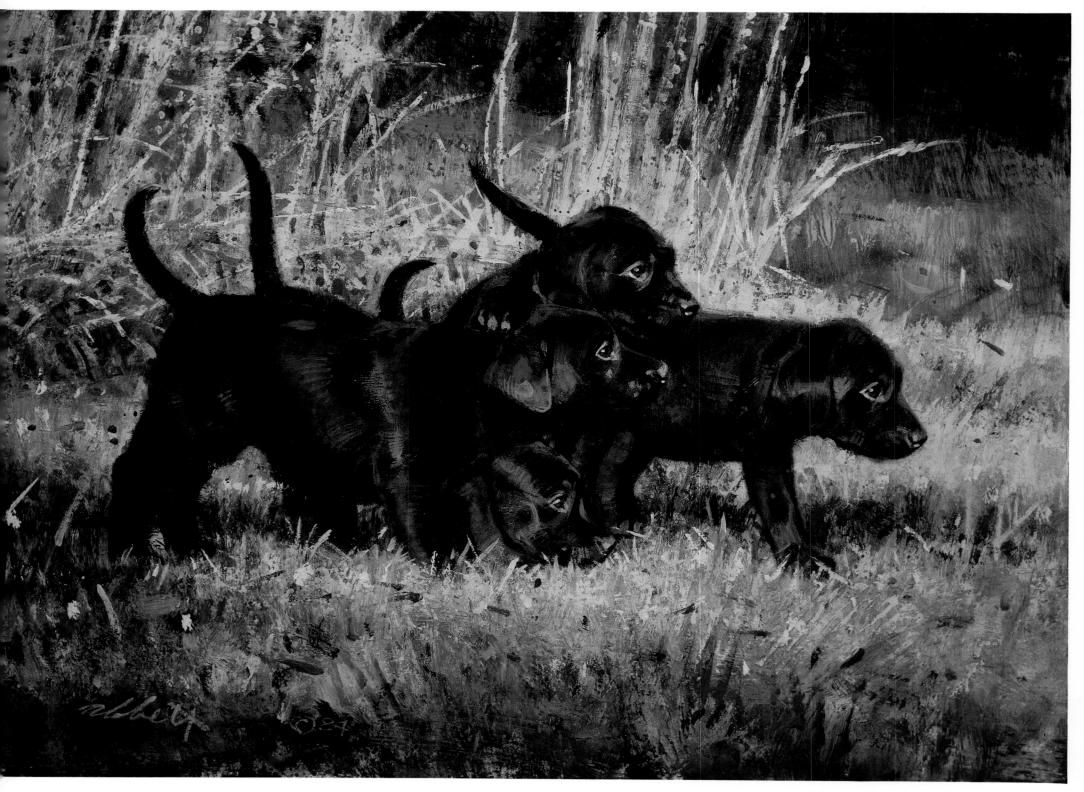

*P*art of my Lab's litter, the pup's constant scurrying and positioning actually led to a pose something like this on one occasion. The title seemed appropriate.

In painting black-coated animals, I tend to separate the secondary tones, some being cooler and bluish, others warmer and of a brown or tan tint. Playing these two shades against one another heightens the satiny quality we see in the young Labs' coats. This same technique could be used to explain and suggest a variety of materials, from fabrics to human skin or even a bird's plumage.

———

The Gallery,
Oil, 9 X 12, 1984

———

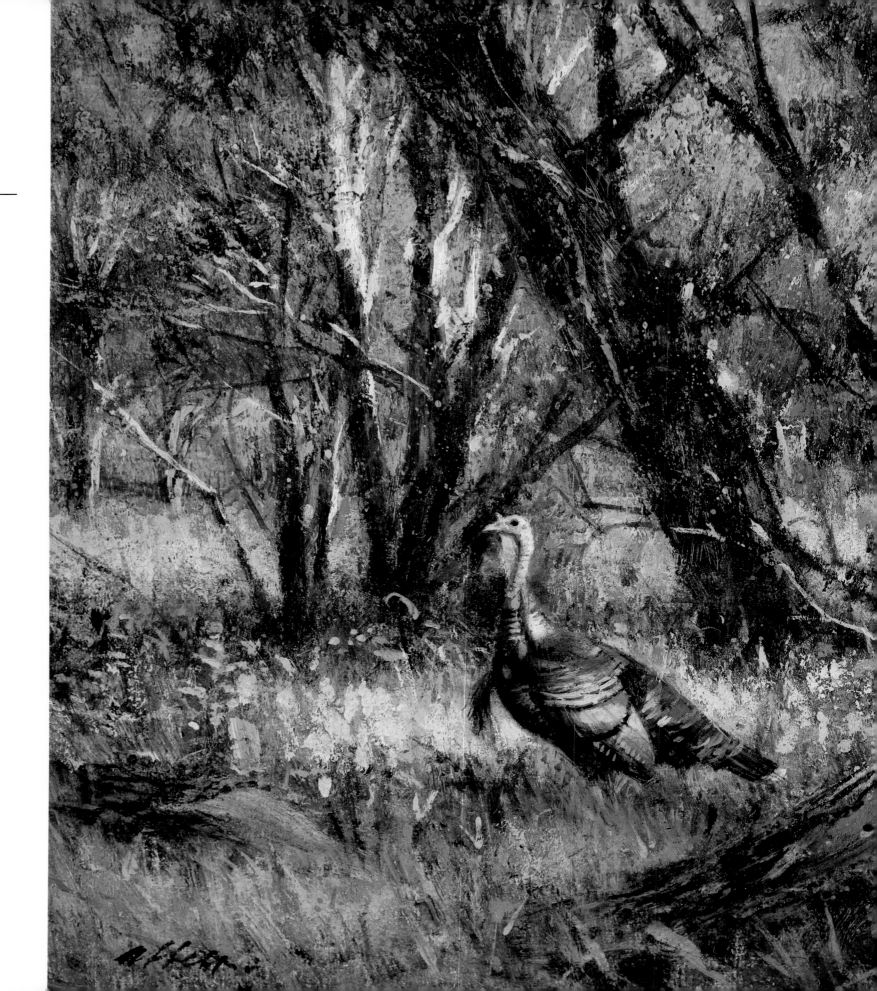

In this miniature painting, the turkey shows off his plumage and at the same time, an almost patriotic coloring of red, white, and blue. Ben Franklin wanted the wild turkey to be our national symbol, although I have no idea whether this kind of coloring suggested it to him.

Walking undisturbed across the woodland floor, the wild turkey moves with regal elegance. But when alarmed, a big tom becomes a sneaky sort, capable of slipping undetected through the driest of woodlands.

———
Texas Monarch,
Oil, 9 X 12, 1985
———

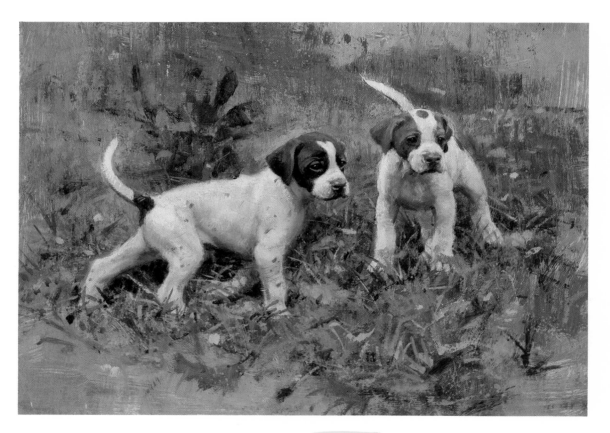

Called a *sight point*, this stance is commonly seen in pointing dog pups, at least in good ones. Pointing is just a dog's way of saying: "What's that?" Later, they will point out a scent without seeing its source. Why do they often lift one foreleg? My theory is that such a pose is simply one of caution, just like we might employ if we were to approach an unidentified and unseen animal. It might be an egg, or even a snake, neither of which should be trod upon.

A trained dog is much more enjoyable than its opposite. Yard training, as it's called in Texas, is the minimum, and includes the commands come, sit, stay, heel, and drop (lie down). Training to hunt, to be steady to wing and shot, is the advanced course and is a lot more fun for both trainer and trainee.

If you haven't guessed, the pup in *Learnin'* is Duke. I later traded a print to Connecticut bird breeder Rupert Kinney for enough pigeons and bobwhites to last the summer. As a result, Duke had some fifty birds shot over him by the age of six months. He's grown to be a fine adult dog, family member, and thorough hunting partner with whom I've enjoyed countless hours afield.

Learnin', Oil, 9 X 12, 1984

A smallish painting, this was done for a miniature art show. These exhibits, which rarely allow any painting larger than 9 x 12 inches, develop a good deal of collector participation because you can pick up some fine art without mortgaging the ranch. They're a little like the two-dollar window at the track – a lot of action for a relatively small investment.

Two Pointer Pups,
Oil, 9 X 12, 1986

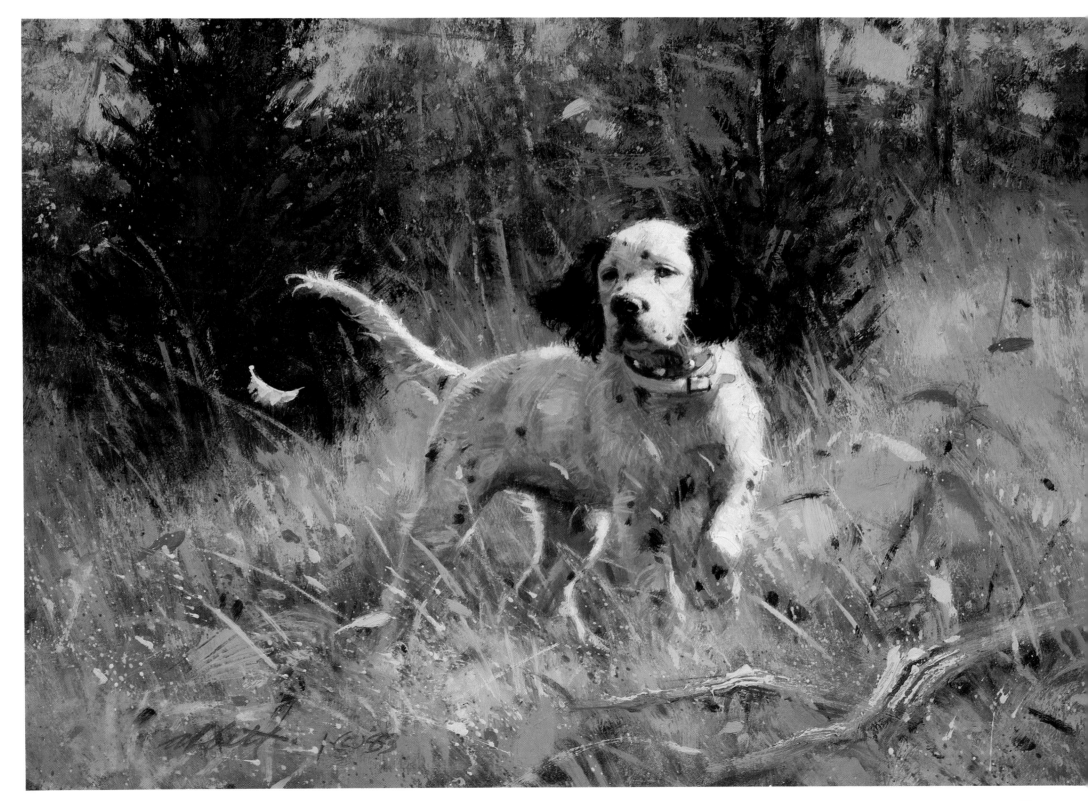

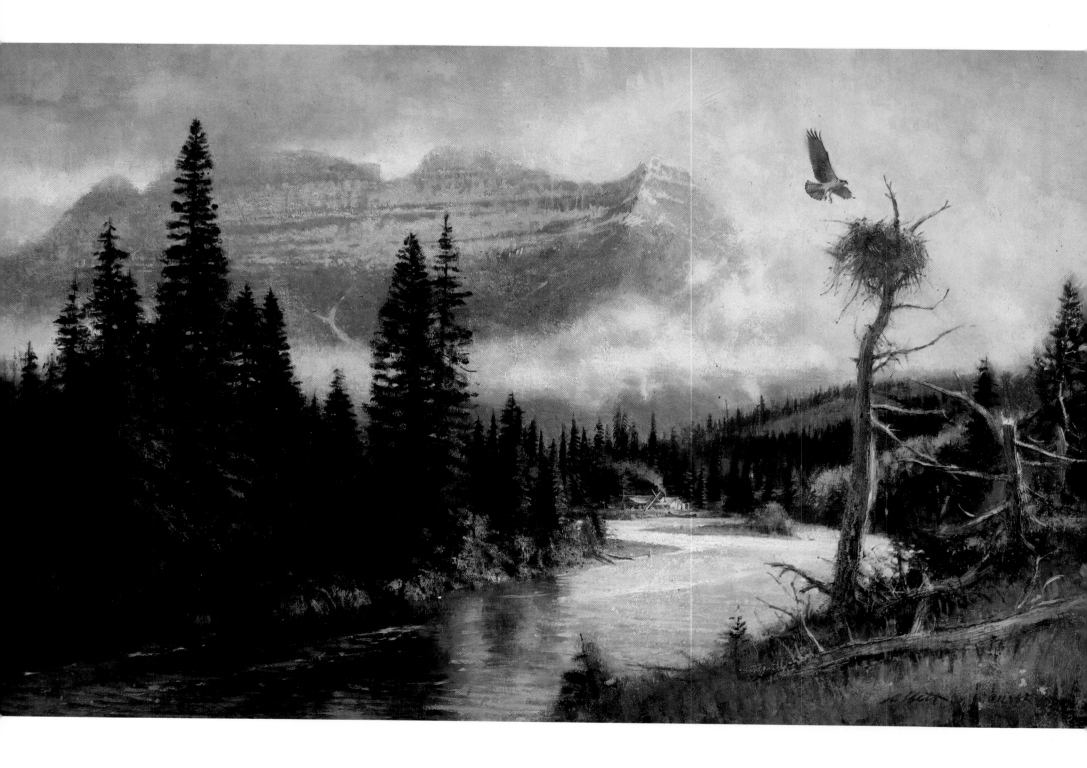

When we visited the Flathead River near the south entrance to Glacier National Park, there was a lot of morning mist swirling around. That seemed to provide a mood that would be lacking later in the day. The osprey and fishing camp found their way into the composition as it progressed.

Mountain Majesty,
Oil, 24 X 40, 1982

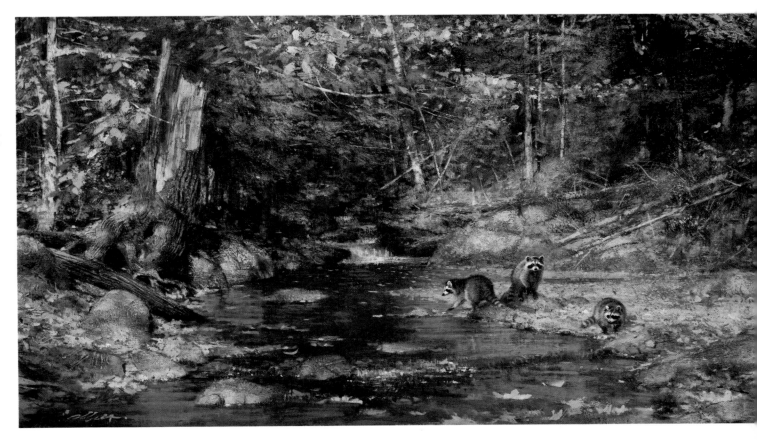

A raccoon named Rocky was the first pet Marilyn and I had when we lived in Oak Park, Illinois. Ever since, I've admired the raccoon's liveliness and curiosity. Its front feet, which are more like hands, have a high degree of tactile sensitivity; it constantly uses them to examine the ground and water. And it's true, raccoons prefer to wash their food if water is handy. Our Rocky would even wash a vanilla wafer, which of course, would immediately dissolve and disappear.

In a painting such as this, I first reinforce the initial pencil drawing with India ink. I then apply tone quite loosely over all. Next comes a khaki color which serves to cover up the dazzling white of the gessoed board, and at the same time, sets the key for what follows. By picking out first the light areas and later the darks, one finds the painting half done.

Coon Crossing,
Oil, 19 X 36, 1987

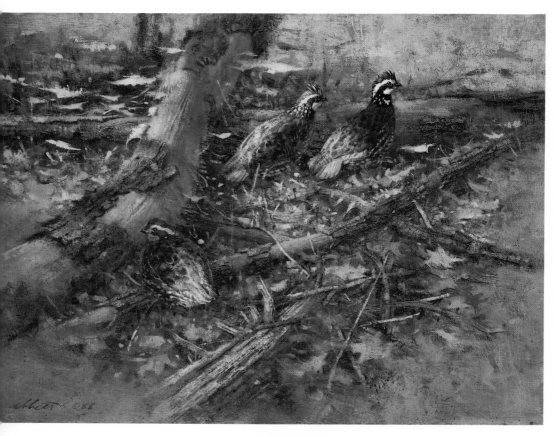

I enjoy taking a few square feet of nature, painting it rather studiously and placing some birds or a mammal into it, and then trying to make all the elements fit together believably. As we know, with their protective coloration, wild birds like these bobwhites are seldom completely visible.

———

At the Edge of the Woods,
Oil, 18 X 24, 1988

———

In this painting I used some background scenery from Riverview Plantation in Georgia, but added the old farm buildings to heighten the Southern flavor. One of the advantages of being a painter, compared to a photographer, is having the freedom to depart from your source material and to eliminate, add, or transpose elements to suit the composition.

There's a lot of planning in a painting such as this: The scenario has to be plausible and, of course, all the mammals and birds must be shown correctly and the lighting has to be consistent. That's still not enough. I always want to weave in a bit of mood, perhaps adding some shadow areas that weren't really there to contrast with the flash of the birds.

I've enjoyed a long friendship with Glenn Cox, whose family owns and runs Riverview and who showed me around the covers when I hunted there.

———

Wild Covey,
Oil, 24 X 36, 1979

———

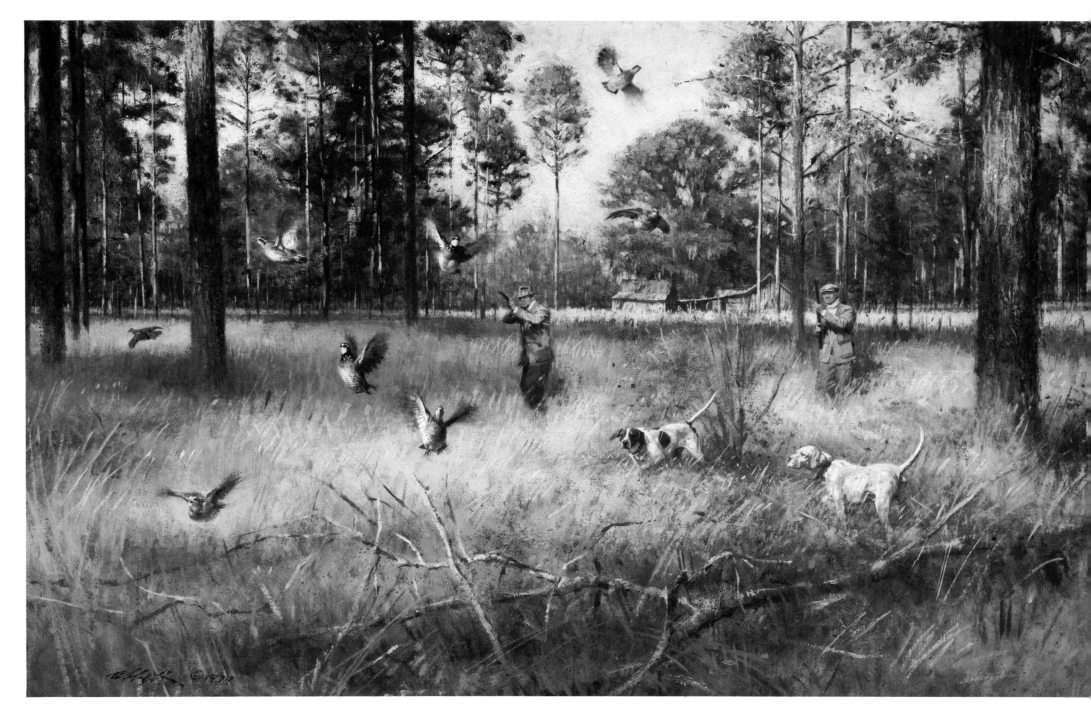

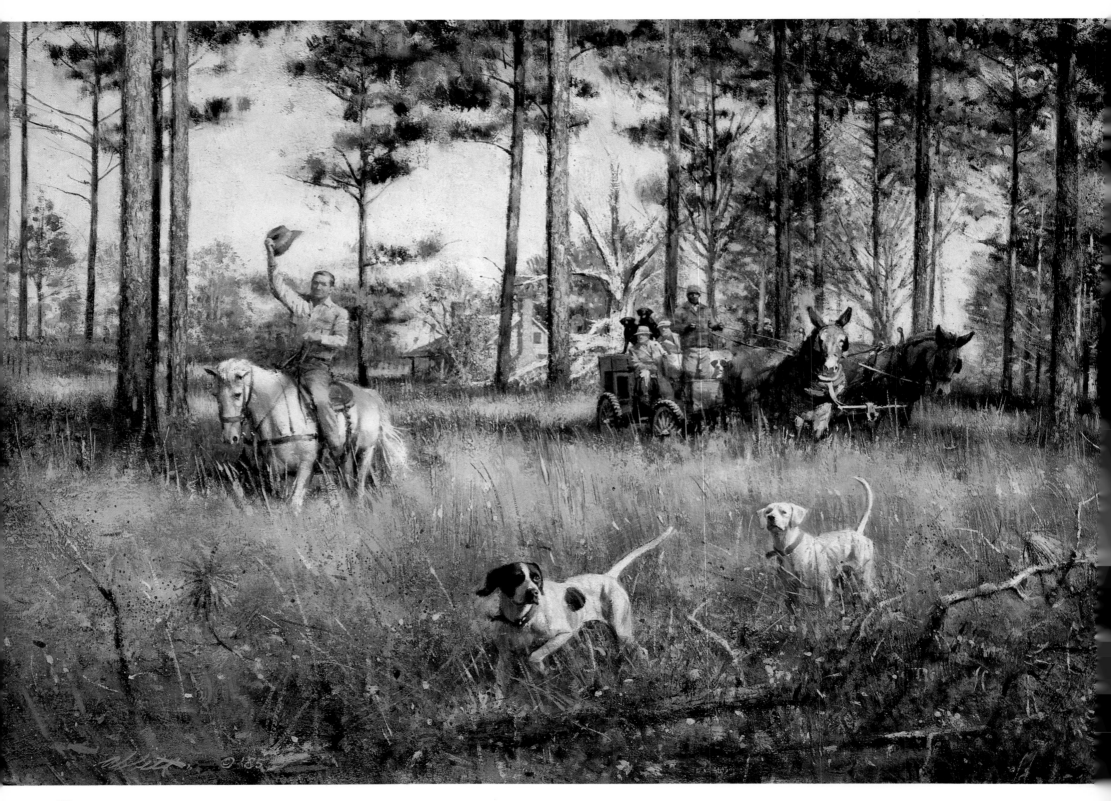

At some plantations in the South, bird shooting is still carried out in the traditional manner—a pace that is pleasantly slower than customary in our modern times and with emphasis on the hunter's comfort. Such are the delights in hunting from a Thomasville quail wagon.

Thoughts of time spent with tested companions, eager dogs, experienced handlers, and at noon, hammocks and a hot lunch served on checkered table cloths can turn this Yankee's mind to mush.

On a plantation hunt, the outrider stays with the dogs, which often range far ahead of the shooters. A raised hat traditionally signals a point. The hunters have time to catch up with the dogs, dismount, and then with the guide indicating the best approach, move in for the flush. Often a Lab is loosed to help retrieve.

I've had good days and I've had poor ones as far as quail shooting goes, but I'll never have anything other than good memories of hunting down South in a quail wagon.

———

The Quail Wagon,
Oil, 20 X 30, 1985

———

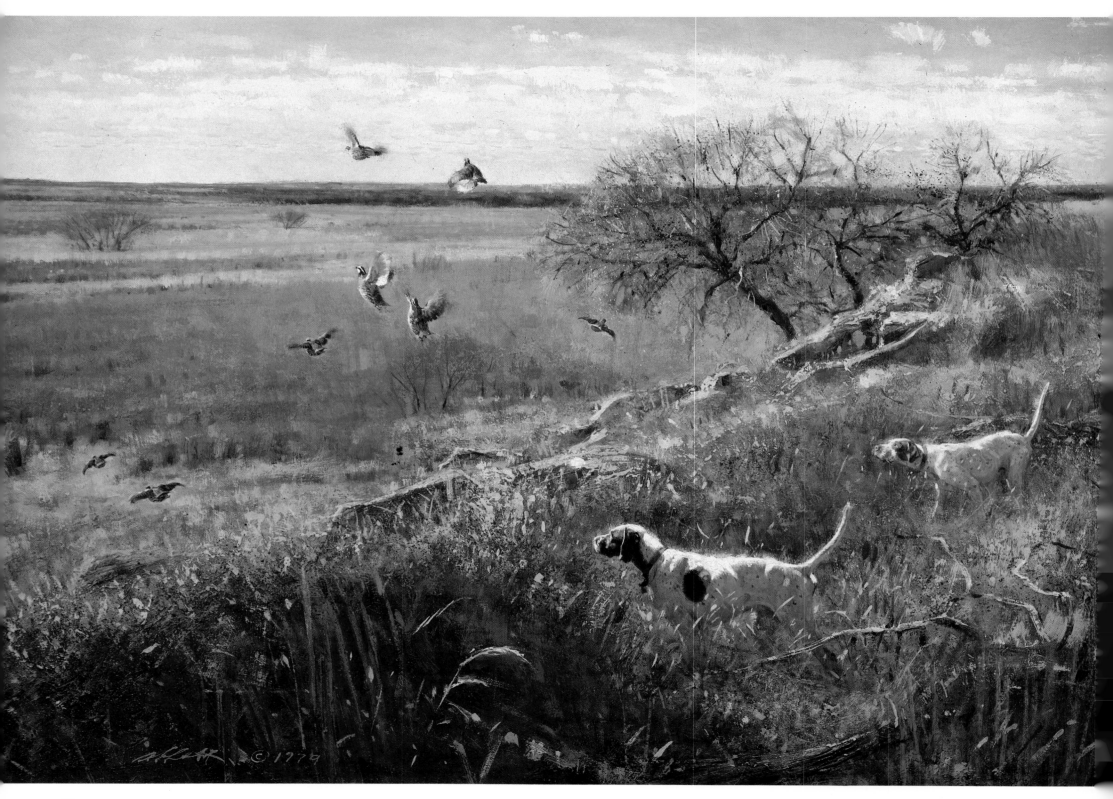

I occasionally like to see a painting with a lot of open space, especially when depicting scenes in a wide-open area like Texas. As illustrators, we were urged to tighten up the scene, to show it close and heighten the impact. But outdoor art often demands a wide-screen approach.

A simple color scheme, mostly earth colors, and two pointers locked and steady to wing on this rock outcropping, helped me to convey my feelings about this day of Western quail hunting.

———

Hilltop Covey Rise,
Oil, 24 X 40, 1979

———

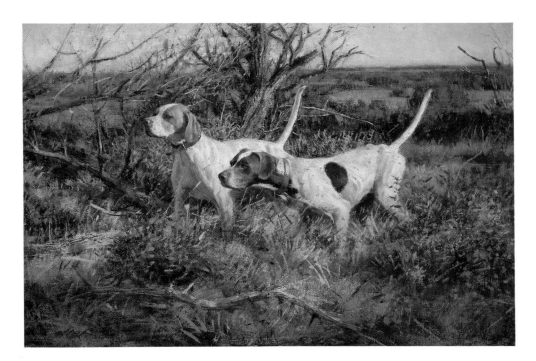

Max Poteet, committee member with Game Coin (Game Conservation International) in San Antonio, Texas, asked me to do a painting for their 1985 biannual auction. It was a great excuse to experiment with a color scheme that would show Texas bird cover as I'd experienced it. This late-day light is loaded with color from the reddish end of the spectrum. To set up a kind of visual vibration, I used quite a lot of green earth color in the underpainting. While the green may not be overly apparent, it does lend a richness to the painting.

———

Untitled,
Oil, 20 X 30, 1985

———

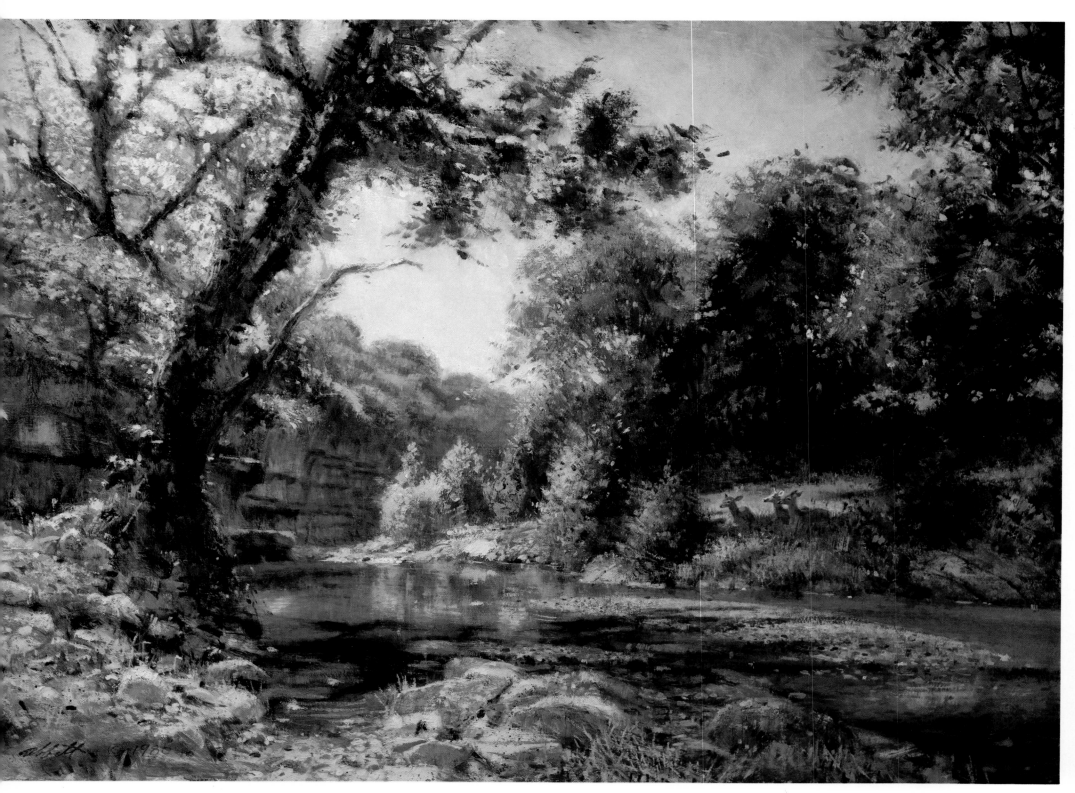

Turtle Creek, Oil, 24 X 43, 1981

WINDOWS OF STILLNESS

A bird dog on point is a bridge between two worlds. There is a magnificent clarity in the moment, a gathering of free-form energy into perfect focus, precise as an arrow against a bowstring. It is the moment of stillness between a man and a game bird, between speculation and magic, between separation and the momentary closing of an ancient circle.

It is this moment — and this bridge — that Bob Abbett celebrates better than any artist now alive. In 1972 Bob Abbett was nearly two years into the third, fine-art phase of his career, and he had not yet found his clearest voice.

"I always loved painting landscapes. But the ones I had in galleries were going nowhere, mostly because they were just landscapes. There was nothing going on in them, no activity, no specialty, so to speak."

Lunch was over, and we were sitting at the tall, round table in the corner of the kitchen, watching a hawk hunt the pasture below.

"The fact is, you have to have an excuse, if you want

to think of it that way, to sell a landscape, even a good landscape. I was just beginning to do some sporting work, which naturally involves landscapes, but I just hadn't found the right element, the one thing I could use to make the connection between a natural setting and the human significance of it.

"Then Martha Sweeny asked me if I'd paint a portrait of her dog."

Tom and Martha Sweeny lived nearby. The dog in question was Luke, a big English setter that was Tom's hunting buddy.

"Martha wanted a painting of Luke as a Christmas gift for Tom. Actually, she wanted Bob Kuhn to do it, but Bob was swamped with work at the time. I wasn't. So Martha brought Luke over one afternoon. She had a bobwhite, and we put it down in the pasture and got Luke to point it while I took a lot of photographs.

"I came to know Tom and Martha quite well and hunted with Tom occasionally. They were extremely supportive. I was also extremely lucky. The painting of Luke got me into Grand Central Galleries. Then Fred King at Sportsman's Edge wanted to publish it as a print. It sold out, and we were off and running."

Off and running indeed. In dogs, Bob Abbett found the missing element, the focus. A landscape alone may stir no particular interest, but a landscape that centers on a pointing dog is something else again.

"At the time, I don't believe anybody in the country was painting dogs except Bob Christy and Owen Gromme. It all finally came together.

"We'd always had mutts when I was a kid. I'd never been around a hunting dog until I was thirty-odd years old. I have nothing against family-type dogs, but hunting dogs are exciting. Everything they did just electrified me — say, a German shorthair just standing still, one leg back, head up, so poised. Their musculature fascinates me; hell, everything they do fascinates me.

"I didn't set out to be a dog artist. But I'd drawn and painted my way through a lot of hemlines and lipstick shades...I got to dogs, and I thought 'Jesus, this is great!' I didn't have to worry about fashions any more, at least not any more than how a Brittany spaniel might change every ten years.

"Anyway, the dogs unified everything. If I needed an excuse to paint landscapes, there was the dog. What was my excuse for having a dog in a painting? The next step was to put in a game bird. It all has a reason to be there together."

There's yet another reason, implicit in nearly every Abbett painting. A gun dog is a natural animal performing a natural action in a natural setting, yet it implies a

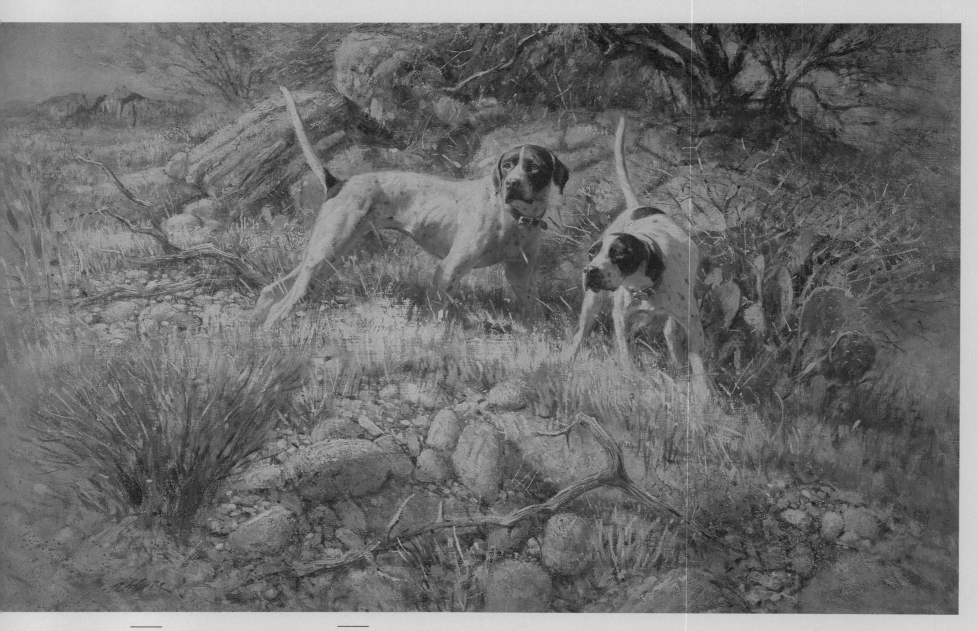

In this painting, entitled *Holding Tight*, Abbett reveals unparalleled skill for capturing the quivering intensity of a pointing dog.

powerful human connection, even if the artist chooses to focus in so tightly that there are no humans in the scene. There may even be a second level of human element, some implication of human presence like a woodpile in the foreground or a barn in the distance or a fishing rod being carried off by three raffish pointer pups in a delightful painting that Bob calls *Fishing at Hawkeye*. The human presence is never obtrusive, but it doesn't have to be. The central focus is almost always a dog, and no matter whether it's a classic setter in the New England woods, a brace of ribby pointers holding a covey of quail in the Texas scrub country, or a Labrador watching the sky for ducks, the dog always infuses an Abbett scene with a spirit that reverberates like fading thunder.

After a couple of days spent working, Bob suggested that an afternoon of shooting would be a happy break for all of us. He phoned a neighbor who keeps pen-reared pheasants and made a second call to Bob Kuhn, an old friend and a splendid wildlife artist who lives in Roxbury, nearby. By lunchtime, we had a half-dozen pheasants crated in the back of Bob's van, and Bob Kuhn joined us shortly after.

The older I get, the less surprised I am by coincidence and by the eerie little ways in which life repeats

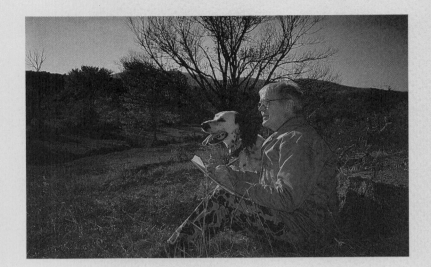

itself, events and circumstances coming around like recurring figures in a long and complicated piece of music. Less surprised, indeed, but not less bemused. As the three of us finished our coffee and the talk shifted to birds and shooting, I remembered the first time that Bob Abbett's work and mine had come together. In the fall of 1977, exactly ten years before, *Yankee* magazine had published a short piece I wrote about an old man I once met, his dog — an almost equally old English setter named Walter — and an afternoon we spent hunting pheasants. The editors lavishly illustrated the story with Bob Abbett art, dog paintings naturally. I admired Bob's work immensely, because it seemed to me that he fulfilled in art

Accompanied by Duke, the artist spends many hours walking and observing the Connecticut countryside around his Oakdale farm.

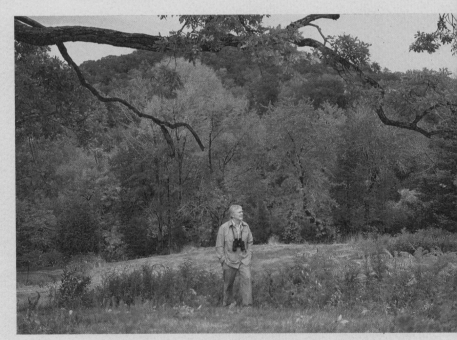

exactly what Hemingway once described as the key element in good writing. The best writing, he said, is true writing. It's writing that distills the essence of experience and renders that essence in ways that ring unmistakably and unarguably true when brought face to face with the reader's own experience.

Anyone who has even the most casual experience with gun dogs can find that kind of truth in a Bob Abbett painting. Half an hour later, I found myself inside a piece of Abbett art, in touch once again with that elemental truth.

Always eager to add new notes to his files of reference photos, Bob loaded his camera and loaned me his shotgun. Once in the pasture below the house, we released the pheasants into a long strip of brush, Bob let Duke out of the van, Bob Kuhn and I loaded our guns, and an Abbett painting began taking shape.

Duke ran a couple of warm-up circles in the short grass, stretching into the long, graceful lope characteristic of his kind. Duke was ten that fall, the son of Luke, the dog that got it all started. Duke has been Bob's principal assistant since he was a puppy, probably the most-painted dog in the country, and he knows this game inside out. But it's not the nature of gun dogs to show any less enthusiasm for even old, familiar games, and presently Duke put his nose into the wind and headed for the brush.

I cannot count the number of times I've played out the fine old ritual that begins with a dog on point and a bird unseen, but the magic never fades. Duke caught the scent and stopped, suddenly as focused as sunlight through a burning glass. In that instant, the circle closes. Man and dog and bird interconnect in an elemental circuit fed by energy as basic as photosynthesis, as subtly powerful as the continual turn of the seasons. In this connection with some ancient part of our own animal heritage lies the appeal of hunting.

Or so it is for me, and so it is for a lot of hunters I know. That moment of connectedness is the key. Had James Joyce been a bird hunter, he would have recognized his concept of epiphany — the sudden, intuitive grasp of an elemental reality — in a dog on point.

Duke, transfixed in a cloud of pheasant smell, probably wasn't thinking about Joyce and neither was I at the time. Such thoughts come later. These are not reflective moments but rather perceptive ones, moments of noticing without conscious effort the perfect stillness, the color of the sky, the dainty fluff of ripening weed-heads, the brittle outlines of grass, twigs, and brambles limned in the afternoon light.

A conceptual sketch for a future painting. Opposite page: Abbett and Duke— family dog, hunter, and model for many of the artist's paintings.

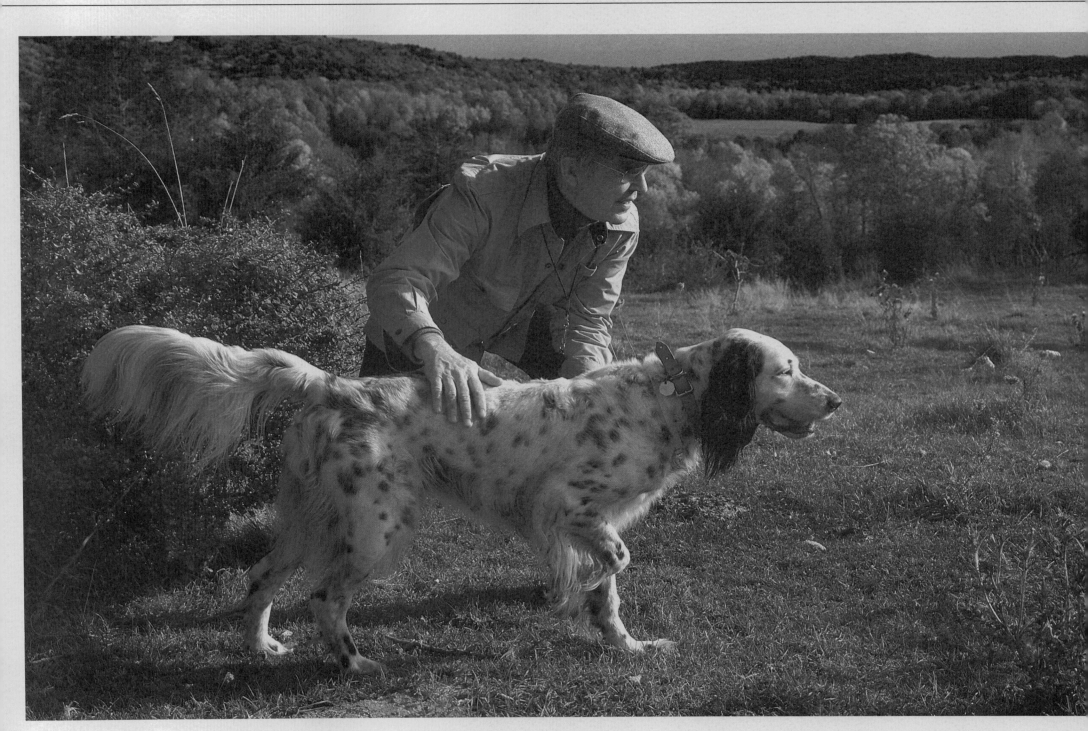

Bob Kuhn took the first pheasant, a gaudy cockbird that roared out of the brush in a tumult of wings and cackles. Duke fetched it in, his eyes bright with pleasure and his plume of a tail waving slowly from side to side.

We rehearsed the old ritual over and again in the next couple of hours, letting the energy of it gather and diffuse and gather again. Later, Duke slept on the kitchen rug while Bob built a salad and I tended the pheasant breasts, filleted, dusted with thyme, and broiled in butter. Over dinner and afterwards, as hunters will, we talked about the day's shooting and about what we both in our different ways attempt to communicate from the experience.

"For a painting, there are two basic points of access," Bob said. "There's the height of the action, with the birds in the air and the hunters focused on that, raising their guns — a lot of inherent vitality there.

"The other is the anticipative lull just before the action. I've done both, quite often, but personally I prefer the quieter of the two pictures — the dog on point and that quiet moment when the man and the dog are communicating, before the birds get up.

"A lot of people enjoy seeing the whole phenomenon, so a flushing picture probably is more popular, all told. But I really love working with the quieter one and implying the action: You know, the way the dog is focused just before the birds flush. That's very exciting. It just happens to be very still."

Compare an Abbett painting with the classical sort of still-life scene, and the differences become instantly clear. The one is a study of repose, concerned with form and light and shadow.

An Abbett painting demonstrates the same concerns, but at the same time an Abbett painting fairly crackles with spirit, with a sense of motion about to break.

That poignant stillness is most obvious in the bird-hunting scenes and in those splendid paintings that show only a pointing dog and a bird, but Abbett renders the same notion in other forms as well. It's the moment when ducks turn toward a spread of decoys, anticipating a connection soon to come with a hunter and a Labrador retriever. It's the moment when a fly-fisherman in some Western stream feels the first twitch of a trout, when a horseman feels his mount gathering its muscles for a jump or turn.

In fact, there seems to be an element of stillness in almost every Abbett painting, even those in which the central interest is precisely the opposite. In the hunting scenes that show birds in the air, notice the dog still frozen in a pointing posture.

That, of course, is an element of realism, too, because the most thoroughly trained bird dogs remain steady to the flush, but it also serves to bring the moment that precedes the action into the action itself and to deepen the sense that what you see is happening in time as well as space. Put your hand over the dog in one of those scenes, and the whole thing will take on a different character.

That stillness might also be rendered as a pool of water, a mountain, a fallen tree, a weathered stump, or an old white house where children chase each other across the lawn. But it's there, and it's a vital thread in the fabric of the world that Bob Abbett paints.

Those who do not hunt sometimes find it difficult to understand the depth or the intensity of what a hunter feels in those still moments. There is no logic about it; it is, in fact, antithetical to logic, because it speaks first to the muscles of the heart and only later to the synapses of the brain. The ability to equilibrate mind and emotion in an objective, concrete form is a peculiarly human gift, and it is the gift from which art derives. And what then is the function of art if not to give us windows through which we may recognize ourselves?

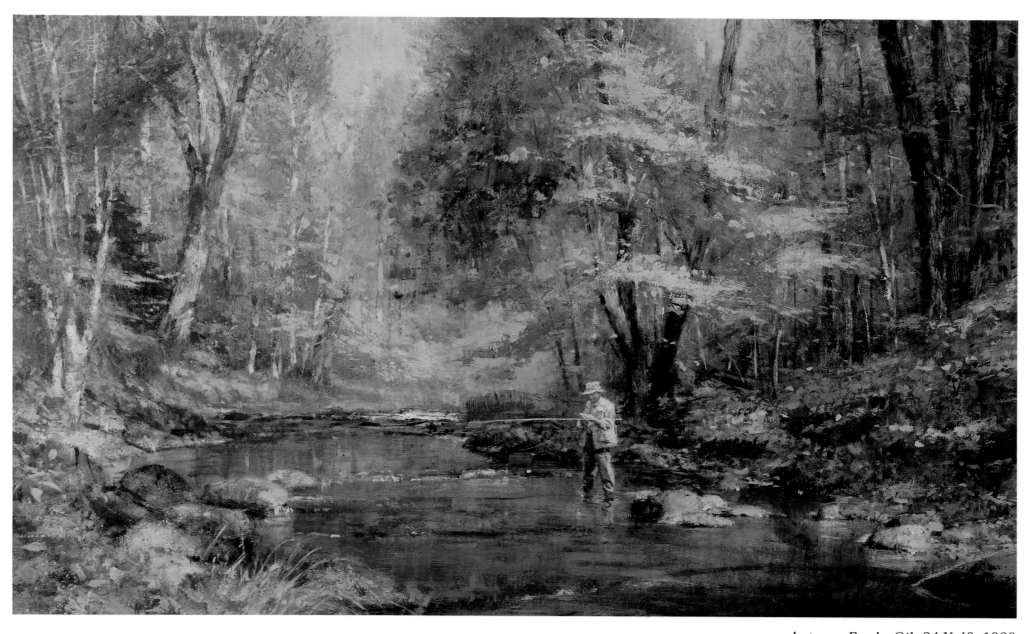

Autumn Pools, Oil, 24 X 40, 1980

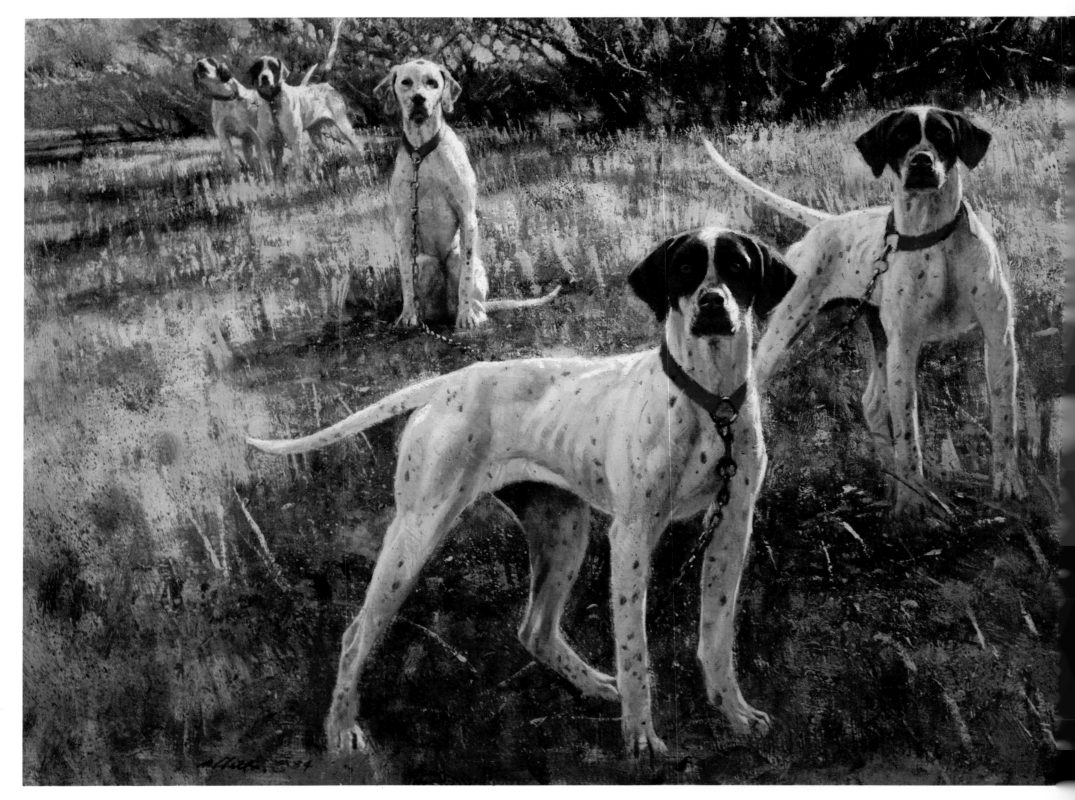

When I attended the National Bird Hunters Association Field Trial in Arkansas, my job was to paint the winning pointer on a staunch point for the organization's stamp/print program. Having done that, I later indulged myself by doing several paintings of other moments and situations.

Particularly intriguing was the spectator-like quality of the participants during off-moments. Tied along a ridge, these dogs could watch the judged events as they took place, and also see and bark at everybody that passed by, dogs and owners alike.

The Competitors,
Oil, 20 X 30, 1984

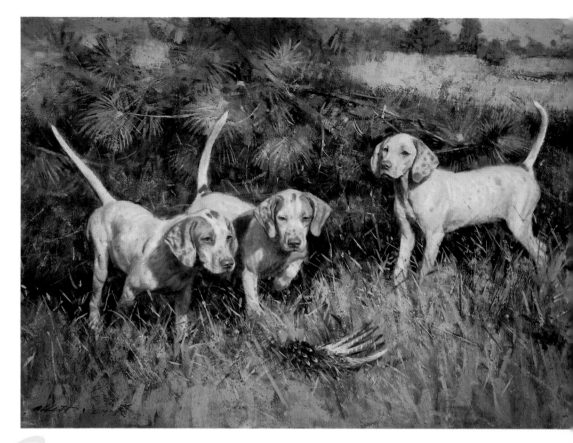

Shown during a training session with Kate Boulos when she was on the staff at Hawkeye Hunting Club, these pointer pups will emerge with a level of skill that is hard to beat. For the rest of their lives, they'll do little except hunt birds, mostly in company with one another. Such is the way of things at a private shooting club like Hawkeye. Most of us will never find enough birds to equal the opportunities that will hone the dogs' proficiency to a sharp edge.

Training at Hawkeye,
Oil, 24 X 36, 1980

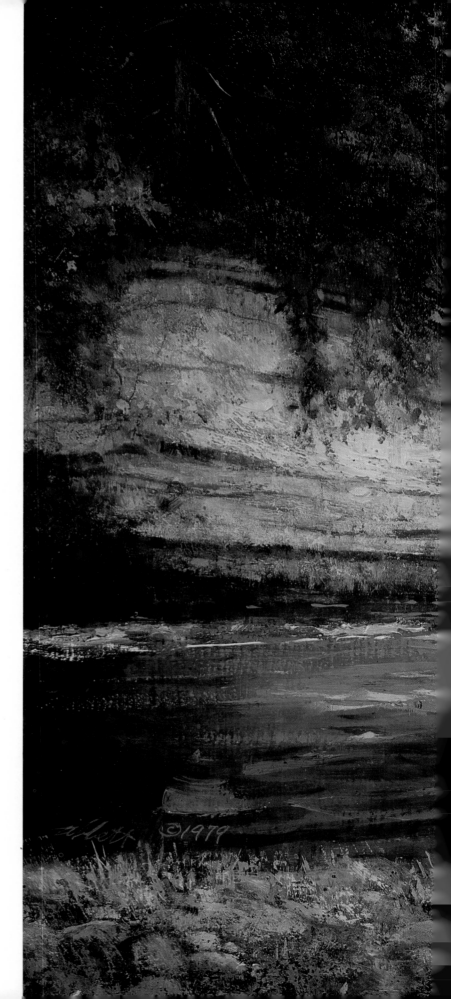

Sir William Gordon Cumming showed me his stretch of the Findhorn River which runs through Altyre, his estate near Forres. The water was clear, but dark and mysterious, or perhaps I was a bit caught up in the locale. But you could feel its power like a locomotive, even while standing on shore some distance away.

This painting is another example of my second choice in weather. I would have preferred sunshine, but as many of you know, overcast is not atypical in that part of the world. The gray day was brightened, however, by the warmth of the people and scenery.

———

Salmon Fishing in Scotland,
Oil, 20 X 30, 1979

———

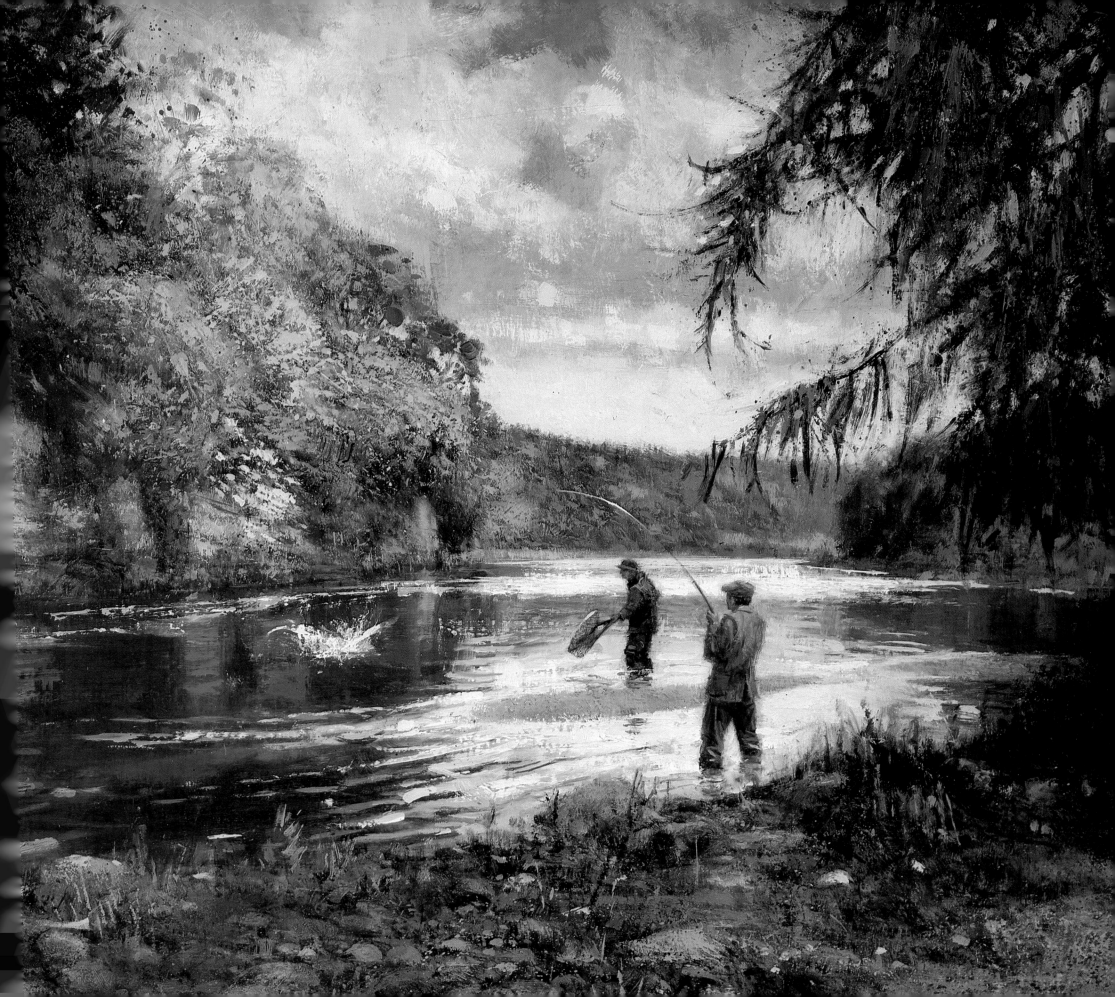

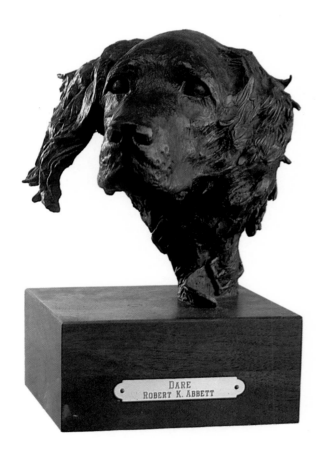

DARE
ROBERT K. ABBETT

By vignetting the dog's neck, our attention is directed to the greater mass and action of the head. This bronze was cast in an edition of two at the Arizona Bronze Foundry in Tempe; one casting was presented to the Dog Museum of America by Dare's owner, Mrs. Gwynne McDevitt. At her behest, a third casting was made and starting in 1987, was awarded as an all-stakes trophy at Gordon setter field-trials.

Dare, Bronze
6 X 6 1/2 X 6 1/2, 1984

Since *Broken Covey* was to be reproduced as a smallish print and also on a stamp, I cut off a big bite by including three birds and two dogs. But I believe an artist can move time and space around to show a piece of action like this. In an actual hunting situation we would probably not see all the principals in such close proximity. But here, I enhanced both the drama and design by compressing the distances and time intervals. Further, simplifying the background promoted readability.

Broken Covey,
Oil, 15 X 21, 1984

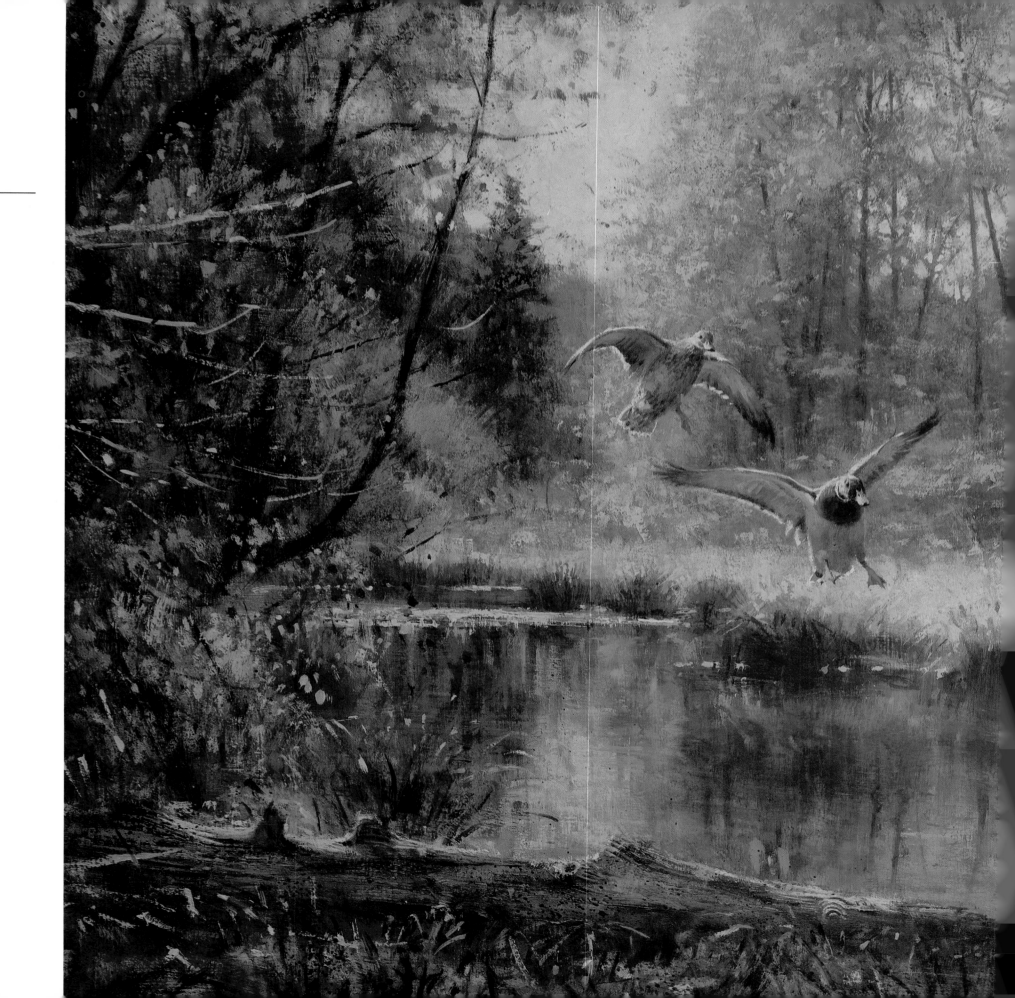

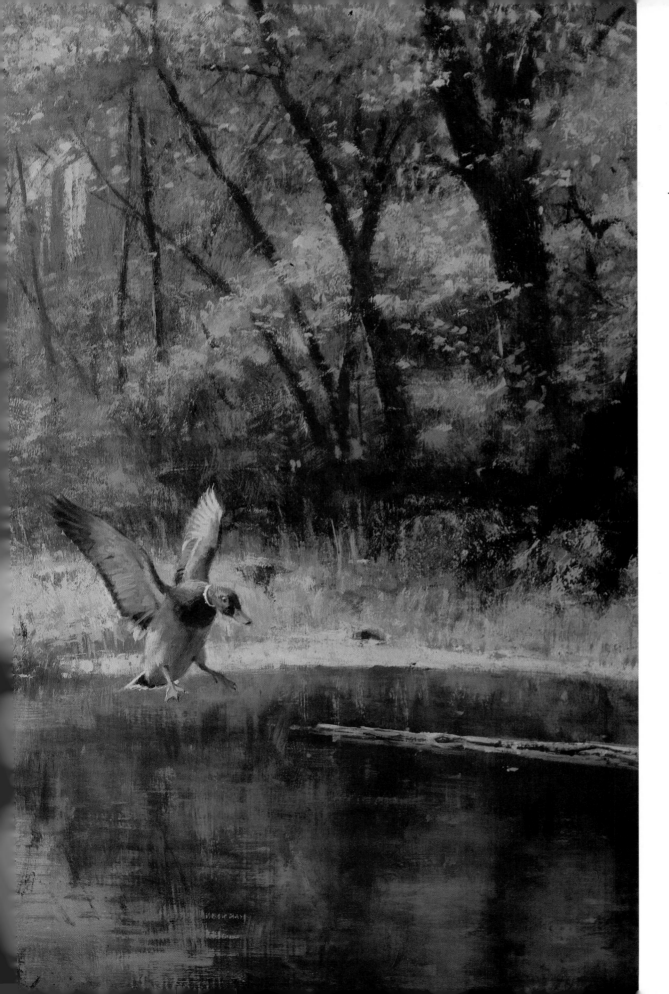

One of the truly beautiful places in the United States is the stretch of Oak Creek running through and near Sedona, Arizona. Erosion has created many cataracts and quiet pools which invite waterfowl in season, and folks of all ages year-round. The stream's red rocks and nearby cliffs, which I included in another painting of a trout fisherman, were once highly favored as backgrounds for Western movies, some of which you can still spot in late-night television re-runs.

As an aviation buff, I see a similarity between birds and their aeronautical counterparts. Ducks remind me of high-performance jet aircraft; they land in a nose-high attitude, use lots of flaps, and even drop their cockpit like the SST. Moreover, ducks use their feet as air brakes and their infinitely movable wings to adjust their glide slope.

Oak Creek—Mallards,
Oil, 22 X 36, 1982

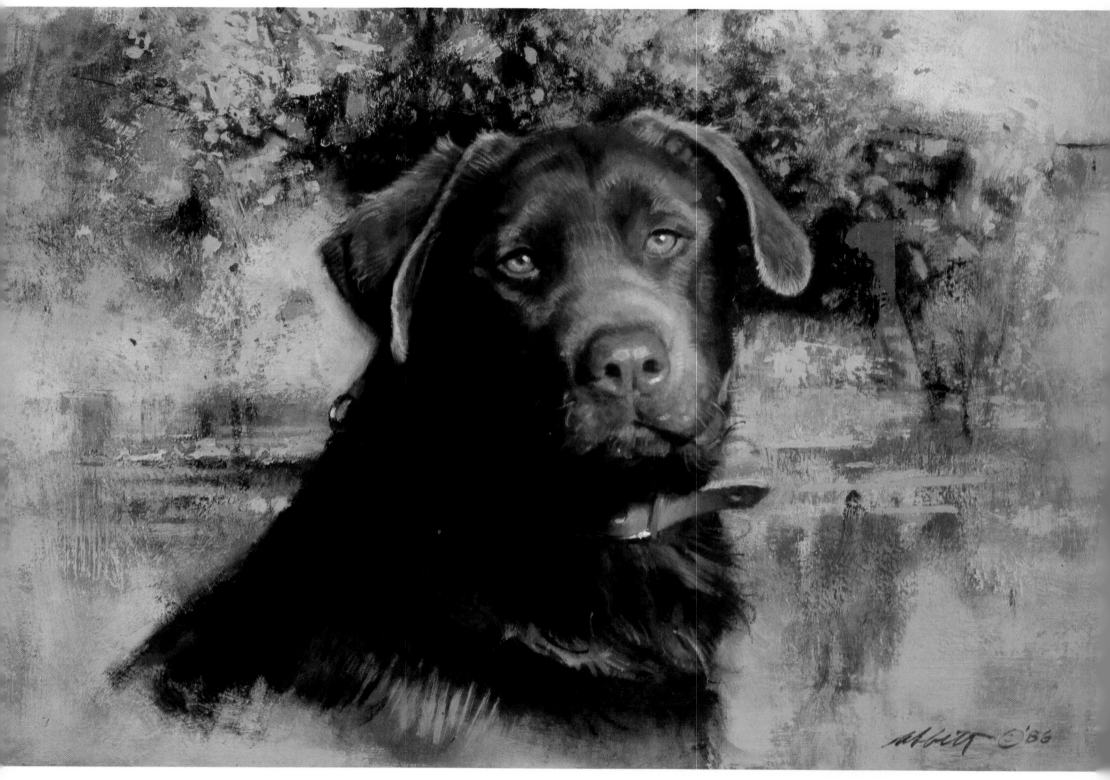

A fine example of a breed that is gaining in popularity, this chocolate Lab belongs to a friend and art collector in Tucson. Since Wild Wings and I planned to publish Brandy's portrait as part of our ongoing head-study series, I decided to keep the background less than specific. I indicated some water and typical Arizona color, but it could be Minnesota or California. That's what I like about painting loose; viewers can personalize the scene and fill in the blanks from their own experiences.

Brandy, Oil, 16 X 20, 1986

*H*oward Halff had been after me for years to visit his Pearsall Ranch in Texas, and when the Society of Animal Artists held an exhibit in San Antonio, we took advantage of the opportunity. Howard had bought a wild turkey painting of mine and wanted me to see his birds' habitat. Several blue-headed Rio Grande turkeys appeared, almost on cue, emerging from the tangles and running off in front of us.

As in many wildlife situations, I've usually found actual habitats to be rougher and much more dense than those so often depicted.

———

Wild Turkeys,
Oil, 24 X 34, 1981

———

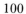

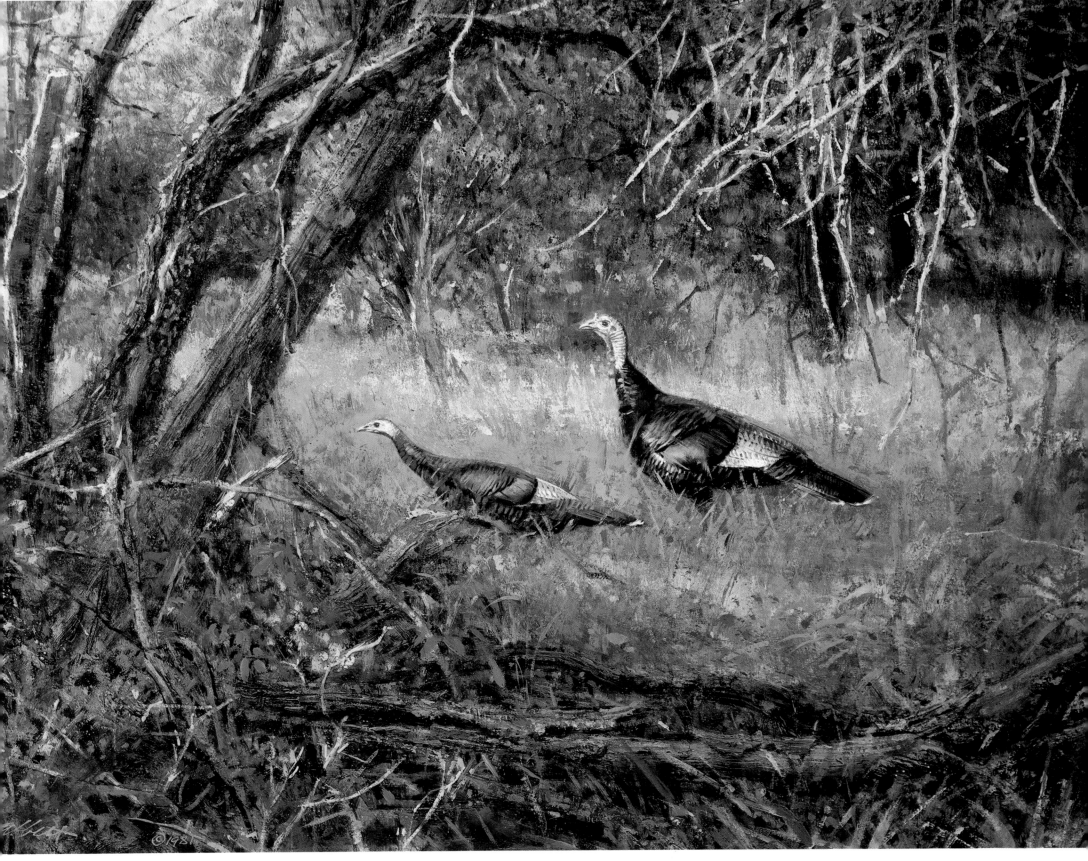

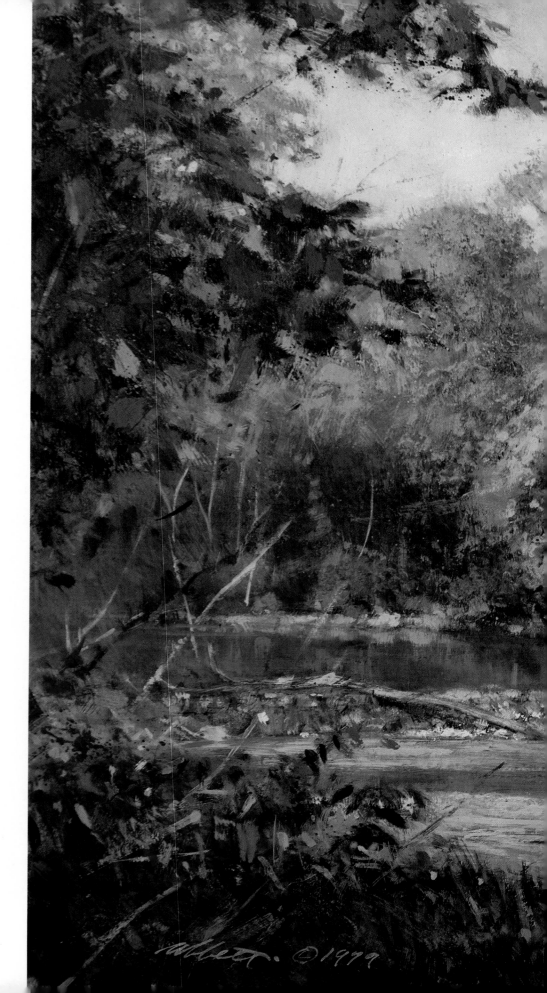

Many rivers and streams have colorful names, some taken from Indian lore and legend, some named after early explorers, and still others reflecting interesting twists in American history. For example, the Temperance River along the North Shore of Lake Superior got its name because it is devoid of sand "bars."

This pleasant stream near Boiling Springs, Pennsylvania, was not named for the color of the flyfisherman's waders, as I first surmised. Local lore has it that the water stained the white pants of British troops when they forded it. A good story, which I cannot prove or disprove.

———

Yellow Breeches,
Oil, 20 X 30, 1982

———

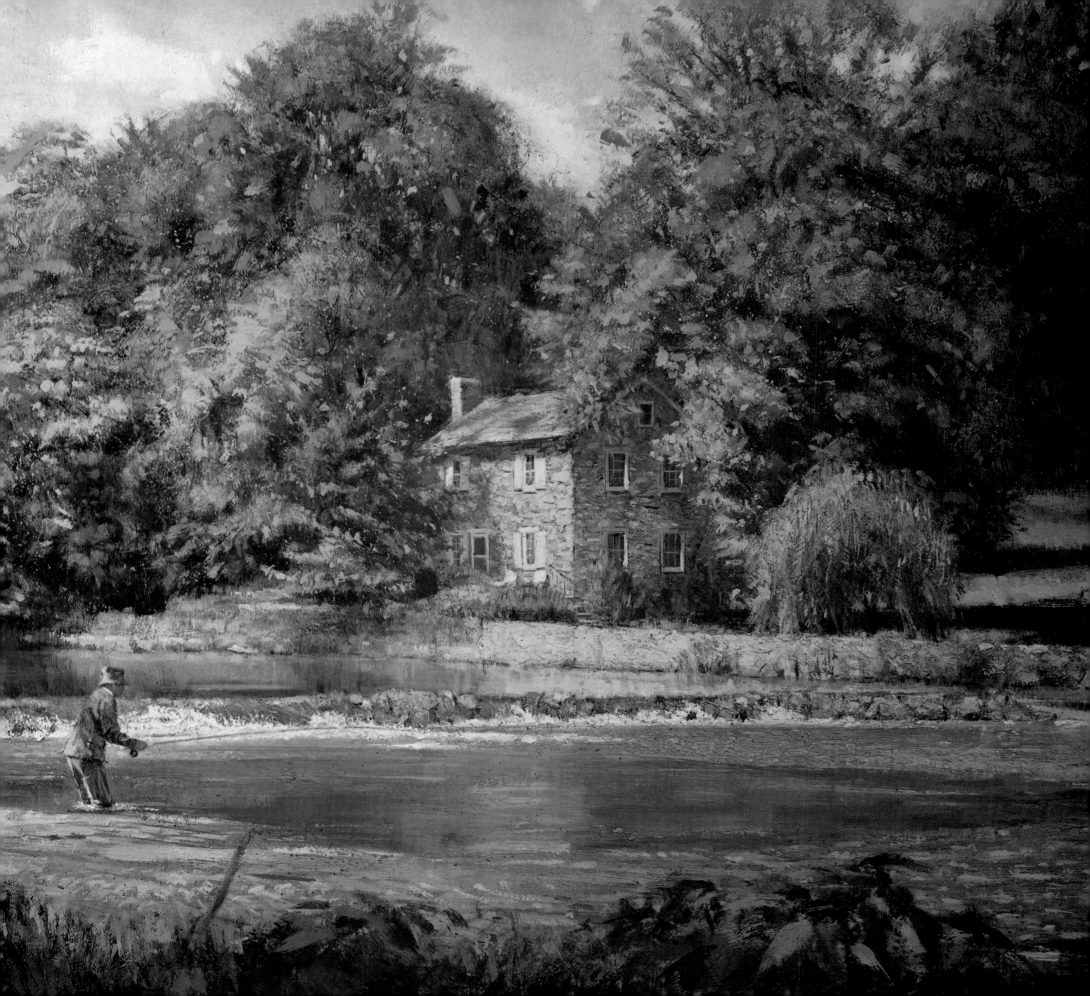

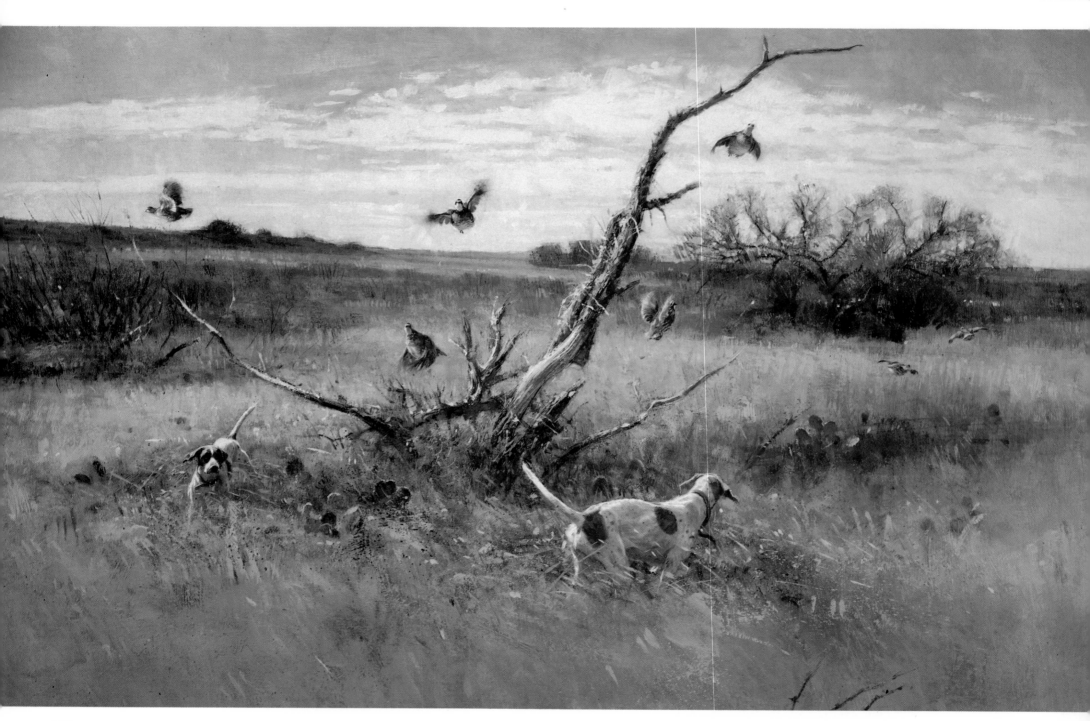

One of the many pleasures in my work and lifestyle is the time spent in travel and research. I would be hard put to convince many readers that doing such on-site observation is hard work. Case in point: On several occasions I've hunted quail with Dallas gallery owner Bubba Wood on a Texas-size ranch where the bobwhite population was in Texas proportion. His hard-working pointers, mostly from Bob Wehle's Elhew Kennels, are always good picture material.

Here, my biggest concern was to create a feeling of vastness. I decided to place the action some distance from the viewer and not crop in too closely. By eliminating and simplifying, I could keep our attention where it belongs and at the same time, explain the specific look of that scene at that place and time.

Clay County Covey Rise,
Oil, 24 X 36, 1980

If you were in the second field on our farm, facing north, you'd see a scene pretty much like this, although I've drastically redone the buildings across the road. And today, our Lab is as big as Duke and twice as energetic.

I'd read about how Connecticut artist Eric Sloan would grab a saw and "crop" a painting in progress. I used the same surgical treatment to help this one: originally there were three more troublesome inches on the right side. Try as I did, I couldn't get that section to contribute to or fit into the composition. Feeling somewhat cowardly, as if there should have been a more creative solution, I simply sawed off the end and Walter Skor framed it accordingly.

Bo and Duke,
Oil, 21 X 37, 1981

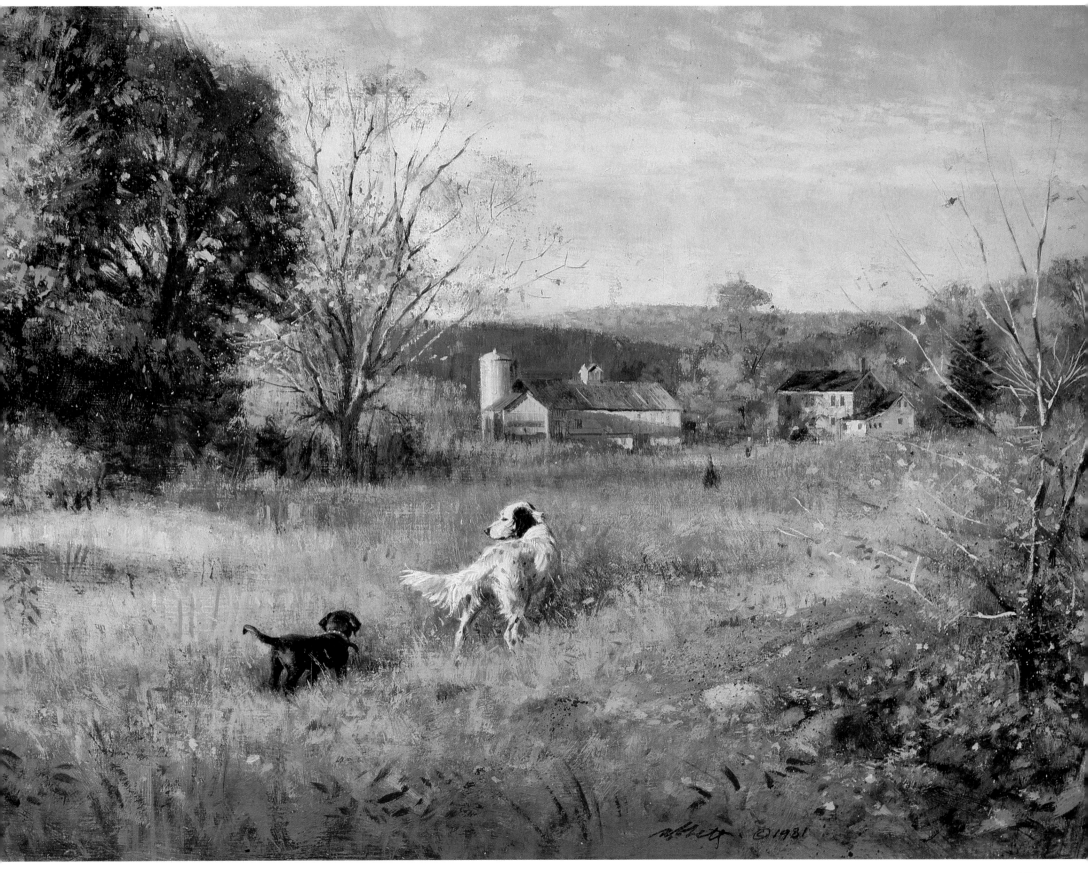

107

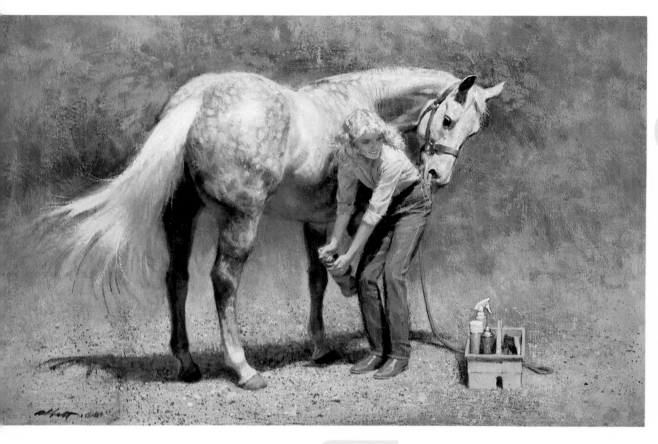

The American Quarter Horse Association commissioned me to paint a series of six paintings for their collection and for promoting the enjoyment of quarter horses. These appeared on covers of their *Journal* and were also published in small editions of prints, this being the second.

This good-looking gray posed for me at Pete Kyle's Arizona stable, where we reenacted this situation.

———

Snack Time,
Oil, 20 X 30, 1984

———

When doing an historical piece, it is imperative to have adequate research because people expect such pictures to be authentic. Further, such paintings join the existing body of research to which others may turn for creating future work. Quite a responsibility.

A professional historian furnished by the American Military Collection helped me work up the concept of showing Generals Lee and Jackson. It was quite eerie to learn that not only is Jackson's riding tack preserved, but his horse, Little Sorrel, was mounted and remains fairly well-preserved. I guess it underlines our mortality when you know that the trappings, relatively cheap scraps of leather and metal, can outlast the bodies and minds of two such outstanding men.

———

Morning Orders,
Oil, 24 X 36, 1984

———

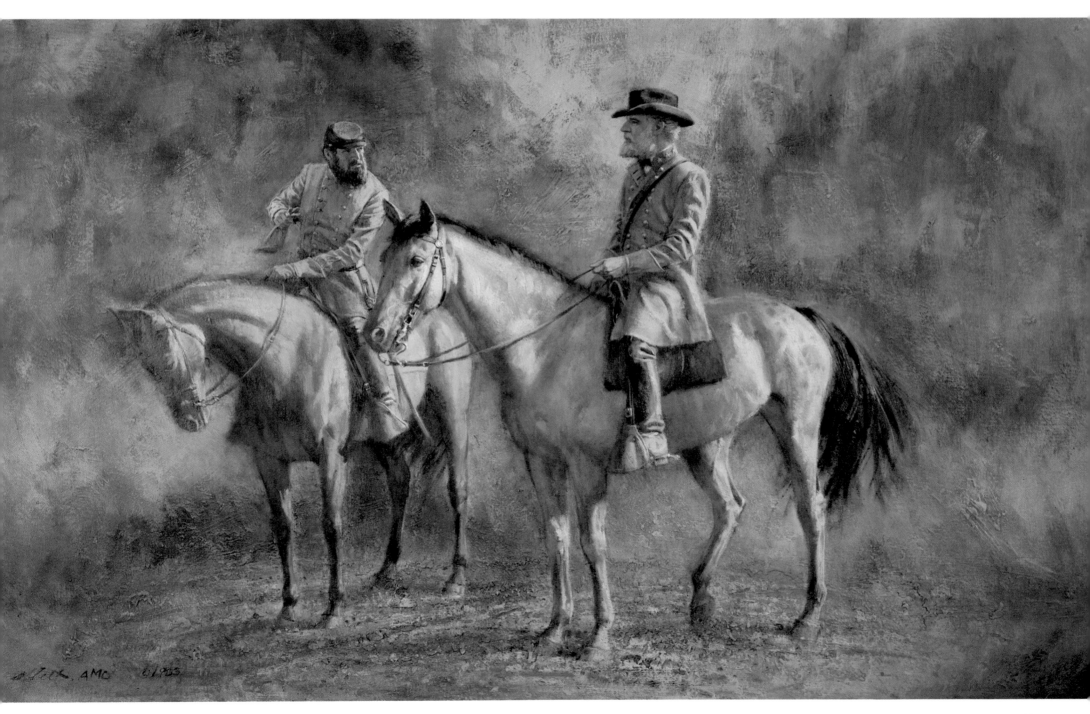

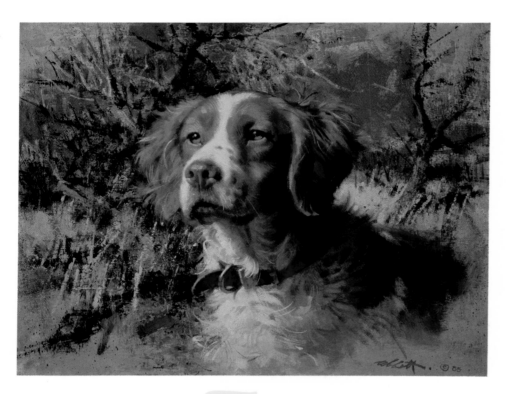

I first hunted over a Brittany spaniel longer ago than I care to discuss. The breed's eagerness to make game and its innate friendliness quickly showed me why so many people favor the Brittany, whether as a gun dog or family pet.

Nick was in training at John Greer's Top Knot Kennels in Phoenix when I saw him work. Nick's responsibility was to find and point birds; mine was to capture that unique spirit that makes a good bird dog.

———

Brittany Head II,
Oil, 16 X 20, 1978

———

*C*ommissioned by Gary Olson for the National Wildlife Art Collectors Society in Minneapolis, *Old Road Cover* became the Society's commemorative print in 1984. I was pleased because I had such a painting in the works, at least in my thoughts, and was able to use Jerry Fatscher's good-looking Brittany, Sherm, in the lead role.

The birds were purposely painted in the shadows, somewhat camouflaged, but I gave the dog center stage and lit him crisply with sidelighting, which reflects upward between his front legs. It is this knowledge of how light works—letting it bounce around and color the surfaces as it would in nature—that helps make the dog's presence more believable.

———

Old Road Cover,
Oil, 20 X 30, 1984

———

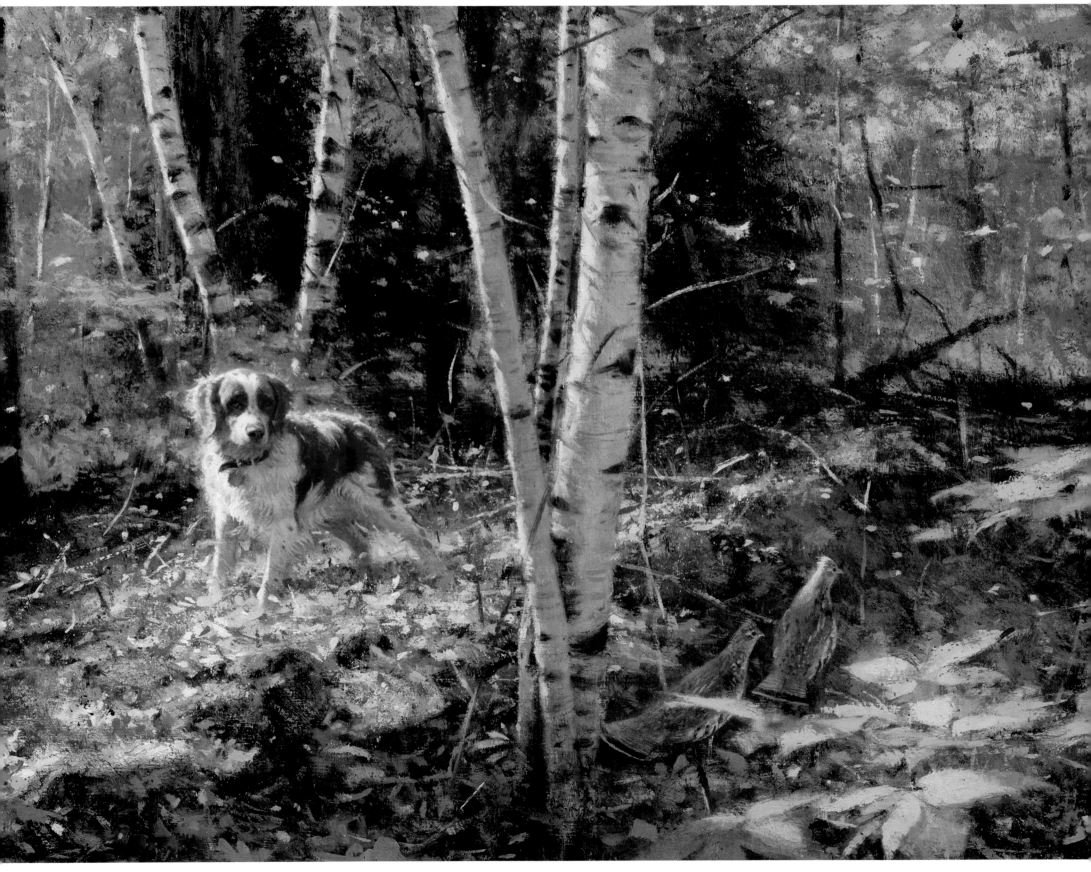

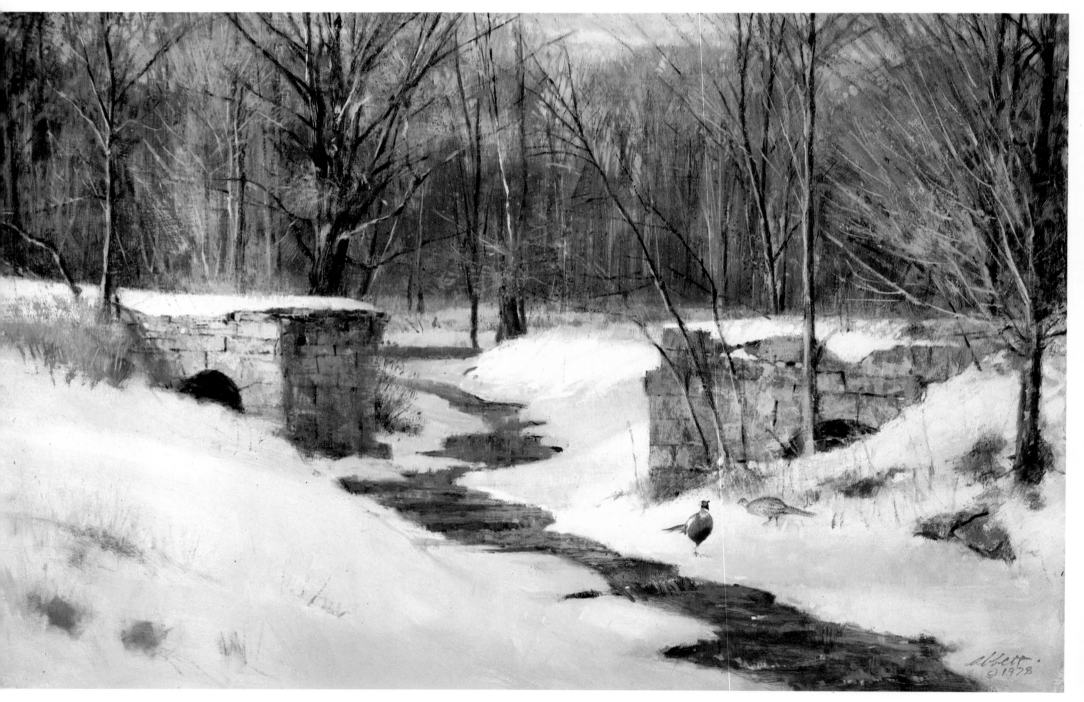

112

laying man-made objects against natural ones can often set my picture-planning wheels in motion. Here, I used a bridge foundation which the old-timers say was part of a railroad line that ran up to Pittsfield, Massachusetts.

My only real problem in painting snow is a recurring one: "What color is it?" Snow reflects colors from the sky almost as well as water does, but I don't care for the garish blue shadows we seem to see outdoors and which color film usually over-accentuates. I prefer to push the tone to a warm gray. It seemed to fit in this painting, though I rarely hit it right the first time.

We remember more about what snow feels like than what is visually apparent; its textures, icy temperature, and wetness are pretty much a matter of past experiences which we could sense from the comfort of our living room. So in painting snow, I fall back to the old art class saying. "Paint what you see, not what you know," and thus try to summon up the viewer's response.

———

Shepaug Pheasants,
Oil, 20 X 30, 1978

———

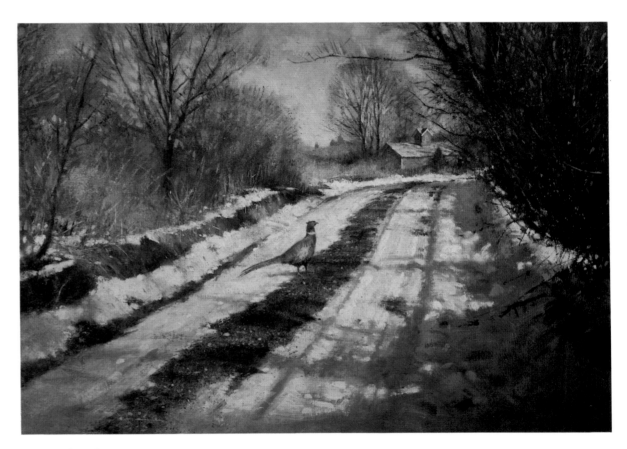

estview Farm in New York is the Pawling estate of Gene Pepe. It was previously owned by radio commentator Lowell Thomas and later by actor Ward Bond. The farm is important to me because much of Duke's early field-training took place there. I enjoyed many pleasant shoots with Gene, some in weather far worse than shown here. The cock pheasant seemed to fit the scene— holding his head high, checking out the cover beyond the road.

Artistic license lets me introduce a barn somewhat older than Gene's replacement for the one lost in a fire. Other than that, the painting is accurate to that period of January, usually the third week, when the weather warms dramatically and gives us hope about the coming spring.

———

January Thaw,
Oil, 18 X 24, 1983

———

everal things struck me as I viewed this scene on the Navajo Reservation in northern Arizona: Its incredible beauty, the chilling wind, and how each animal had sought some protection from the cold, the dog by hunkering down in an old stump hollow and the horse by turning his rump into the wind.

At our Connecticut place, we notice that animals often quietly seek out each other's company. Our horse, for example, will graze close to the dog kennels or even near a fence when deer are in the next field.

Navajo Buddies,
Oil, 18 X 24, 1980

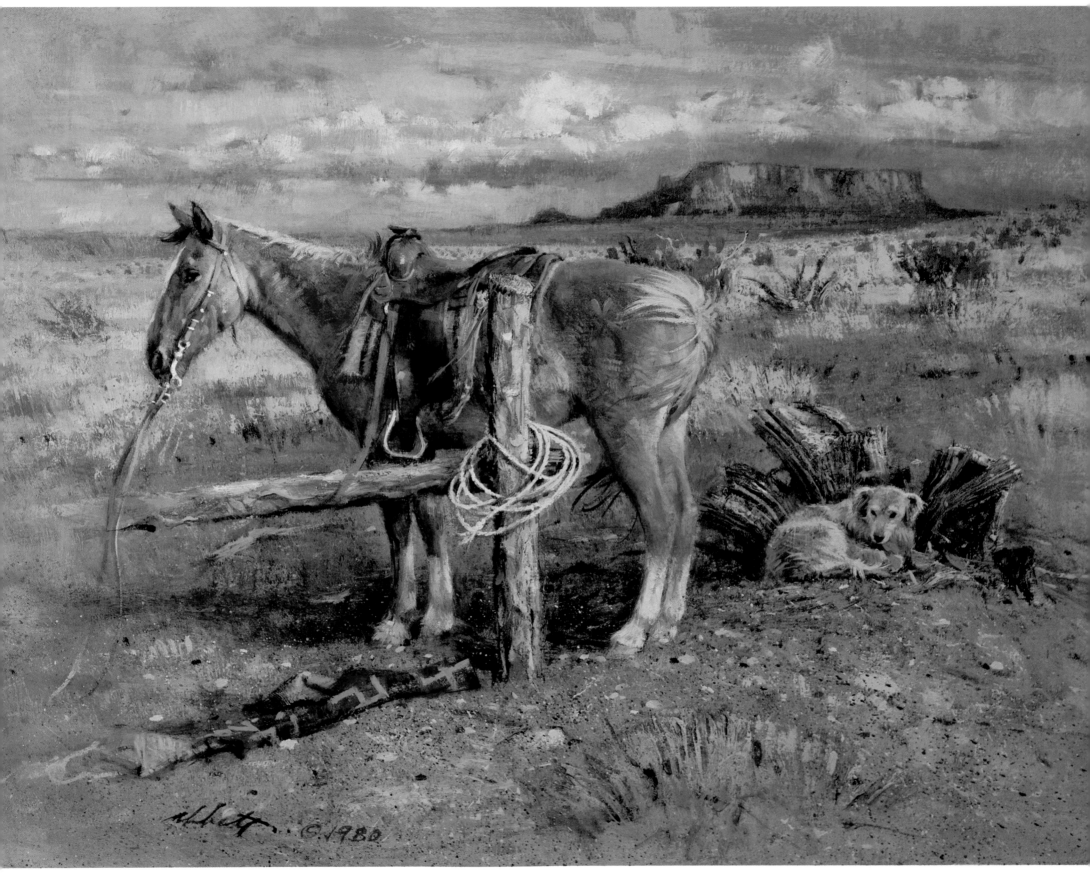

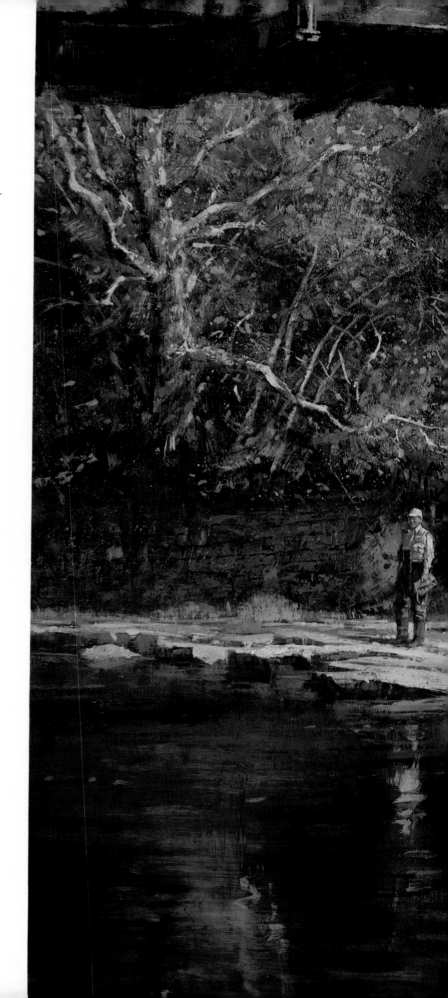

There are certain things in life that are best done alone, and to me, flyfishing is one of them. I watched these young boys whooping and splashing off the old iron bridge across the Beaverkill near Roscoe, New York. I also noticed a rather pinch-faced fisherman obviously displaced from his favorite pool. I can remember living in Wilton, Connecticut, where after work I rushed to a somewhat urban stretch of the Norwalk River, hoping desperately to find it unclaimed for the evening.

A Conflict of Interests,
Oil, 24 X 36, 1978

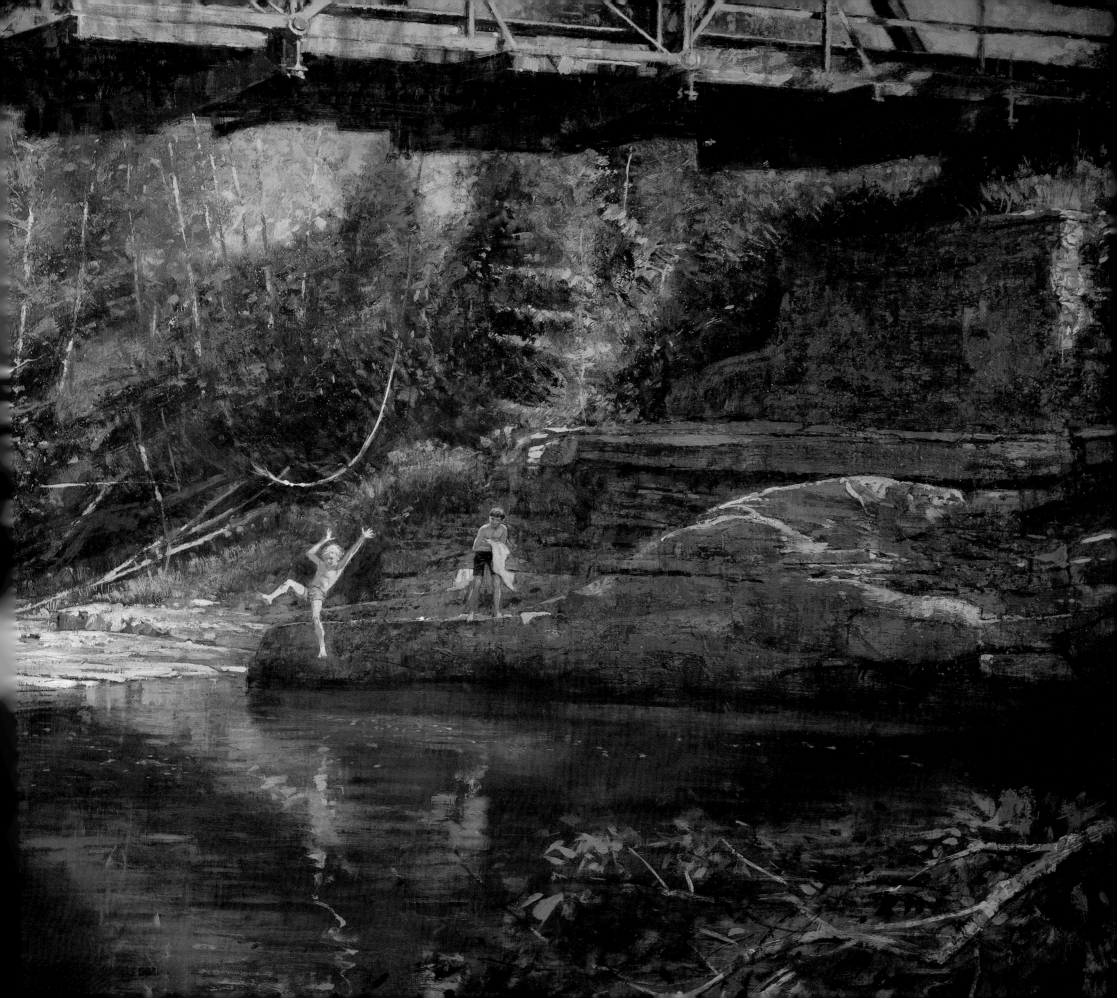

A kind of bony cover I found in Vermont fits the subject of this painting. It shows the hunter's view from behind the dog; to the gunner, the bird can look agonizingly small. With only a few seconds in which to mount the gun, swing and fire, it is a time to depend on hopefully good reflexes and past experience.

Upon seeing a complicated picture such as this, people often ask me if I have difficulty getting started and staying at work on a major painting, some of which may take up to six weeks to complete. My answer was summed up in a tongue-in-cheek piece I wrote in my column, "From Behind the Easel" in *Wildlife Art News* magazine.

It's an inhibition that can rise up like a dragon between the artist and his mockingly white, empty canvas. And somehow, life is ready and willing to house and feed this dragon. It can emerge the first thing in the morning with that vague, restless feeling while you clean your palette for the second time, shorten all your pencils with needless and prolonged sharpening, and rearrange your oil tubes in a neat row going from cadmium yellow pale on the left to ivory-black on the right.

Yes, artists can "shuffle papers" with the best of them.

———

Hillside Woodcock,
Oil, 20 X 30, 1983

———

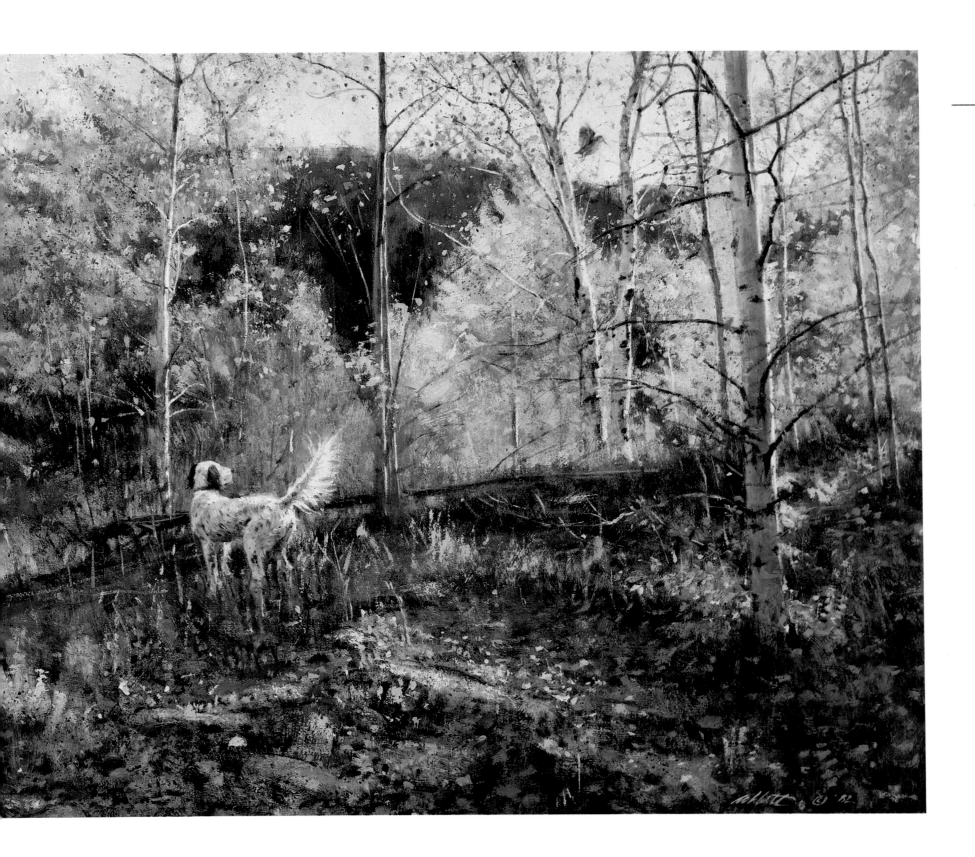

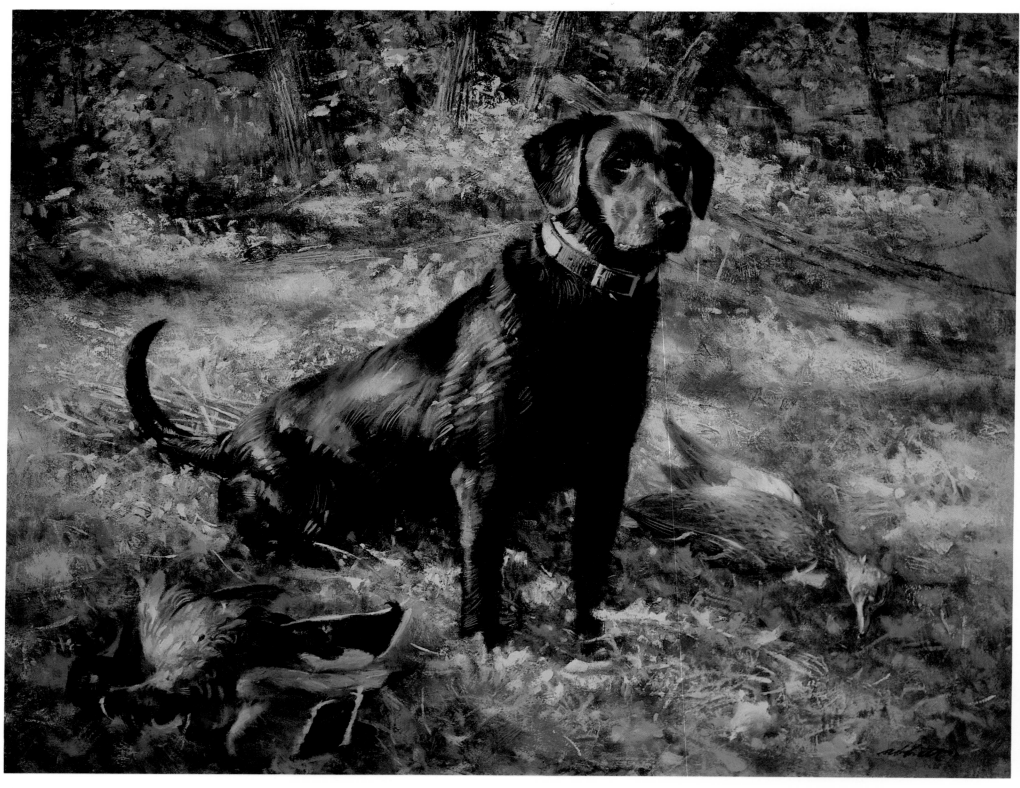

Charley Hunter of West Augusta, Virginia, and I posed his black Lab near one of his hunting locations. As we approached the site, the dog underwent a remarkable transformation. He almost shook with anticipation, and as he sat on the streambank, his eyes searched the bend in the river, telling me "That's where they come from!"

I posed the mallards later outside my Arizona studio, much to the curiosity of several neighbors who were not accustomed to seeing an artist work with dead game.

Brandy, Oil, 20 X 30, 1985

This is the other part of the gang that appeared in *The Gallery* (page 66). While painting a litter, I'm never quite sure which pup is which.

Who's That?,
Oil, 9 X 12, 1984

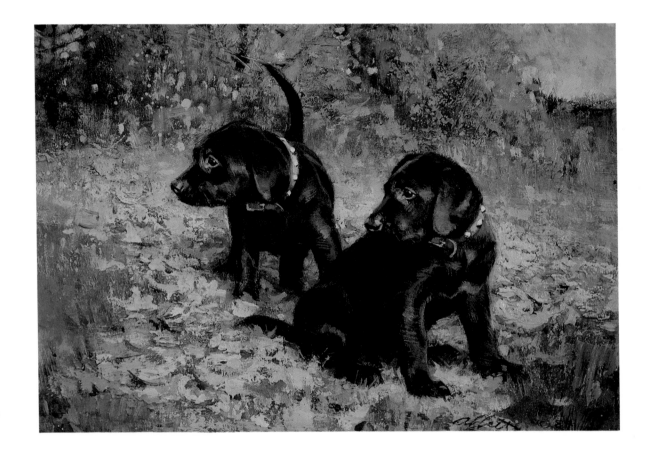

High Country ,
Oil Sketch, 7 X 10, 1988

ketches are extremely important in commissioned work; they remove most of the surprises from the process, especially for the client. For the artist, the trick is to solve the important problems at this stage, but save as much spontaneity as possible for the painting.

High Country ,
Oil Sketch, 7 X 10, 1988

In 1981, with the help of gallery owners Dan and Elaine May, we shopped for and quickly found our Scottsdale, Arizona, home in just one day. Marilyn is apt to tease me about the brevity of our search. Well, we still think our choice was a good one, and anyway, I was in a hurry to get to California.

While driving down the California coast road from San Francisco, the fog was there waiting for us. No surprise, we had seen it earlier while flying over from Arizona. But there's no way I could stand there on our country's western porch and not do a painting of what I saw. So if you can't fight 'em, join 'em...the fog became a part of my picture.

I can't speak for all other artists, but to me, painting fog is much more complicated than just skimming some gray paint over the top of a previously painted area. Fog lessens the number of values (shades of darkness) that we perceive, and of course, it also diminishes the intensity of colors. Therefore, I've learned to "paint it foggy" from the start rather than attempting to doctor up my painting later.

Doing this kind of painting provides a sort of therapy – a time to pause and think, to let the action go on by for a moment. This place won't change too fast. Nature will work at its own pace, just as it has in carving out "sea stacks," the peculiar arches such as the one just right of center.

I'm pleased that *North of Big Sur* is now in the personal collection of Dan and Elaine.

North of Big Sur,
Oil, 20 X 36, 1981

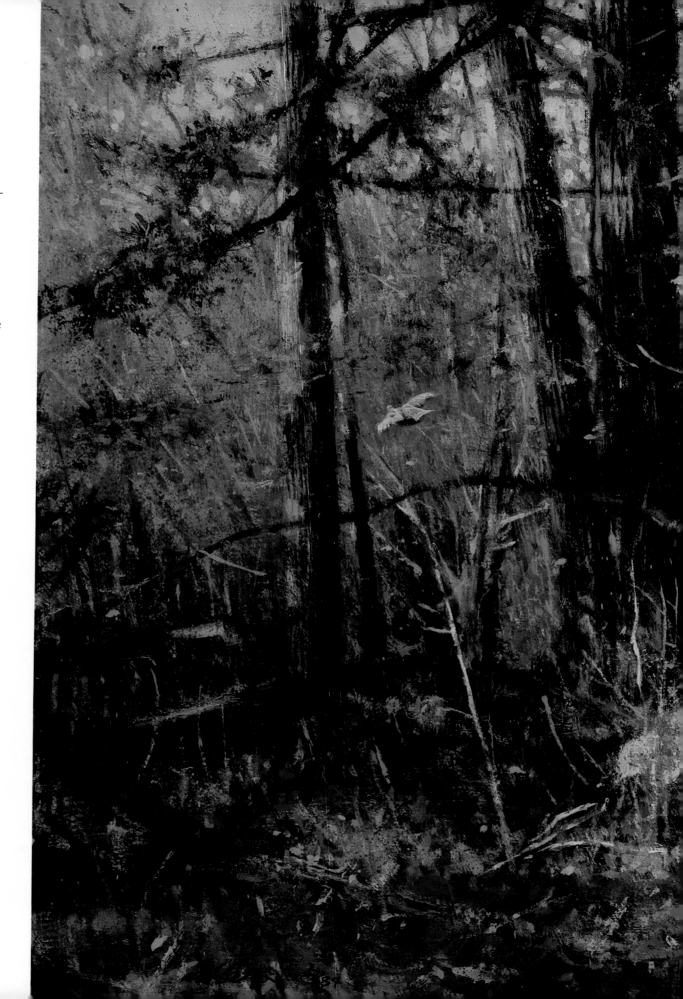

good part of New England's bird-hunting season occurs after the leaves are down, and most of the birds I've found came out of thickets and tangles rather than the open, park-like scenes I see repeated so often. This habitat makes for a gray, brushy setting that furnishes a fine, dark backdrop for the shining coat of a setter.

The various textures are painted with a lot of scumbling — dragging the final color over the top of heavier, rougher paint underneath. The old, tumbled-down stone wall serves as a kind of compositional spine that unites the various other elements.

Brush Cover Grouse was painted for the private collection of Russell A. Fink, a gallery owner and publisher in Lorton, Virginia. It is a good example of one of my favorite kinds of paintings. Here, as in many of my works, I paint selectively — that is, I can tighten up and explain important areas, while leaving others looser and rougher to lend interest and variety to the whole.

———

Brush Cover Grouse,
Oil, 20 X 30, 1984

———

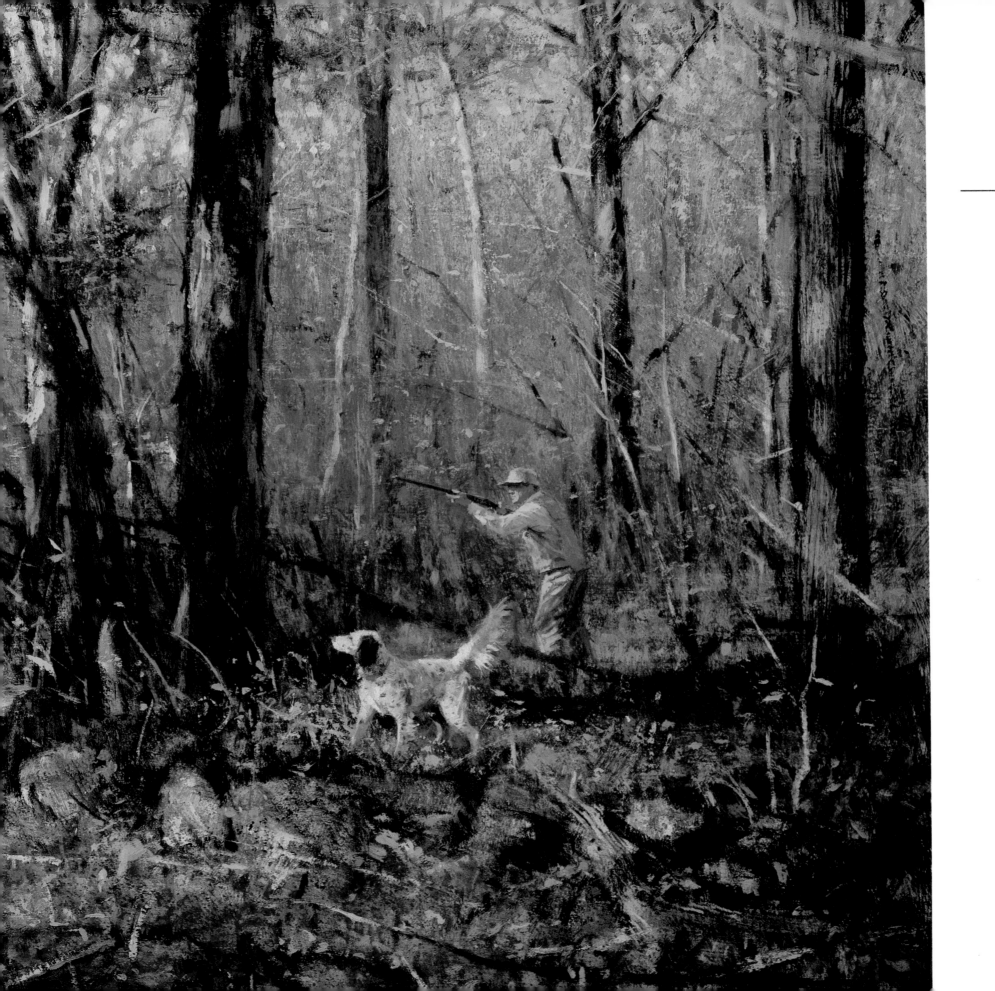

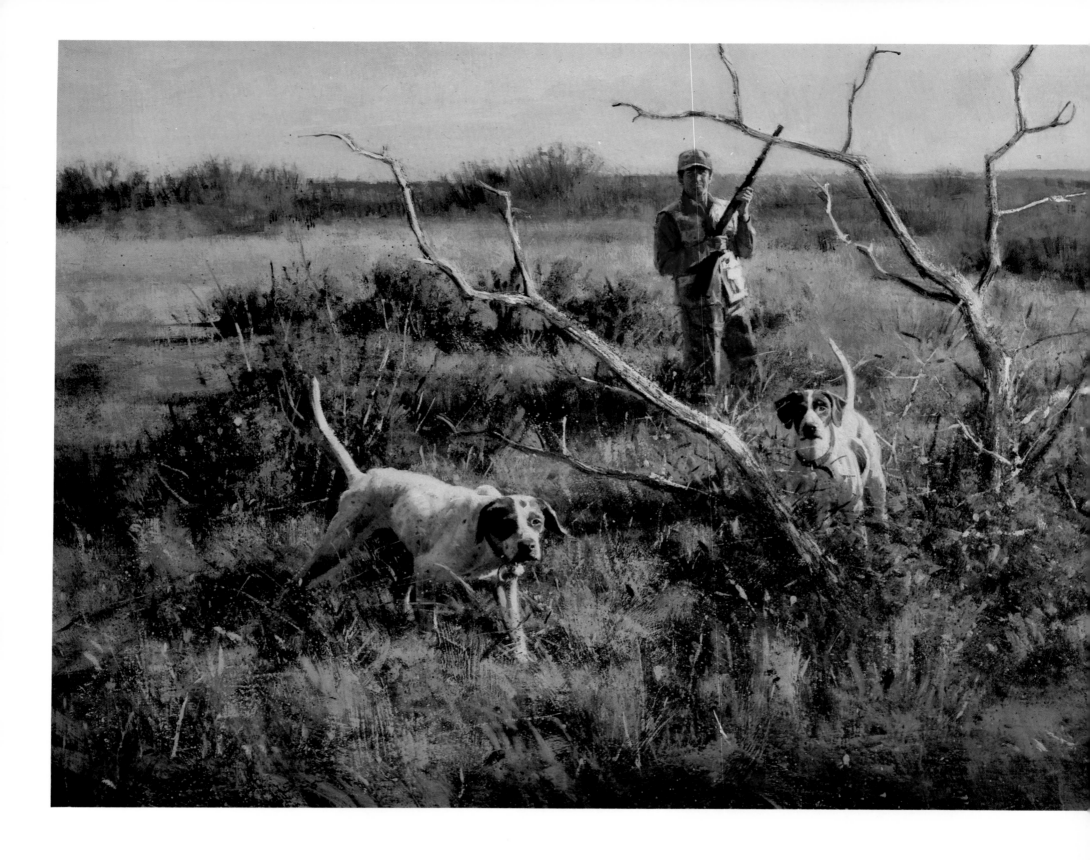

*T*o portray the intense anticipation just before the birds burst from cover is a challenge I never tire of accepting. I hope other bird-shooters share my excitement when viewing this painting. It's an instant I never quite get used to and the often unspoken connection between man and dog is almost touchable at that moment.

———

Just About Now,
Oil, 20 X 30, 1985

———

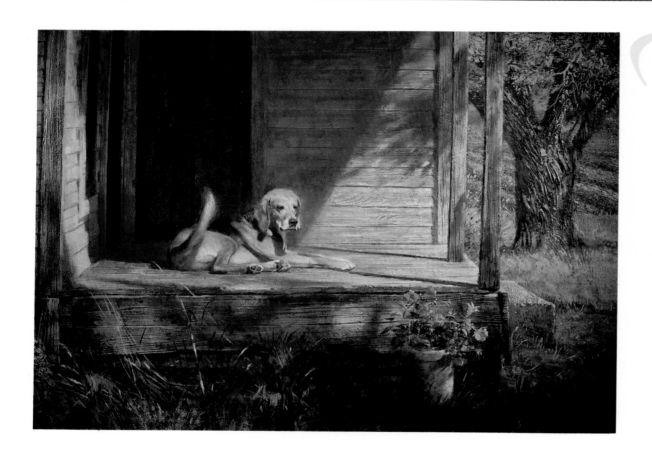

one early in my career, the conceptual birth of this painting was our dog's habit of announcing the return of our children from school by wagging and thumping his tail on the floor. Of course, he would always hear the school bus long before we did. Later, when I found this West-Texas farmhouse porch, I had my setting.

The model was Pup, owned by my neighbors, Ruth and Dan Cipolla. He was frankly underwhelmed at being asked to pose. His initial reaction was to get up and trot down the road about half-a-mile. A lot of petting and the warm afternoon sun made things right, and he naturally fell into this pose.

School's Out,
Oil, 18 X 24, 1975

s kids, we'd always go to the high school football game on Friday night, then on Saturday morning, while we still had our heads filled with the action, we'd get up a game of touch football, at least until the weekend chores caught up with us. I can still feel the dry leaves underfoot, the chilly morning air, and the satisfying thump of a well-thrown pass.

Saturday Morning,
Oil, 20 X 30, 1984

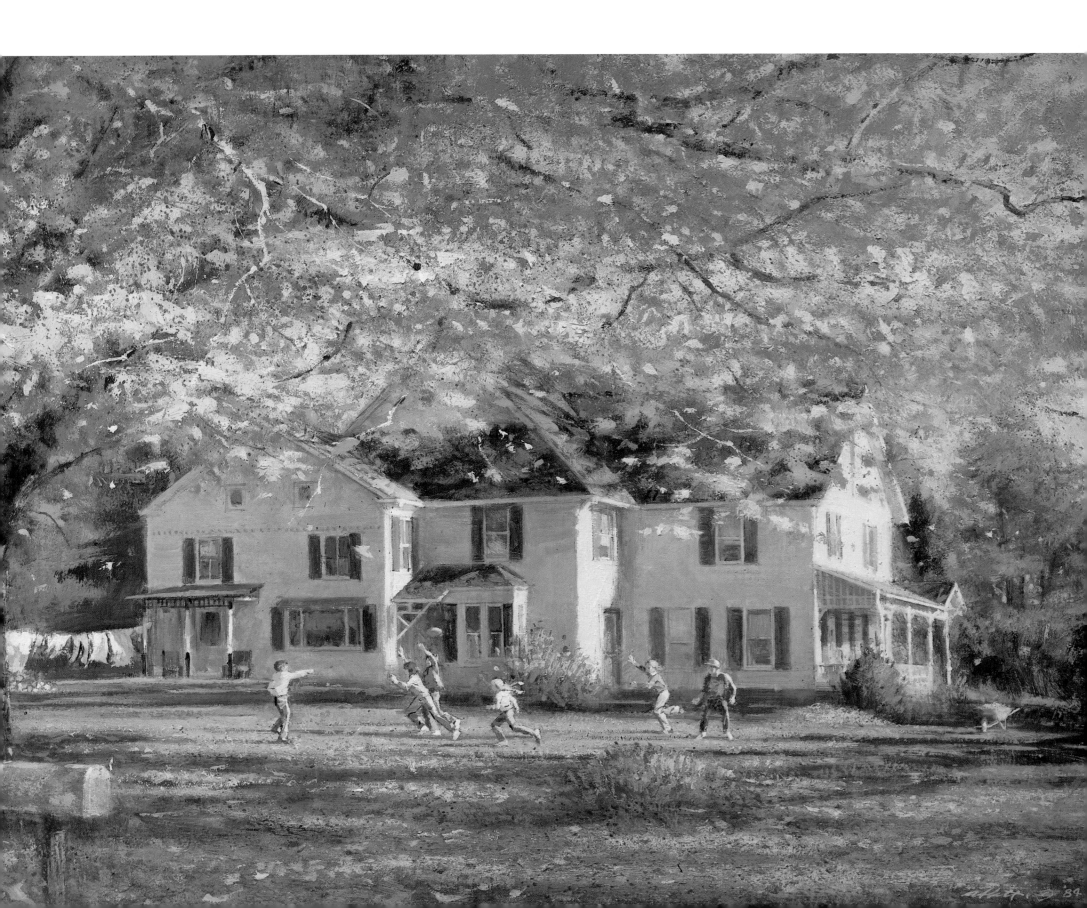

*T*his is another fantasy painting, pure and simple, and does not represent an actual stream or pool. If I close my eyes and allow myself a five-minute fishing vacation, the scenery would look something like this. It's a composite of bits and pieces from places I've been, perhaps photographed. Nevertheless, it affords me the pleasure of painting nature — mountains and trees and a beckoning stretch of moving water.

A lot of folks seem interested in the dogs, houses, and fishing scenes that I have painted and many swear up and down that I've visited their neighborhood or painted their favorite trout stream. I guess this hints at the universality of symbols in communication. I've learned that if an artist paints things he enjoys, then chances are many people will have shared his pleasure.

———

Good Livin',
Oil, 24 X 30, 1987

———

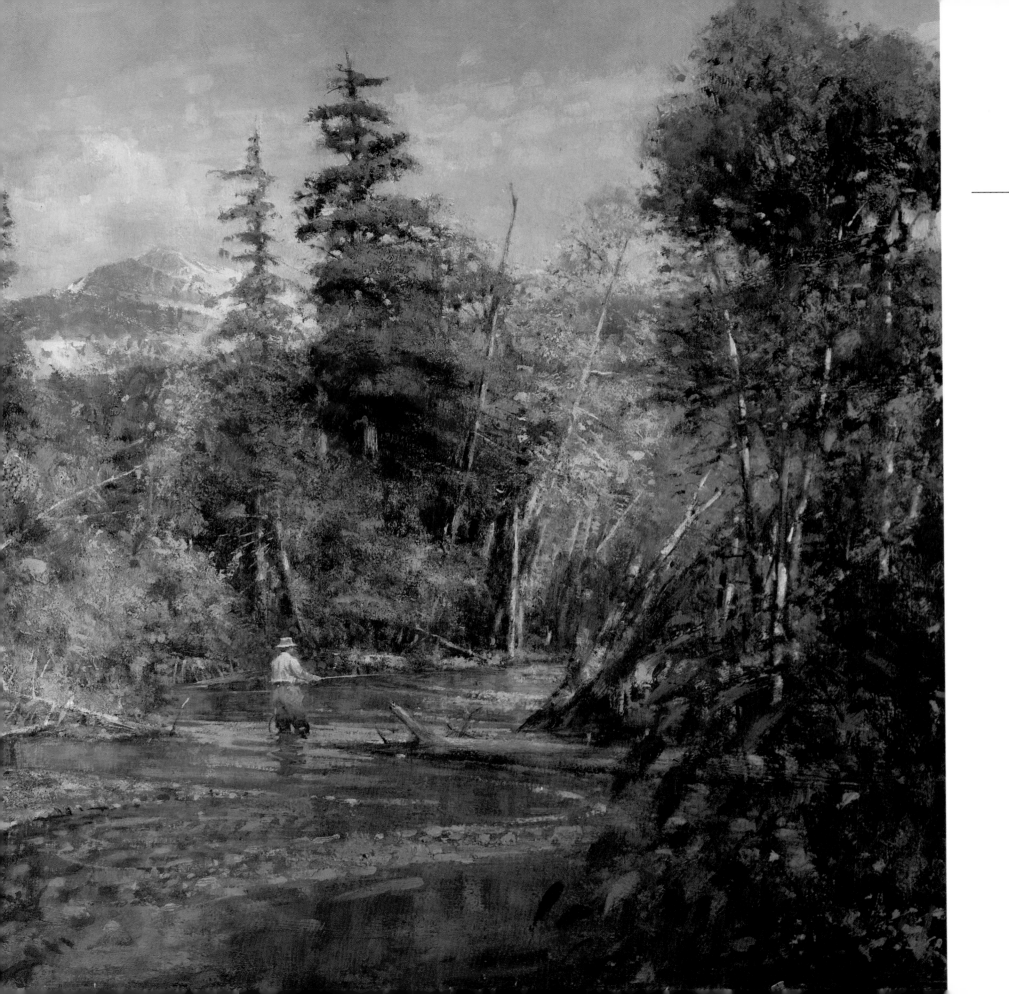

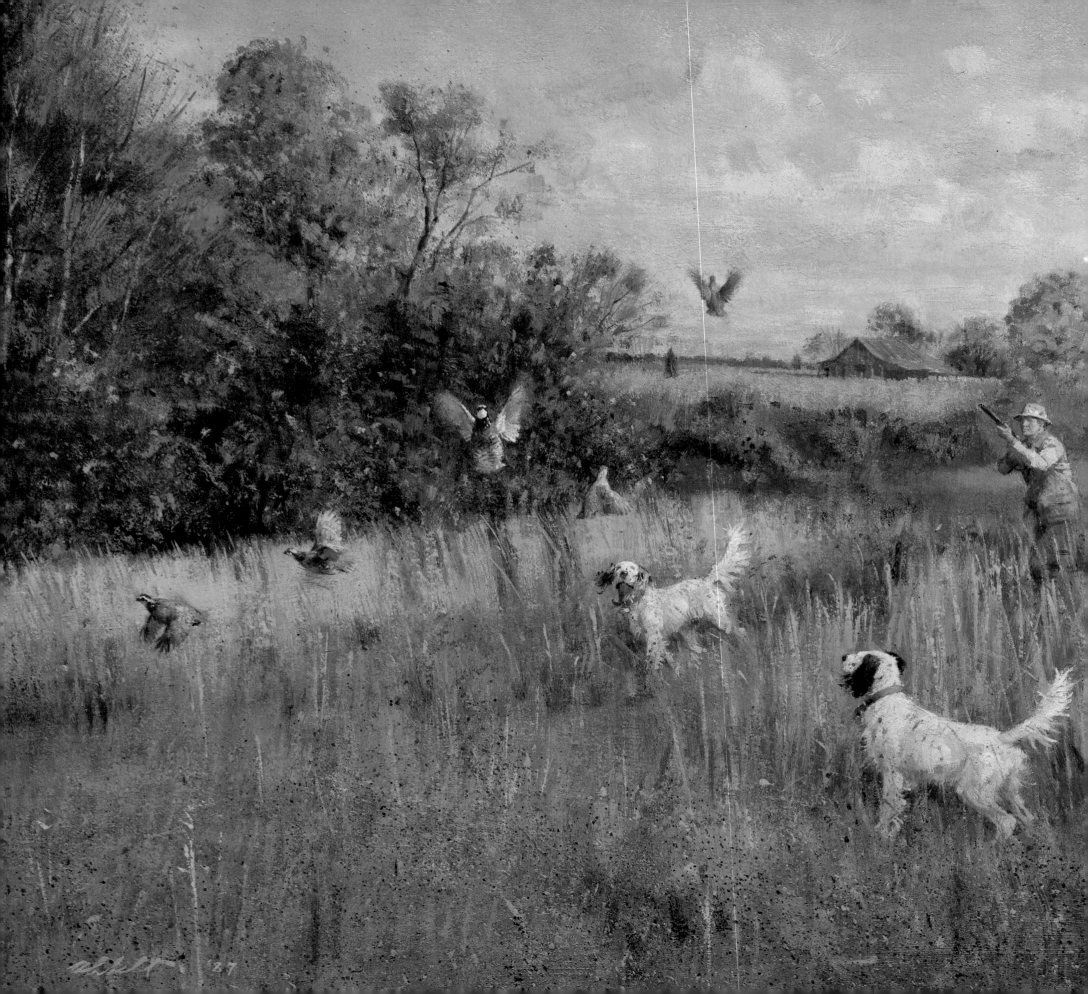

A commissioned piece on quail shooting in Arkansas, I was immediately excited by this project. My client, Harry Cornell of Carthage, Missouri, shares my love for English setters and his dogs are of similar coloration to my Duke.

Arkansas seems to have its own color scheme; I notice it every time we cross the country by car. I think it is two basic kinds of grass that show up this way in fall and early winter— one is orange-yellow, what they call broom sage in the South, and the other a much paler, silvery yellow, probably common fescue.

A Day to Remember was published in 1988 as *Sporting Classics*' first limited-edition "Print of the Year."

———

A Day to Remember,
Oil, 20 X 30, 1987

———

These registered paints were done on commission for Mr. and Mrs. Charles Hunter III of West Augusta, Virginia. As in many paintings, the simplicity of the subject matter often betrays the amount of trial and error in arriving at what I think is a commanding composition. The placement of two dogs in the field, or two horses' heads, can require as much attention as would a much more complicated picture.

In this case, for some inexplicable reason and in spite of my labors, the concept seemed a bit humdrum until I cut and placed an oval mat over the rough drawing. At that moment, the picture came to life.

The right eye on the near horse is called a "blue eye;" her mother's is on the left side. Blue eye is neither good nor bad in horsedom.

———

Cookie and Oreo,
Oil, 24 X 28, 1986

———

A West-Texas farmhouse had this menagerie spilling off its porch and into the yard. I couldn't believe it; goats, pigs, chickens, and a fairly good-looking pointing dog. I left out several animals in the group, thinking they would be too much to be believed.

Patches of light on the far porch wall tell us the roof is filled with holes; the yellow extension cord leads out to a mysterious contraption, either an outdoor shower or...you tell me?

———

The Neighbors II,
Oil, 20 X 30, 1986

———

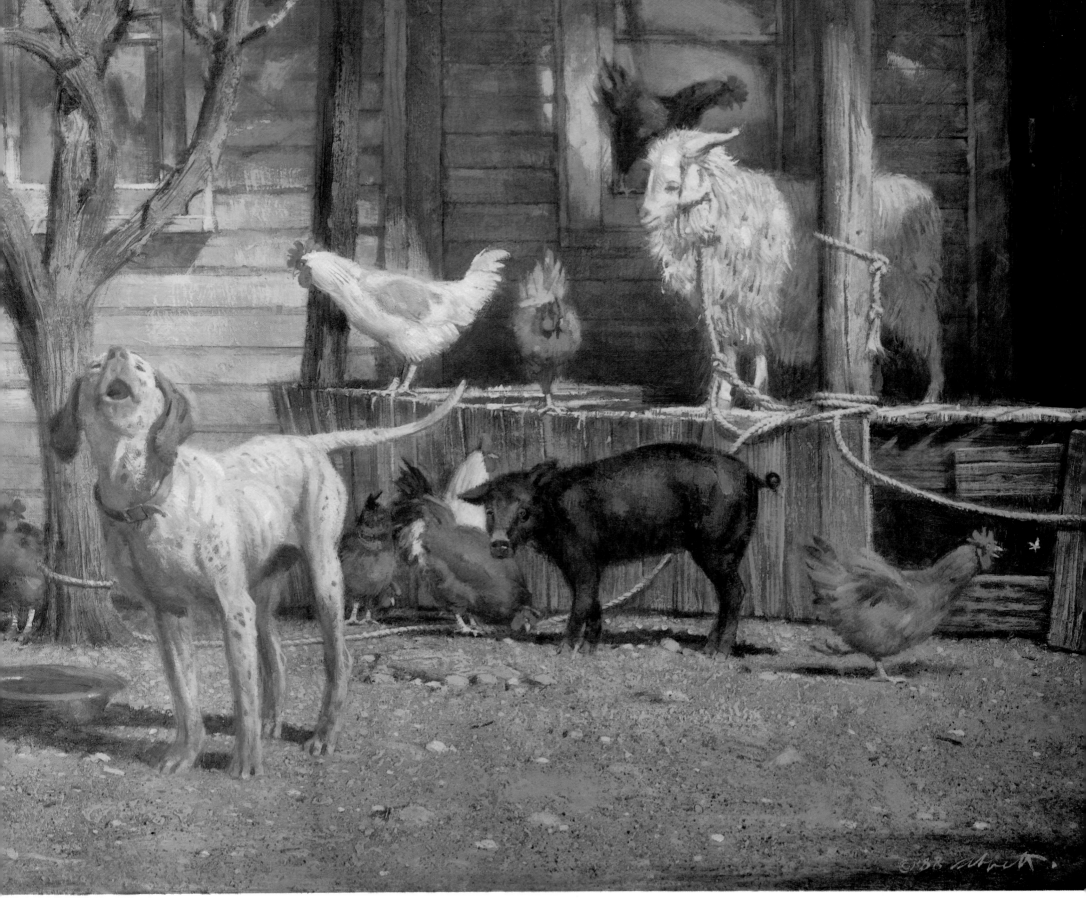

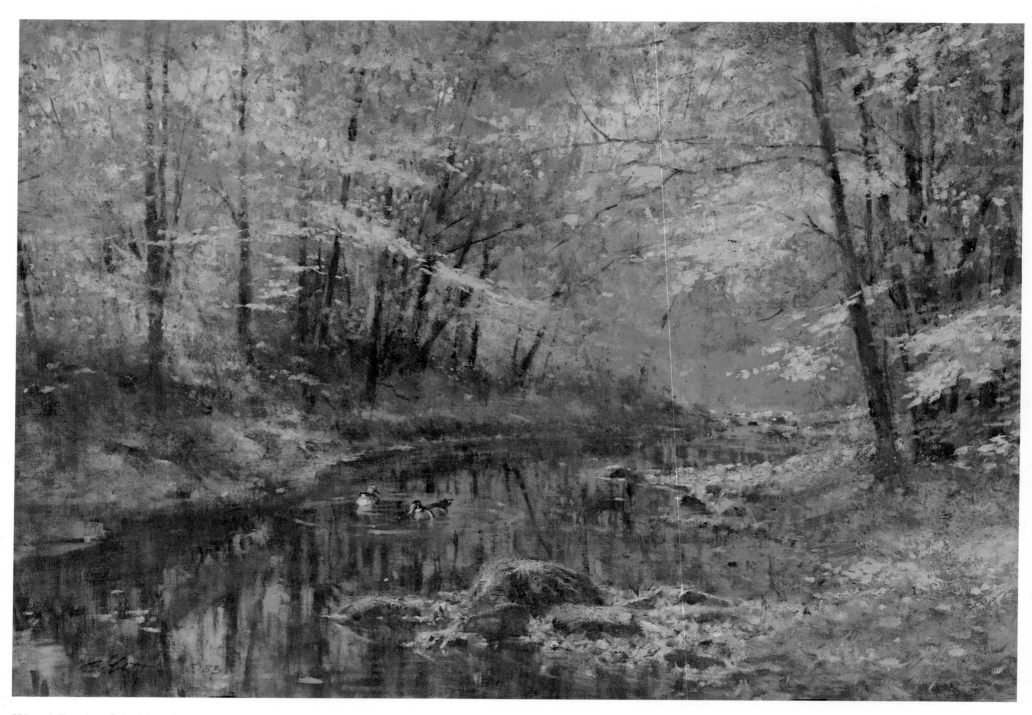

Wood Ducks, Oil, 20 X 30, 1983

AMERICAN IMPRESSIONIST

Conceptual Sketch for "Fishing the Aspetuck" not yet painted

There is a famous story in the academic world of literary criticism about a turn-of-the-century undergraduate class at an Ivy League university. The topic of the day was *To His Coy Mistress* by the 17th-century English poet, Andrew Marvell. For fifty minutes, a professor of great scholarly credentials discussed Marvell's family, his education, his politics, his career as a member of Parliament and secretary to John Milton. At the end, some student brought up the matter of *To His Coy Mistress*, which the professer hadn't mentioned at all.

"Ah, yes," the great man said, gathering his notes and heading for the door. "Damn fine poem, gentlemen, damn fine poem."

Fortunately for our desire to understand the world's great literature, that approach is no longer current. Unfortunately for our appreciation of sporting art, it seems to be the standard approach at the moment. Those who write about sporting art too often seem to find the art itself impenetrable and focus instead on the artist, lending a specious currency to the old cop-out, "I don't know anything about art, but I know what I like." From that point of view, the only difference between fine art and a cartoon is the price.

The fact is, the best sporting artists are genuine artists. They're serious about what they do, and they approach it with all the power of thought and feeling they command. The only real difference between them and the artists whose work now makes up university art-appreciation curricula is subject matter — and subject matter never was a valid criterion in resolving the question of what separates great art from visual junk-food.

Every serious artist, regardless of his medium, has sought to communicate essential truths of human experience. This is the case whether the medium of expression is literature, music, painting, sculpture, theatre, dance, or any other; the intent is to render human experience in ways that provide an immediate, undeniable connection between the artist's vision and the viewer's own experience. We respond to Hamlet's agony because we all have at some time felt trapped between a profound sense of duty and fear of the consequences we know will result. We sympathize with Gatsby because we know that we cannot relive the past, no matter how we try. Anyone who has felt true, heart-bursting joy can recognize the same feeling in Beethoven's last symphony.

On and on. The point is that art seeks out the most basic truths of what it means to be human, and the great artists are those who can

see and communicate those truths most clearly.

If subject matter has no validity in defining great art, it does, on the other hand, impose certain limitations. Sporting art is likely to appeal most — or perhaps only — to those for whom sport is a significant part of life. A bird hunter isn't Macbeth. Shooting a grouse hasn't the same universality of human experience about it as attempting to keep ambition in balance with moral decency. Sporting artists therefore are not likely to end up as subjects of doctoral dissertations, but that of itself doesn't mean that sporting art is second-rate art nor that a serious analysis of their work is any less rewarding.

As an artist, Bob Abbett has much in common with certain French painters of the 19th century — Renoir, Degas, Manet, Monet, van Gogh, Toulouse-Lautrec, and others. These were the Impressionists, so called because they believed that art should present the artist's impression of a scene rather than the more objective rendering that characterized the Neo-Classical approach. Where the Neo-Classical painters emphasized logic and a reserved, coolly technical style, the Impressionists brought emotion and vitality. The Neo-Classical painting says, "This is a scene as it appears to anyone who views it." The Impressionist view says, "This is how this scene appeared to me at this specific time in my life, at this particular time of day, all filtered through what I was thinking and feeling at the time."

Impressionistic painting is not realistic in the sense that the painter strives for an almost-photographic duplication of what he sees. The impressionistic approach is looser, more energetic, less concerned with absolute accuracy of detail and more concerned with combining the way something looks with the way it feels.

One result of the impressionistic approach is to remind us that we're seeing a painting of something, not the thing itself — an idea that is central to abstract art and an idea that, it seems to me, originated with the Impressionists. This, in turn, means that we viewers are invited to participate. Classical and Neo-Classical art can be powerful and interesting, but at the same time there is a stand-offish quality about the ultra-realistic wildlife painting that often is so admired.

Such work seems preoccupied with technique, with an insistence upon rendering every feather and leaf and blade of grass with the fidelity of a photograph. There is a certain appeal to it, but it also can amount to a barrier between the spirit of the

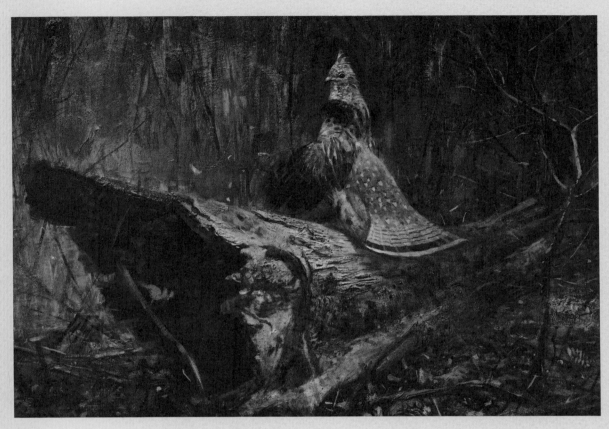

painting and the viewer. We can admire a *tour de force* demonstration of sheer technique, but what then? Without some means of relating what we see to our own experience, art remains an exercise of the mind and not, as it should be, an interplay of thought and feeling.

Bob Kuhn, whose own lean, powerful style reaches for both the mind and the heart, has watched Abbett's style develop. "Bob was a good painter when he took up sporting art; now he's knowledgeable as well," says Kuhn. "I appreciate an artist who puts paint down with conviction and gusto—especially since we coexist in a world of nitpickers. Bob loves what he paints. That's clear in every new piece he does. He's a painterly painter, and that's for me."

Bob Abbett: "I don't like to put in every detail, because I want the viewer to add something of his own.

"This goes back to the Impressionist paintings I saw as a kid at the Chicago Art Institute—those jumbly things. They were wonderful. They left something for me to put in with my imagination, and I try to leave something for the viewer to put in with his experience and his imagination.

"It seems to me that the guy who's looking at the picture is as much a participant in the process of art as the painter. Not only that — he's better at it, because he has his own experience to draw upon, and that experience may be extremely broad. I want to leave him every opportunity to look at a painting and think, 'Ah, that reminds me of a time...'

"Art, to me, is a door that opens both ways."

In Bob Abbett's paintings, these doors usually lie in the landscape, in that powerful sense of place that is

———

Of *Yankee Drummer*, painted in 1987, Abbett recalls: "The first time I heard a ruffed grouse drumming, I honestly thought it was someone down on the river trying to start an old outboard motor. After later flushing, and missing, the partridge, I was able to put two and two together."

———

Abbett drew his work sketch for *English Setter Litter* on this gessoed masonite. Drawing one pup on a tissue overlay enabled the artist to try out various positions in the composition.

Closeup of the work sketch shows how the tissue pup was traced down and then redrawn in position.

At this stage, Abbett has reinforced his drawing in ink, and using a large brush, applied a loose, khaki-colored turpentine wash.

central to so much of his work. His backgrounds are rendered to an extent and in a degree of detail sufficient to clearly show that the central action is taking place within a larger context but not some place so specific that the artist's experience precludes that of the viewer. He can, if doing so fits the intention of the piece, create a powerful portrait in virtually no environment at all; his famous painting of Robert E. Lee on his horse Traveler is a case in point. But the Bob Abbett paintings that speak with the most spirit are those that provide a place for us to enter the scene and share the way it feels.

Paintings do not simply happen, although the best ones often look as if they did. Just as the best writing reads as if it unrolled in an unbroken skein from a writer's mind into print, a great painting has an organic quality about it, so tight a unity among its parts that the whole thing would fall apart if any principal component were removed. Sometimes it really happens spontaneously, but those times are infinitely rare. Usually what looks and sounds and feels spontaneous is the result of considerable effort; that it works is the element of art that is nothing so much as pure magic.

Because Bob Abbett constantly seeks to equalize action and scene, an Abbett painting can begin with a perception of either.

142

"Sometimes I see a place that instantly triggers my imagination, and I'll set about finding a situation that fits it — or perhaps some action occurs to me first. Maybe I decide to paint a Brittany pointing a grouse; then I look for an environment that's right for that, some place that amplifies the action and gives it dimension.

"I start with the whole thing in my head, but before I make the first mark on paper, I'll do the research. I want it to be that specific, so that when I do pick up a pencil, I'm drawing a tree, *a* tree, not just any tree. By the time I do the rough sketches — and I might do six or eight, all slightly different — I'm working with real dogs and trees and stumps and whatever else I decide needs to be in the picture.

"It's almost an abstraction at that point. I'm concerned about the authenticity of everything, but I also have to have the shapes working in a forceful way. This is something I can feel. I can feel when it's right and when it isn't. There won't be much detail at that point, but it's planned mentally to the point that I know the dog is going to face left — I won't always know why, but I'll know that I want it that way.

"I've learned that if I start that way I can work fairly quickly once I get to the point of actually putting paint on board. That helps

Here, the wash underpainting is complete. He used a lighter tone for the dogs, because they will end up almost white. Some underpainting always shows through a finished painting.

Working in opaque oils, Abbett has established the light and dark areas.

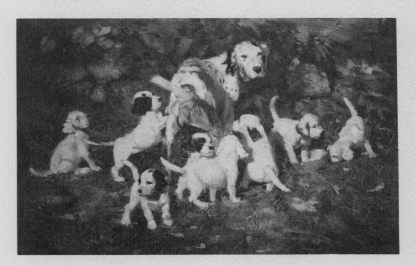

The 24 x 36 painting is now about 80 percent complete. The final image appears on pages 38/39.

143

preserve the spontaneity, keeps the energy up.

"It usually works out that the finished picture will look quite a lot like what I had in my mind. It always poses more problems than it did in my mind, but you have to expect that. Mental images are always perfect."

True enough, whether it's an image meant to be a painting, a story, a sculpture in stone, or a lifetime's work that seeks to bring the reality of a finished piece into a flawless match with the ideal that always hovers close behind the artist's eyes. How well each new image, unfolding in oils under the touch of Bob Abbett's masterful left hand, fits the perfect painting in his mind only he can know. Ask him to name his favorite piece of work, and you'll get the same answer you would from every serious artist: the next one.

The artist begins with a blank ground and fills it with images of his own device. He has complete control of everything we see, the way every element is placed in relation to every other, the angle of view, the colors, lights, and shadows. If he is a good artist, he offers us a way into the scene and provides a way out. While we're there, we see a sliver of the world through his eyes, and if he is a great artist, the view he gives us is at once a window and a mirror.

The world according to Bob Abbett is usually a sunny place, early or late, newly freshened by rain or sun-baked and patient in the hope of rain. It may be New England, Georgia, Texas, Arizona, Wyoming. It is a landscape that hums with life and speaks of time. Growing plants are balanced by fallen leaves and dead branches, thriving trees by moldering stumps and deadfalls, water by dust, flesh by stone, light by shadow — in all, a complex tapestry that preserves impressions of place and time where continual change speaks of what is past and yet to come.

We spent the last afternoon hanging around the studio, the dogs underfoot, early-November sun brightening the south window. The DU painting, finished but for a signature, hung in a temporary frame by the door. In it, a black Labrador splashes his way through a marsh-water slough, a mallard drake held high and businesslike. The dog's eyes are on the hunter, waiting somewhere outside the scene. Bo, housebound and healing, snoozed on the rug, stoic in his sun-colored bucket.

In a few weeks, Bob and Marilyn would leave the house in the care of their winter family, pack the van, and head southwest for another winter, more work, the next painting. We talked about regionalism in art.

"I suppose there really is a peculiarly Western school, but I don't think of it that way. Making that kind of distinction certainly doesn't help me work out any of the problems in a painting. What I'm after is to paint what's there, bring out the spirit of the place in some meaningful way, wherever it happens to be.

"I'd like ultimately to be known as just a good outdoor artist."

Next morning, I settled up with the innkeepers, looked over the map to find a way back to Windsor Locks that would take me through some countryside I hadn't yet seen, and headed down the long hill toward the Housatonic, then north beyond the head of the lake, following the river as it narrows, flowing lean and strong.

Wood Ducks, Oil, 16 X 24, 1979

146

Artists, like fishermen, are interested in the surface of the water. At least they ought to be. Painting water is like painting a woman's lips–you like them so much you can overdo them. When I'm painting water, I really don't like to be disturbed. (Not now, Marilyn, I'm painting water.)

Depending on the direction of the light, and size and color of the background, various textures of water can be darker or lighter than those next to them. Smoother water reflects the background quite well, while rougher water or riffles will not. Like painting glassware, a few bright highlights are often better than showing all those you would actually see.

A good fisherman will have his own set of rules as to what these things mean to him, and these will help him read the water—its currents and where the fish might lie.

Fishing the Yellow Breeches,
Oil, 20 X 30, 1982

——

ointing dogs are trained to be staunch by twitching a bird wing attached to a length of monofilament line from a fishing rod. I don't think you *teach* a bird dog to do anything, by the way; you just refine and reinforce traits and talents that he brought into the world with him.

But pups will be pups, and after some schooling at Jerry Waters' Hawkeye Hunting Club, it apparently seemed a good idea for the trainees to run off with the rod while the trainer was momentarily distracted.

——

Fishing at Hawkeye,
Oil, 13 X 18, 1984

——

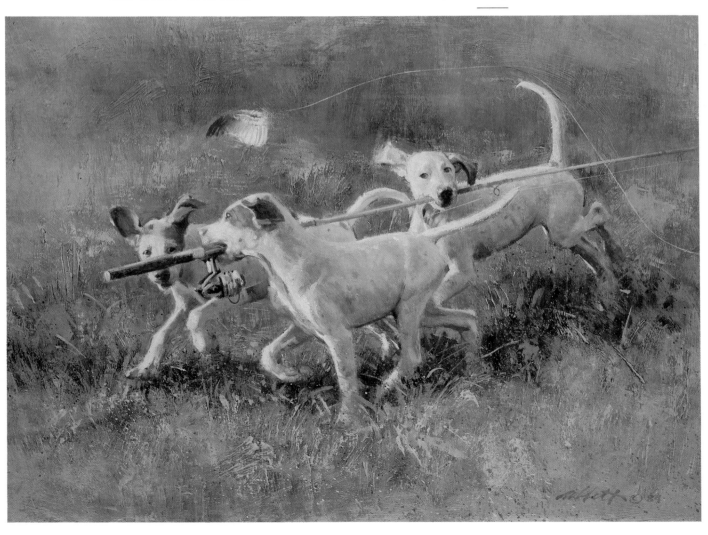

here is no adequate way to describe the excitement I feel when a ruffed grouse blasts from cover. In situations where the bird has not held for the dog, it seems like the gunner is either straddling a deadfall or bulldozing through a dense thicket when the action erupts. I keep trying, and I hope my paintings have succeeded in showing at least some of what I feel about "partridge" hunting.

Painting the scenery is almost as exciting. Somewhere as a boy, probably at one of the Chicago museums, I saw many diorama exhibits that I remember every time I paint a woodland floor. You've probably seen such displays where the background painting is a visual continuation of the actual objects in the foreground. All of this heightens the illusion of reality.

Like the diorama painter, I luxuriate in the pleasure of painting the textures of stones and dried leaves. To keep such a painting spontaneous, I often begin with an underpainting that includes arbitrary strokes of almost pure color. The small pieces of color that are not completely covered by the finished painting lend energy to the picture.

Fast Feathers,
Oil, 24 X 36, 1981

148

149

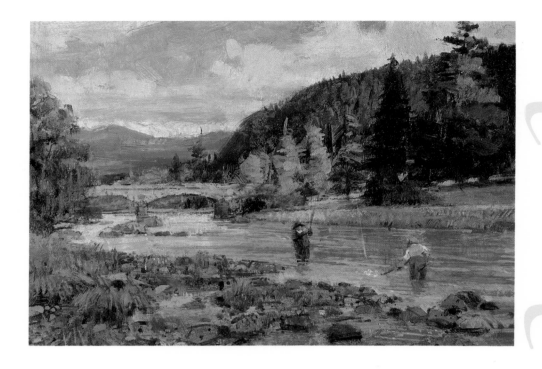

his small, conceptual oil sketch helped my client, Robert Small, and I work out the technical as well as artistic considerations for this painting of salmon fishing in Scotland.

Brig-O-Dee, Invercauld,
Oil Sketch, 6 X 10, 1987

For the painting, I was aided by one of our most modern research tools: video tape. Small, who for years steered Dan River, Inc. in Danville, Virginia, took some excellent on-the-scene video pictures. Next to being there, the video furnished me with source material and a strong feeling about the place and time. I got cold just watching the tape.

I was intrigued, among other things, by the gillie relaxing on the grassy bank, a human touch that deserved to be included.

Brig-O-Dee, Invercauld,
Oil, 20 X 30, 1987

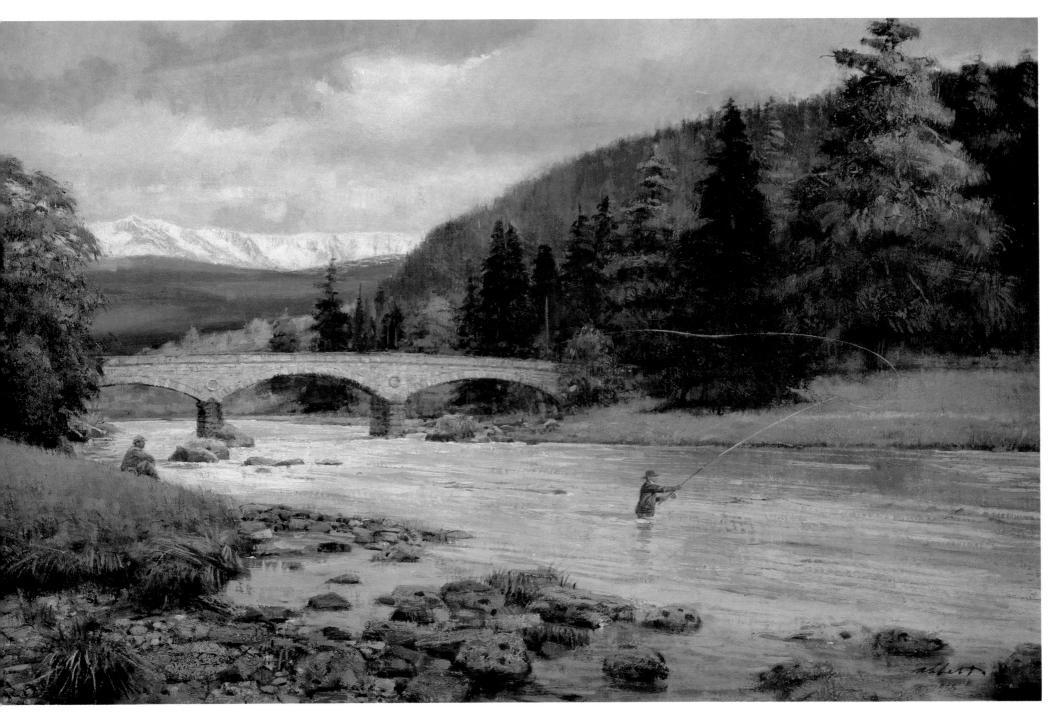

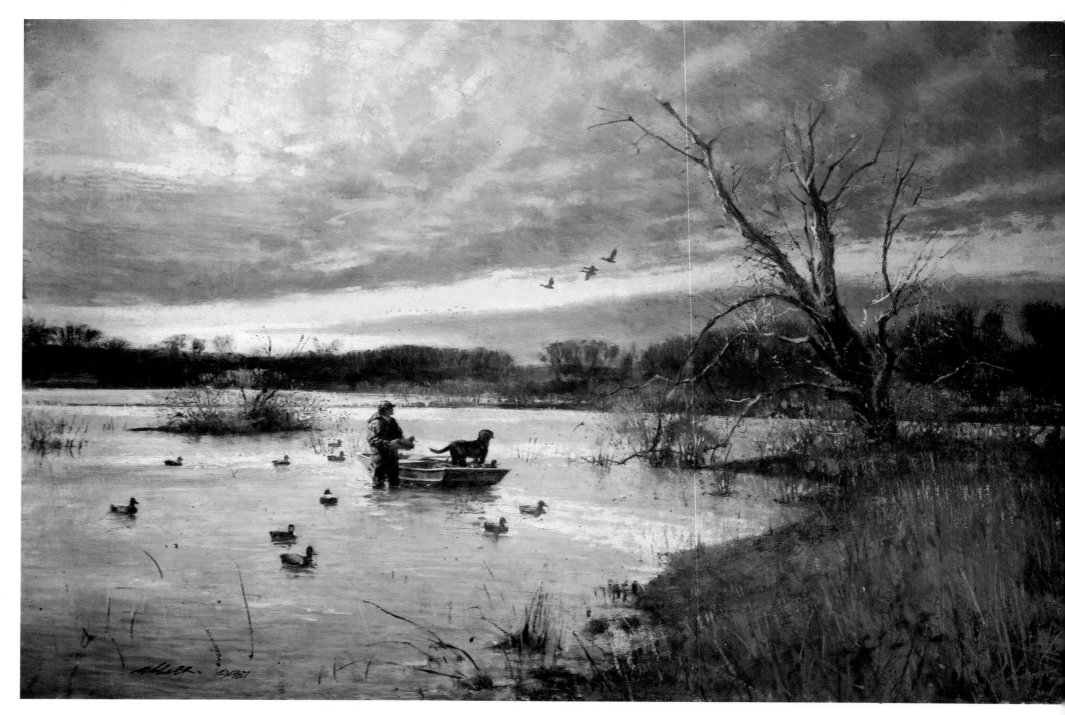

I t is not uncommon for artists to change a picture, often quite dramatically, during the painting process. It *is* somewhat uncommon to document and publish both versions, perhaps because we don't want to appear indecisive.

Though I've experienced this same hunting situation, as the picture progressed I became displeased with my staging, as shown in the smaller reproduction. The postures of the hunter and Lab seemed cramped, and I didn't like the idea that the ducks had flown past them. So, I reposed a figure for the waterfowler and redrew and repainted both man and dog. The ducks were then moved into their present position, and I believe the various elements now work together much better.

Duck hunting furnishes an artist with a chance to study early-morning skies, though admittedly, I'm not always at my creative best at this time of day. But I welcome the opportunity to portray different clouds and weather patterns, and although there are some notable exceptions, I feel many of our sporting artists are passing up these very dramatic phenomena.

This color scheme was a distinct change of pace for me, and I was reminded of paintings from times past when artists seemed to feature gray as a more important ingredient. Its

use, in addition to helping depict the early hours, gives added brilliance to a small amount of color.

Leeper Lake was published as a fund-raising print in 1985 by the Texas chapter of Ducks Unlimited.

———

Leeper Lake,
Oil, 24 X 36, 1981

———

For many paintings, I have part of an idea for a long time, but it takes one final element to get the idea off dead center and onto my easel. This time, it was the great old gate and stone steps. I really began to notice them when Jim Loomis began remodeling his old colonial home in Bridgewater. I thought I'd better do the painting before he remodeled (and decharmed) the gate and fence.

Marilyn had been after me for years to do a cat painting, and while protesting that a gun dog artist might suffer ridicule for doing a kitty, the setting prompted me to proceed.

The Gatekeeper
(formerly *Silly Cat*),
Oil, 16 X 20, 1987

Bill Webster, whose Wild Wings Inc. publishes my prints, is to be complimented for going along with me on several tangents of subject matter. After all, I enjoy painting a range of subjects that is wider than hunting and fishing. But it is another thing to risk publishing them. The *Old House* series has done exceptionally well, however, so there's a happy ending to this paragraph.

I may be fixated on raking leaves, but it seems to be a picture I'd like to do over and over. In my boyhood we burned the leaves — this was before environmental protection became a national concern — and the whole town was enveloped in a pleasant, aromatic haze. These are indelible sensations for a Midwesterner. Here in the East, leaves are sometimes vacuumed, a process less than picturesque.

Our House (formerly
Raking Day),
Oil, 20 X 30, 1985

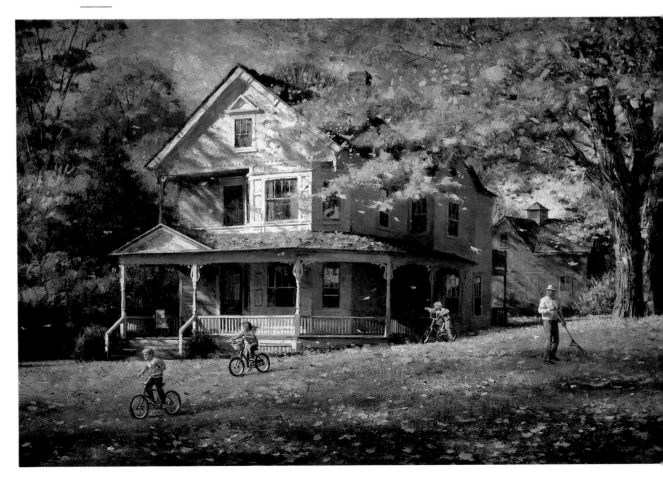

The Buzzard Council of America, for whose stamp-print program this painting was done, was a kind of tongue-in-cheek organization that poked fun at the wildlife and sporting art industry. No monthly meetings, just one or two "fly-in" barbecues (Rocky Mountain oysters were among the hors d'oeuvres), where everyone was the target of good-natured ribbing.

Founded by Minnesota wildlife artist Art Cook, the organization decided to publish an annual print which had to depict a species of buzzard or vulture. Some pretty heavy artists participated in the print effort, including Dave Maass, Bob Kuhn, and Harry Adamson. So, when I "lost" the annual drawing ("lost" meant you were selected to do the painting), I plunged in all the way.

Black vultures are somewhat rare in the East, but I did find one in the Tucson Desert Museum Zoo and placed the birds soaring above some rimrock on a Texas ranch where I've hunted quail.

Ironically, like so many of its namesakes, the Buzzard Council is now extinct.

Black Vultures over Clay County, Oil, 15 X 21, 1980

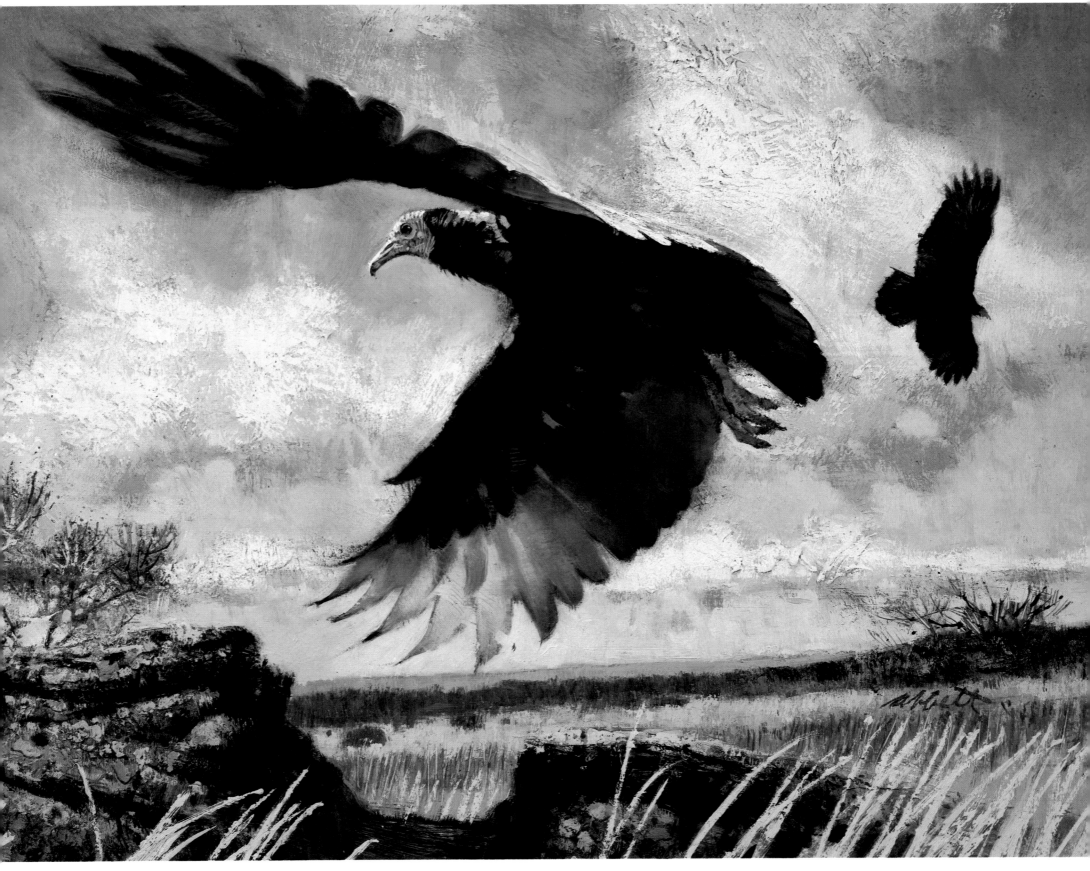

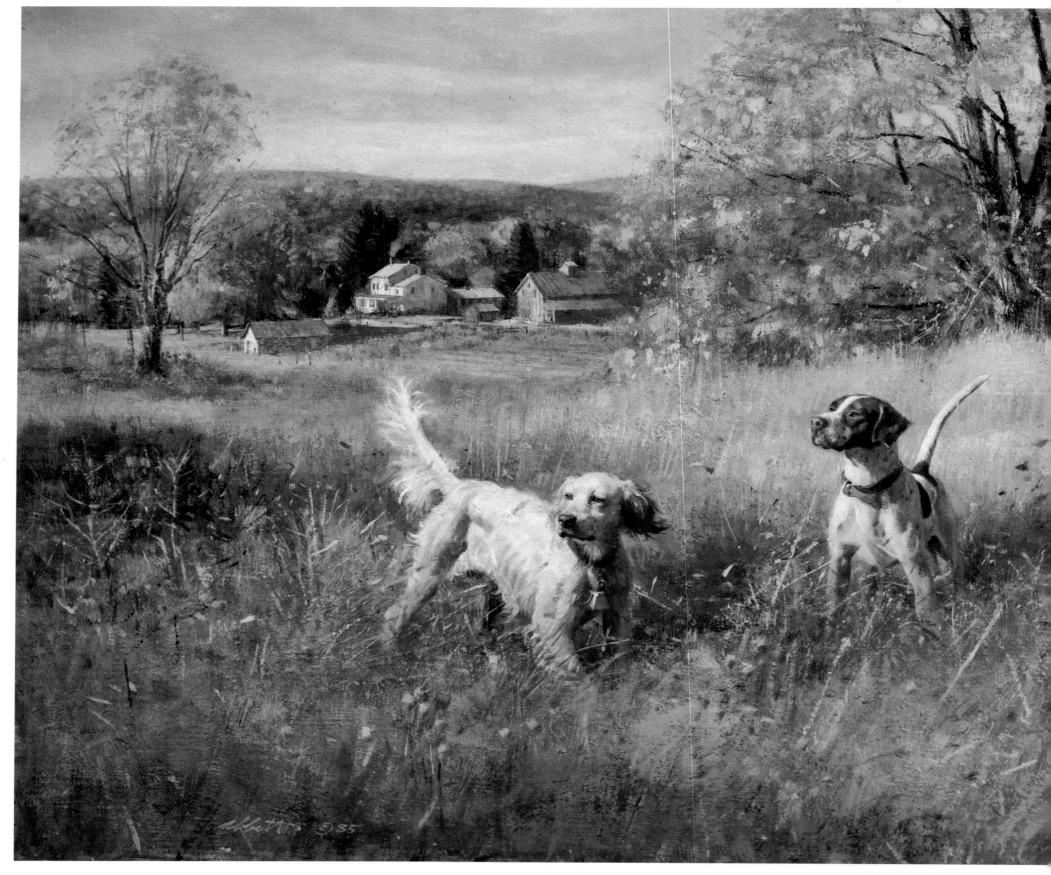

*T*here is some symbolism in the depiction of dogs, birds and other wildlife which I don't entirely understand. I think it has to do with the concepts of freedom, innocence, and the flight from our perceived bonds of job and responsibility. In any event, I've sold paintings of hunting dogs such as *Autumn Fields* to people who have never owned a dog. Whatever and however it works, symbolism can be strong medicine.

———

Autumn Fields,
Oil, 22 X 32, 1985

———

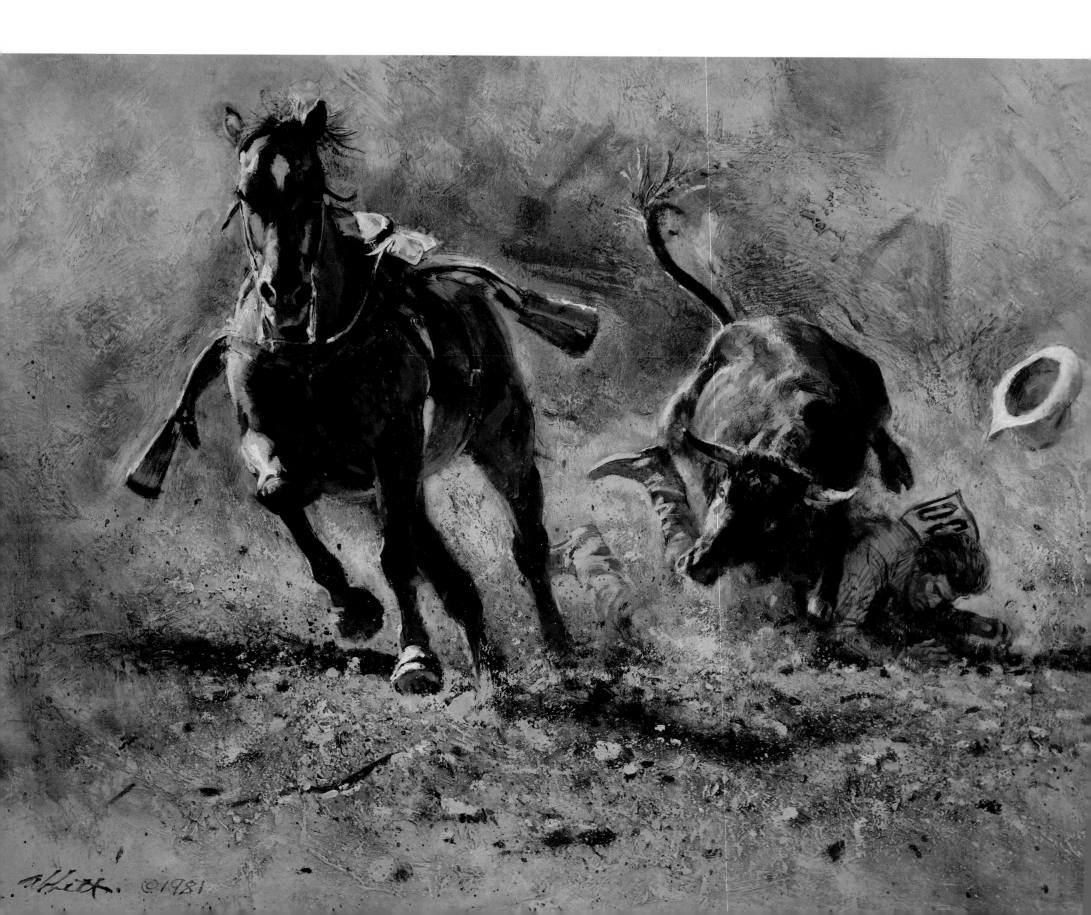

erhaps my picture sense sometimes runs toward the unusual, or maybe as an illustrator, I was routinely asked to show things at their ideal best. In any event, I occasionally like to paint a picture that portrays a less-than-perfect performance, which as we all know, is much more like real life. The great Western artist Charlie Russell often showed his horses and cowpokes in a tangle of unfortunate roping and awkward arms and legs.

I think it takes one tough guy to leave the comparative safety of the saddle and throw himself over the horns of a galloping steer, so I'm not making fun of the bulldogger, that's for sure.

Some Days was born in Cheyenne, Wyoming, at the Frontier Days Rodeo and was exhibited there. It appeared on the annual Frontier Days poster the following year.

———

Some Days ...,
Oil, 24 X 30, 1982

———

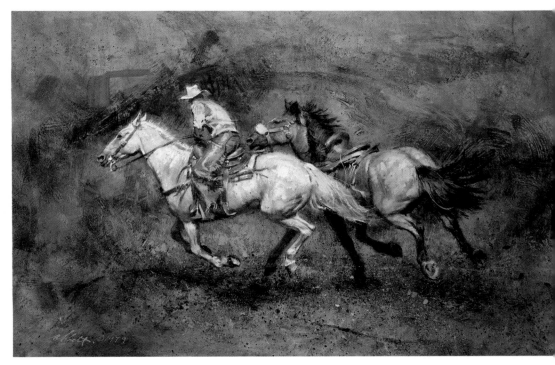

hen I spend time hanging around rodeos, my attention is often seized by the lesser moments of the sport: those times just before or after what many would consider the height of the action. After a rider has left his bronc, either intentionally or more abruptly, someone has to get the bronc off the field as quickly as possible, which is the job of the pickup man. You can see how the juxtaposition of these two magnificent animals has an almost sculpture-like quality.

———

The Bucking Horse,
Oil, 20 X 30, 1979

———

I wanted to take some photographs of Max, so I asked his owner, Roy Young, who would be at work at the time, if I could take the dog out of his kennel. He replied that my greatest and only danger would be getting licked to death. Like all goldens I've had anything to do with, they not only have an unsullied reputation for friendliness, they also look the part. So to help portray this nonsporting facet of their dual personality, I purposely showed an inch of Max's tongue in an expression I'd probably not use with an "all business" breed like a pointer.

Max was published in limited edition by Wild Wings, Inc. as the second in the *Sporting Dog Heritage Series*.

————

Max - Golden Retriever Head, Oil, 16 X 20, 1983

————

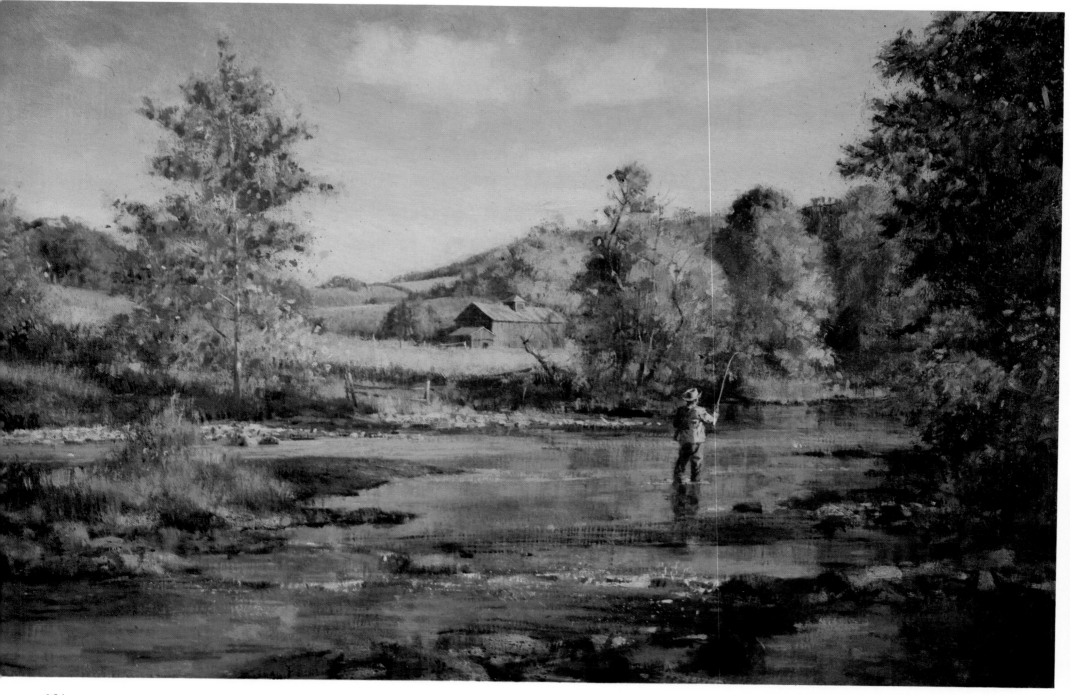

In my experience, one of the best times to fish coincides with that part of the day proven most attractive to artists; what we call "magic time." Beginning in late afternoon, shadows lengthen to reveal a bolder quality of modeling and colors become infinitely richer. Lasting until sunset, this golden light can enhance the humblest of scenes.

As a "sometimes" fisherman, my desires always conflict with the full-time artist's curiosity which wants to see as many pools as possible from numerous vantage points in that productive but limited time span.

——

Five Mile Pool,
Oil, 20 X 30, 1986

——

My own bird, Tom, served as the model for this painting, done for the Wild Turkey Federation's stamp/print program. At one time we had several wild turkeys at Oakdale, and their antics and beauty were both entertaining and educational. For instance, they really do dance a kind of "turkey trot" during mating. They are great watch birds, announcing all visitors; mine even responded verbally to aircraft flying overhead, especially jets. But most important, having them close at hand enabled me to learn how to paint their peculiar red-green iridescence.

It was with some pride that I could use a corner down on our property in which to place this marvelous bird. The painting was shown at the 1988 Leigh Yawkey Woodson Birds in Art exhibition. As of this writing, *Autumn Monarch* is among a select number of paintings from the exhibit that are on a ten-city tour around the country.

——

Autumn Monarch,
Oil, 21 X 28, 1982

——

*F*ran Lynch of Connecticut posed with his two quarter horses so I could paint them into this Colorado scene. Here we have a good example of a device called *aerial perspective*—conveying distance by painting the far objects progressively weaker in both contrast and color.

In this painting we see nothing very changeable; no cars, buildings, or clothing subject to the whims of style (western work clothing doesn't look too much different now than sixty years ago). The result, as far as our lifetime is concerned, is a quite timeless piece of art. If I were to depict a village street that included cars, for instance, I would fear that in a few years their appearance would have become so odd, especially to younger people, as to form a barrier to their enjoyment of the picture.

———

Crossing at Split Rock,
Oil, 20 X 40, 1980

———

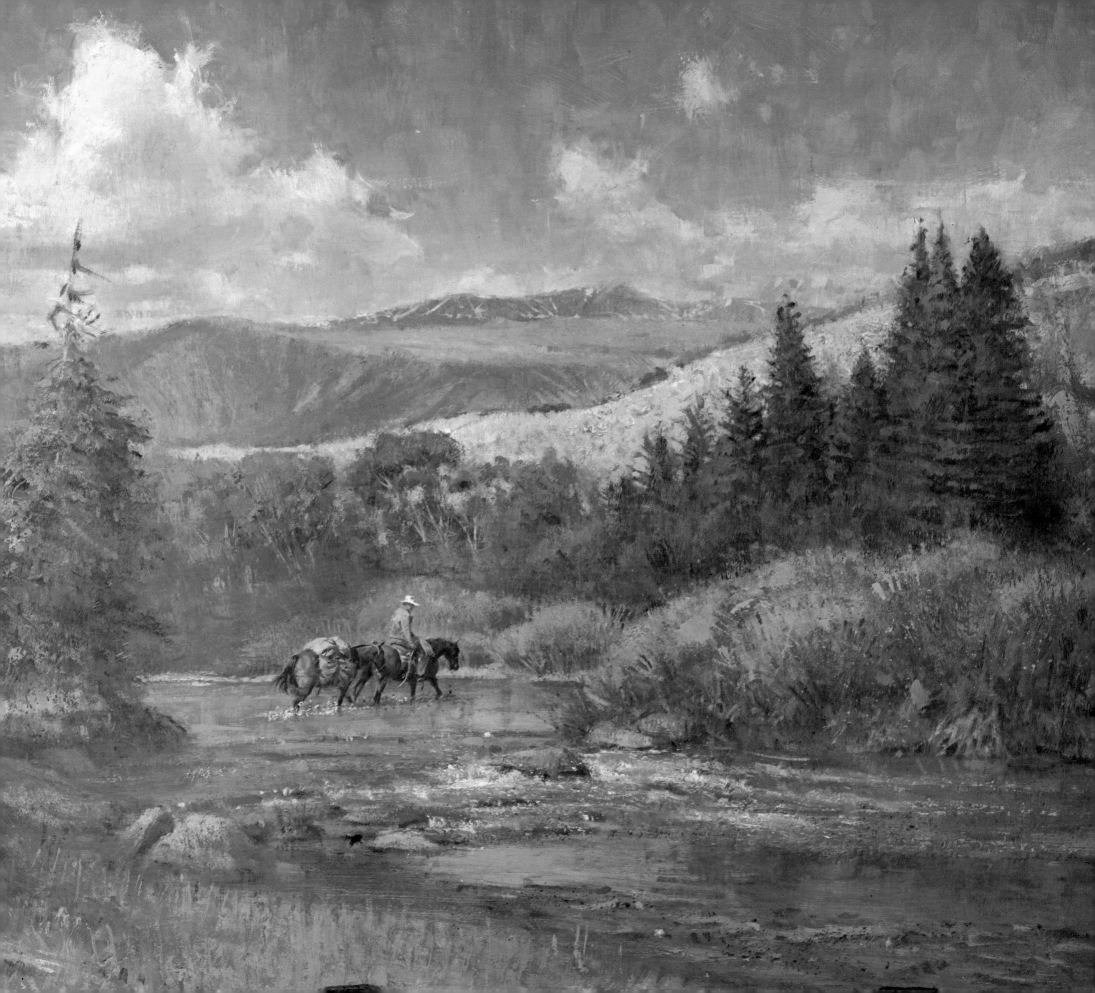

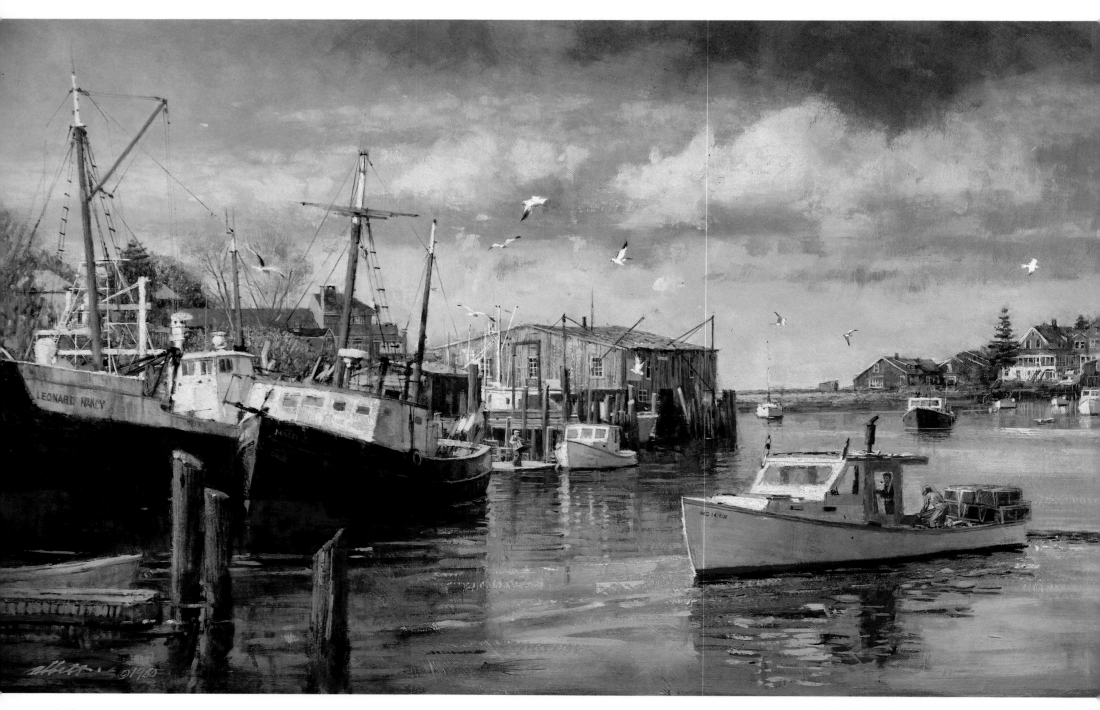

First of a projected coast-to-coast series of paintings for the collection of an Oklahoma oil man, *Gloucester Harbor* necessitated a pleasant mini-vacation in that thriving Massachusetts community. Everyone loves to look at a harbor scene; again the symbolism of freedom, perhaps. It was important to design a picture that contained the bustle and color of a working harbor and at the same time, organize it so the viewer's eye remains in and around the picture.

Gloucester Harbor,
Oil, 20 X 40, 1980

What does his duck boat look like, what does he wear, how does his dog stand in the boat, where is he hunting, what kind of day is it, and *what must it feel like to be there*? This is only a partial list of the questions I must answer whenever I do this kind of portrait. All are as important as: "What does he look like?" and they should be answered before I even pick up a pencil.

To these ends, I visited Dick Schreiber for a firsthand look at his favorite shooting spots on Long Island's south shore. It just happened to be one of the coldest days in history! For my comfort, Dick had

another of those heavy coats that we see him wearing. The coat, by the way, added substantially to the feeling I wanted to show, that is, the rugged individuality of this tough saltwater outdoorsman.

Dick Schreiber and Dutch,
Oil, 34 X 40, 1977

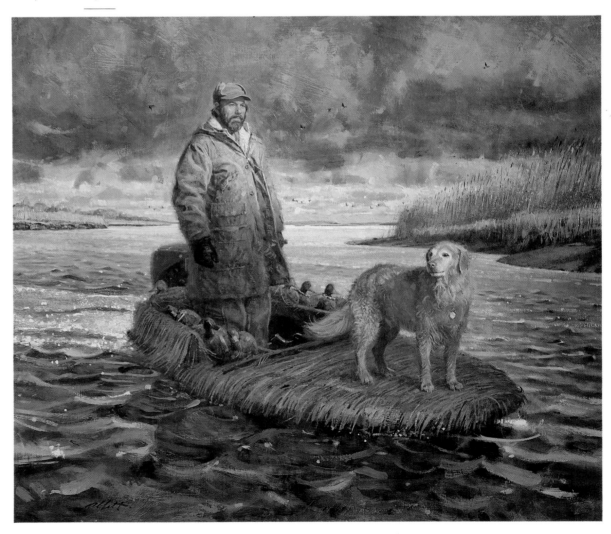

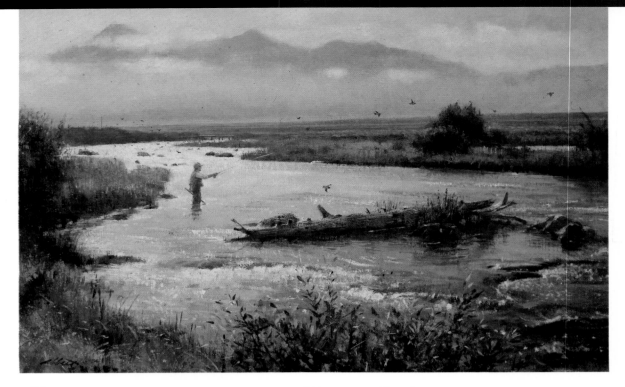

*T*here really is a bridge in this painting, way in the background, and it crosses Montana's Madison River to take you over to Wade Lake, hence the title for this painting. Dr. Ben Houser commissioned the piece and the research was as satisfying as doing the painting. Being there *is* half the fun, and also more than half of the research. For instance, had I not been at the scene personally, I'd never have known about those little mustard-colored swallows we saw darting up and down the river, probably sharing a hatch with trout.

———

Wade Lake Bridge,
Oil, 20 X 30, 1985

———

*W*e followed this Utah stream — I believe it's called Joe's Creek — for some miles downstream during one of our Western research trips. These jaunts are always enjoyable — we fly somewhere, rent a car, and just follow our noses for a week or two.

As we drove, I kept watching the "pictures" change. I probably stopped a dozen times, at each place seeing more than enough material for a painting. This particular location grabbed my attention and later took shape in *Spring Thaw*.

I could write a lot about the underlying abstract design, which really is there. Or I could just say the picture makes me feel cold and makes me remember how the sun was like a saving grace beaming into a rather chilly but beautiful place.

———

Spring Thaw,
Oil, 20 X 30, 1984

———

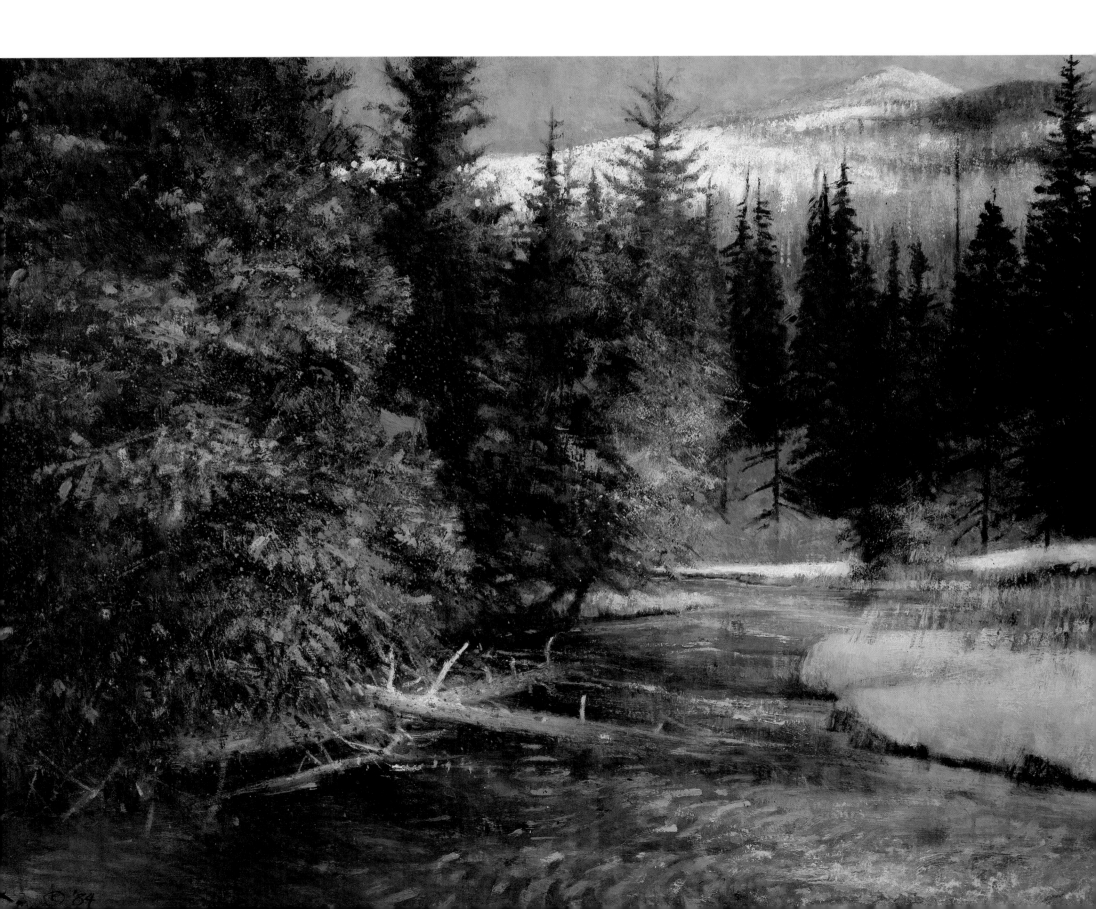

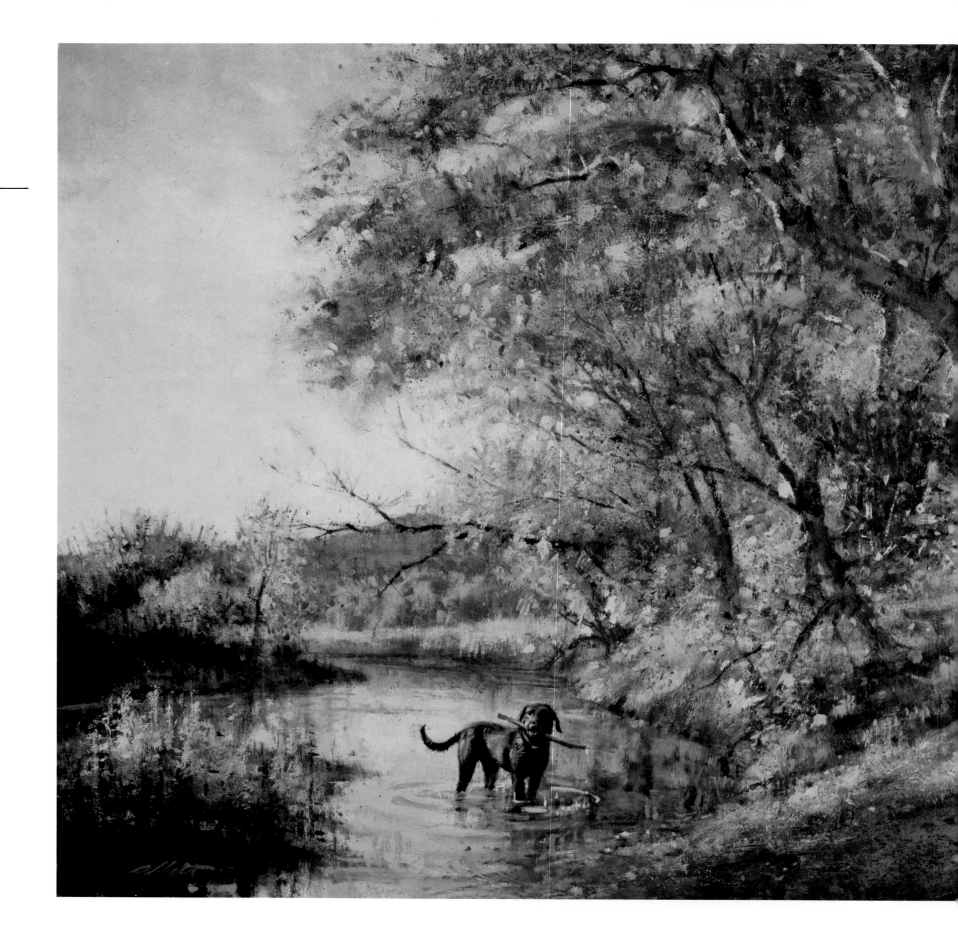

I was very delinquent in training my lab, Bo, compared to the fairly good amount of field work I gave our English setter, Duke. (This disparity is somewhat reminiscent of how the first child in a family is apt to get much more attention than later siblings.) As a result, Bo was almost full-grown when we finally got him to some water.

But finally, as we walked down to a stream near our property, Bo became quite animated as we approached the water. Once there, and with no urging, he was soon frolicking and retrieving sticks from both the surface and beneath it. He certainly showed me how strong a Lab's instincts and breeding can be.

This is Beaver Creek, Arizona, with its lush stand of cottonwood trees. The painting was hung at the 1985 Artists of America exhibit in Denver.

———

Fetching,
Oil, 20 X 30, 1985

———

I wanted to show a pointer screeching to a point at the same instant as a jumpy bobwhite flushed. My original version had the dog's hind feet off the ground, but Collectors Covey owner Bubba Wood suggested that one foot on the ground would give us a more believable point, so I changed the wax model accordingly.

I didn't want to weld the bird to the foliage, which is commonly done in wildlife sculpture. Instead, I placed him at the end of a thin wire, which in some lighting, at least, is practically invisible.

Whoa!, Bronze,
10 1/2 X 11 1/2 X 7, 1979

Holding this picture to its bare essentials enabled me to dramatize the amazing intensity of a working Texas pointer. I retained only those elements which served that purpose, and at the same time, fixed the scene geographically.

Concentration,
Oil, 20 X 30, 1983

174

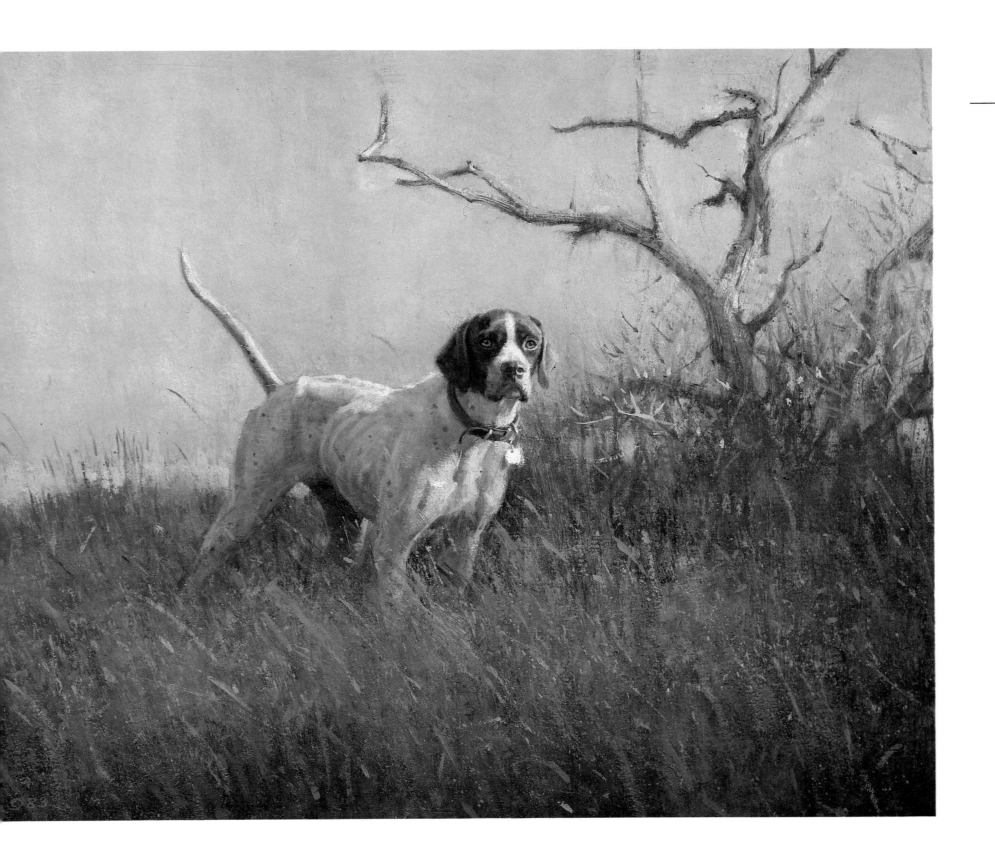

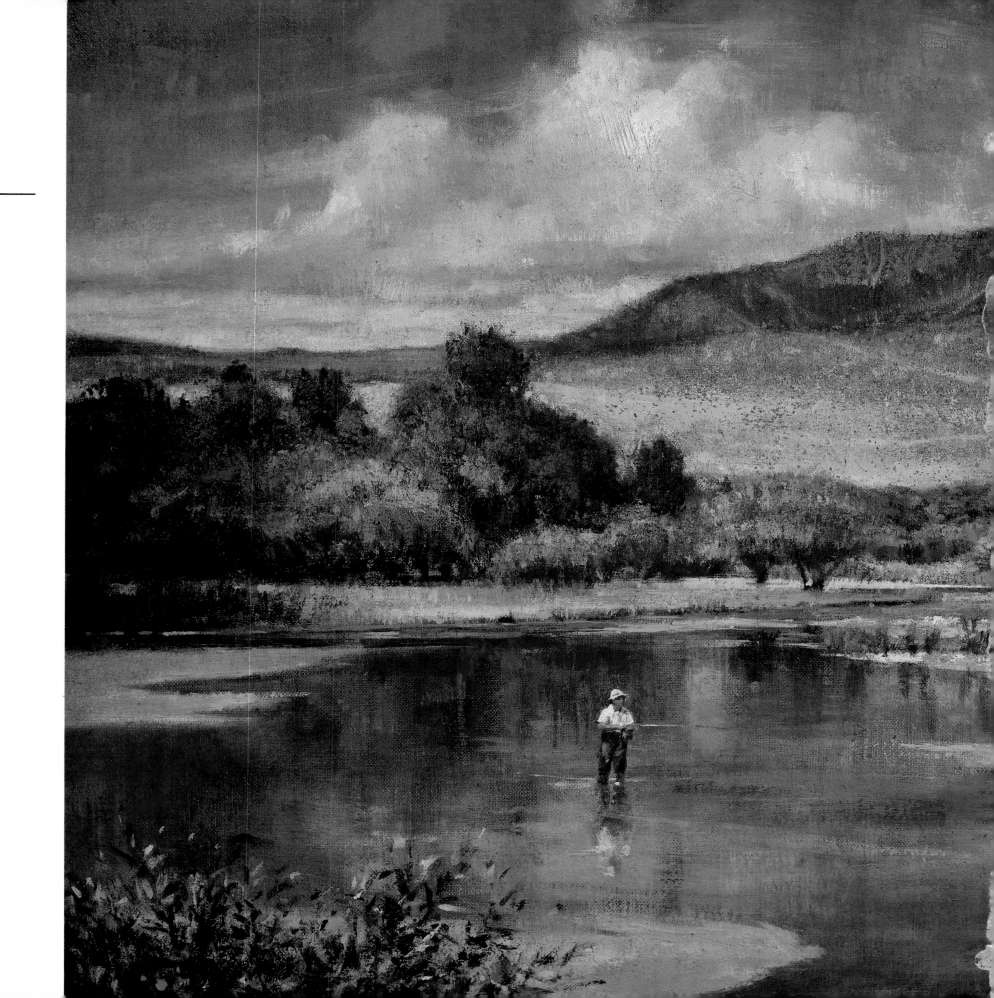

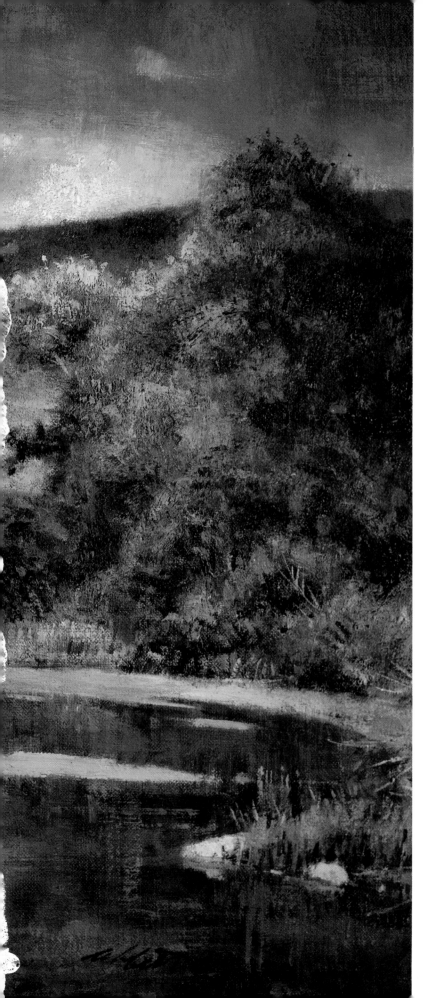

With its water heated by subterranean thermal currents, the Yellowstone nurtures a surprising crop of marine growth, which in turn supports the river's well-known trout population. And the trees and brush along its banks are in marked contrast to the semi-desert topography of the adjacent hills.

At the risk of being misunderstood as immodest, let me add that it's impossible for me not to think of other artists when I confront a compelling scene like this. It seems natural to wonder how such towering painters as Thomas Moran, Thomas Hill, or Sir Edwin Landseer might have responded to similar inspirations. But, having learned to hoe my own artistic rows, I should not be prevented from having my own shot at such pictures, any more than I would for a minute try to imitate these artists.

———

Fishing the Yellowstone,
Oil, 18 X 24, 1985

———

A pointer's anatomy is so close to the surface that it's an artist's dream. And with the light coming in toward us, we can fully appreciate and realize the dog's athletic construction.

Trainer John Greer invited me to watch him work this dog near Arizona's Luke Air Force Base, where the noise from F15s and F16s was at times deafening. The jets didn't bother the dog's pointing ability one whit, however.

Through artist's magic, I transported the scene eastward. For the background, I used a cover from Enid, Oklahoma, where I had hunted earlier with the Grand National Quail Club, which includes such celebrity members as Roy Clark, Lee Majors, and Johnny Bench. I again found myself near an air installation, this time Vance Air Force Base. The club invited the colonel to come along, which he did, and coincidentally, all fighter-plane operations were shut down for the day.

The painting was exhibited that year at the National Academy of Western Art and Cowboy Hall of Fame in Oklahoma City.

———

Early Pair,
Oil, 20 X 30, 1986

———

178

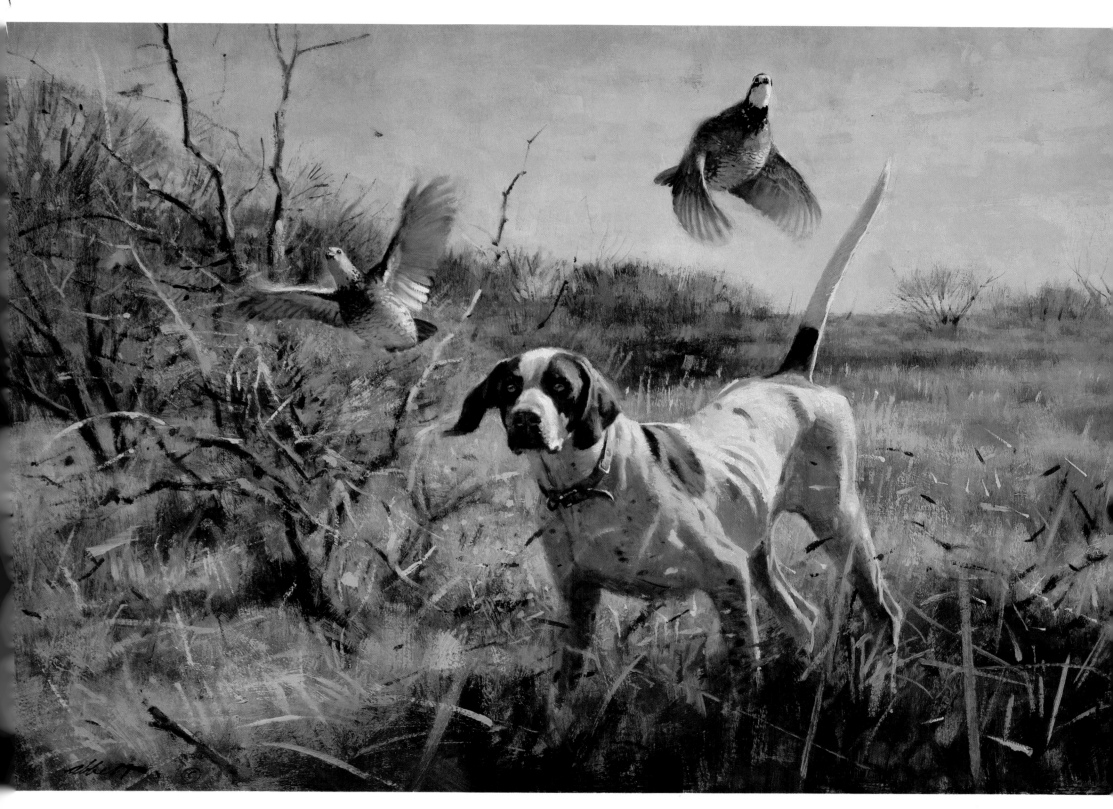

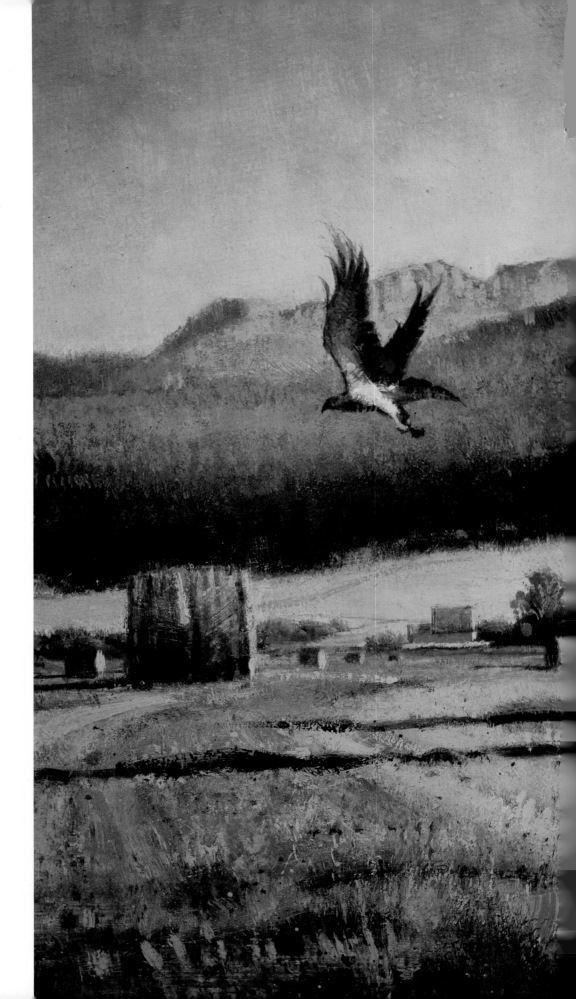

*D*an Lufkin is extremely interested in wildlife as well as crop management at his Oxbow Ranch in Oregon. A few years ago he invited me out to do several ranch scenes for his art collection. In the evening, the hawks would perch on these big bales and wait for their dinner to come along, probably mice that were a lot more visible once the field had been mowed.

Since I'm an artist and not a horticulturist, my interest in a picture like this does *not* include identifying the exact species of grasses and trees which are native to this part of Oregon. However, I am vitally interested in showing you their *feel* or how they might appear different from one another as our eyes wander back and forth over the painting. Therefore, I'll search out varieties and subtleties in the textures and colors as I see them, and employ these characteristics to help you sense the special look of this location.

———

Hunting at Oxbow,
Oil, 9 X 12, 1984

———

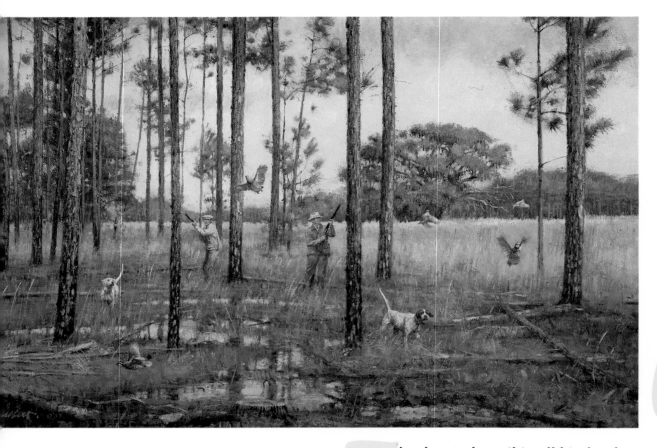

The colors are quite muted compared to those seen in bright sunlight, and the degree of contrast in tones is much less. Without harsh shadows, one can see into the dark areas more easily, helping me to explain various textures in the pine woods.

———

Puddle Covey Quail,
Oil, 24 X 36, 1988

———

I've hunted quail in all kinds of weather in South Carolina and Georgia, including driving rain. I tend to stay away from painting soggy, somber conditions because rain doesn't seem like an attractive atmosphere for a painting. Yet many after-the-rain situations do have a good pictorial quality in them, and I occasionally incorporate these effects. For this painting it was the sunlight partially filtered by the overcast.

Early-morning light is generally thought to be cleaner and cooler in color than the sunlight we see in later afternoon when, after several hours of dust being stirred up by wind and traffic, the light becomes warmer. These dogs were up so early, watching the field trial and waiting to run, that the sun only grazed the tops of their bodies. *Waiting to Run* was shown at the 1983 Denver Rotary Club's Artists of America Exhibit.

———

Waiting to Run,
Oil, 18 X 24, 1983

———

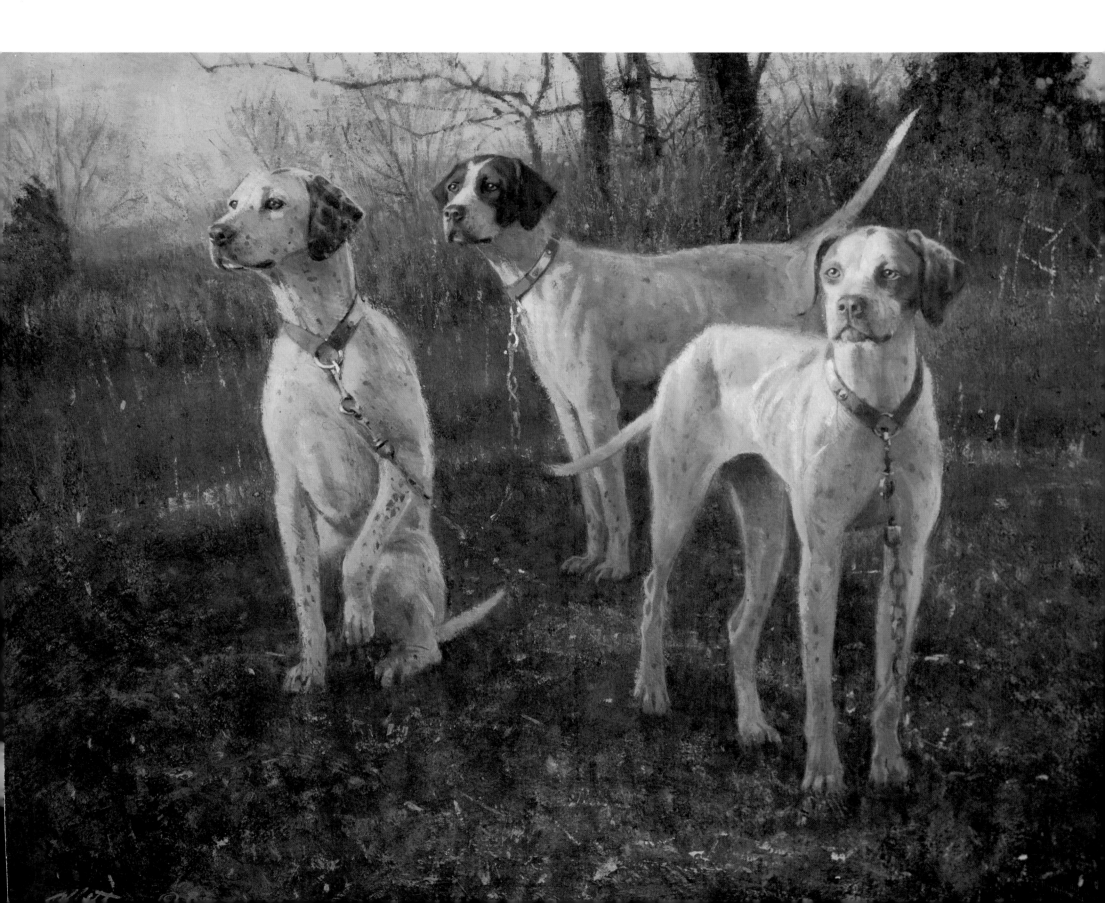

A hunting trip in Iowa with Oklahoma oilman Jess Jernigan presented me with the setting for a pheasant painting that had been knocking around in my head for several years. The open, rolling fields suggest much of the Midwest where ringneck hunting has a long tradition.

Although we hunted with my setter, Duke, and his half-brother, Winston, I chose German shorthairs for my painting because they are so popular in the Midwest.

Basic to my approach in painting is to select the props, elements, and scenery that are not only correct, but will remind viewers of their own experiences. There are always regional differences, but if I include the important symbols, a strong communication can take place. I know that each time I see a reproduction of this picture, my mind instantly flashes back to those brisk fall days, the scratchy feel of corn stubble, and the bold cackling of cock birds.

Fencerow Pheasants,
Oil, 24 X 36, 1983

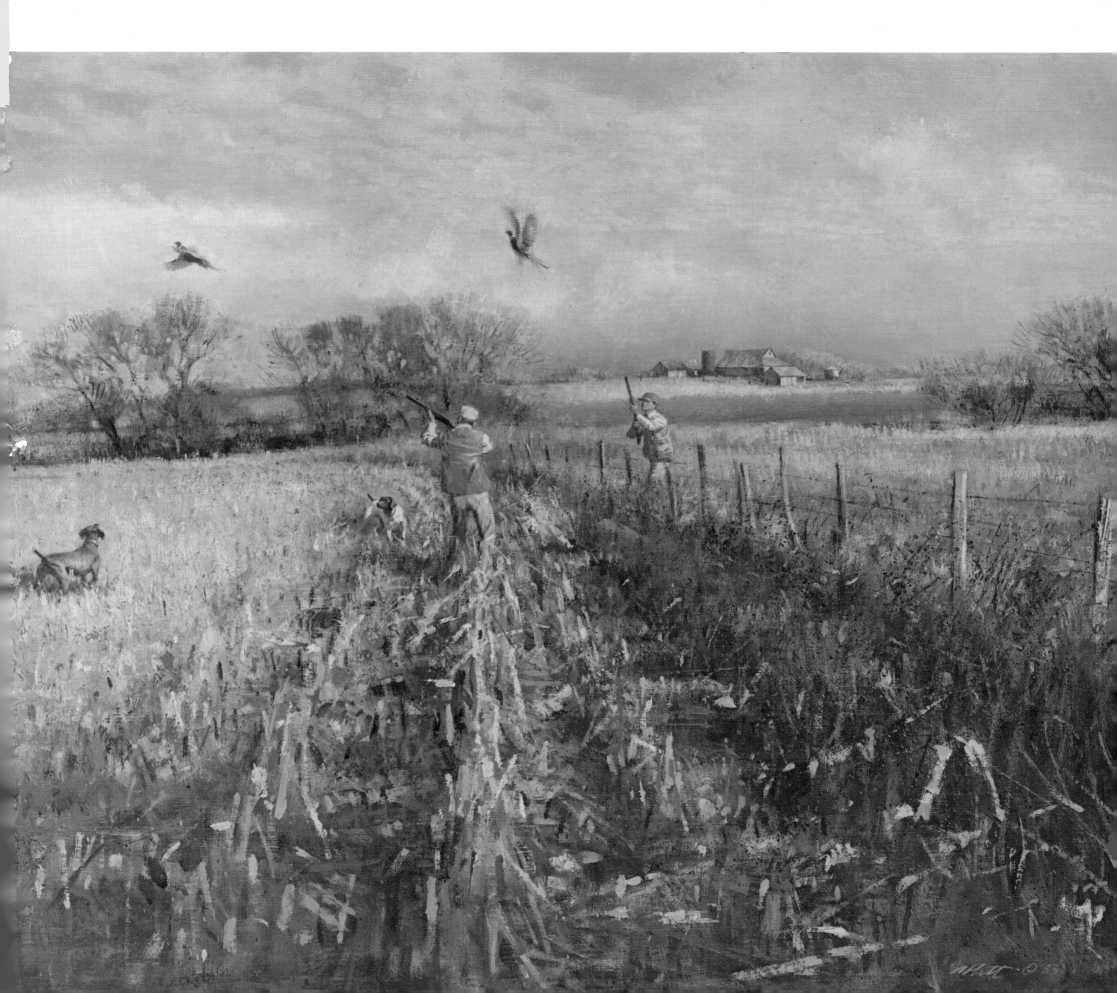

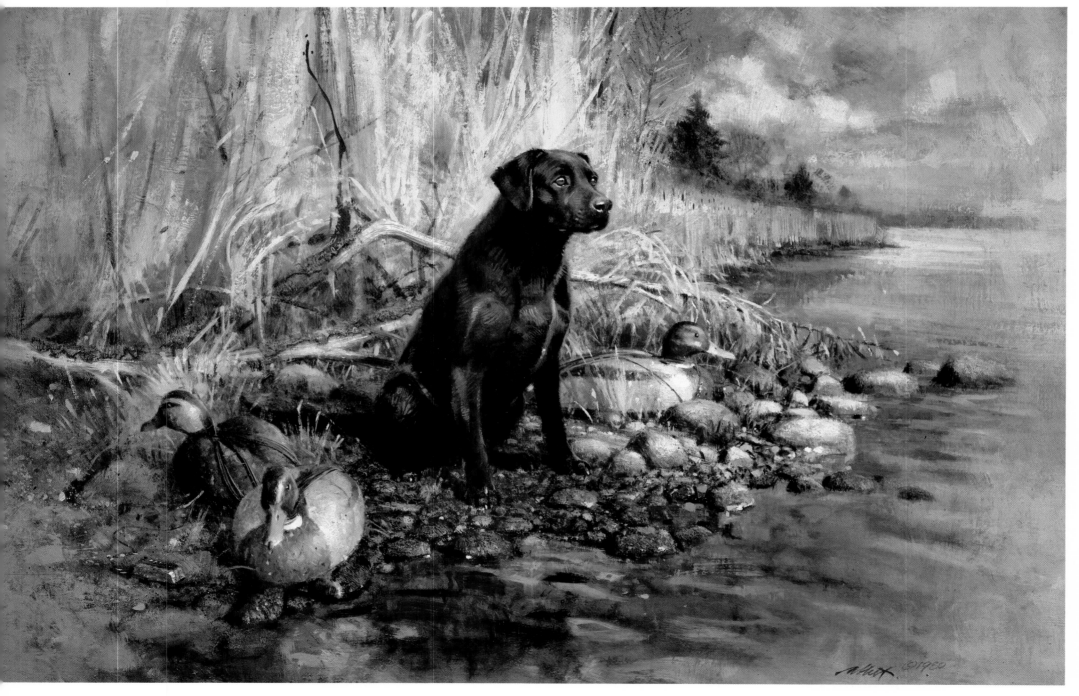

In this painting of Baron, a Lab owned by Connecticut neighbor Harold Kohler, I purposely let some areas go out of focus while painting others in sharply. This is no profound philosophy of art, but worth mentioning. I believe it is in the artist's province to plan and direct his painting, much more than just thoughtlessly rendering what he sees. For one thing, I can establish the relative importance of the various elements and not bore the viewer to death with uniformly-painted objects.

Second Season,
Oil, 24 X 36, 1980

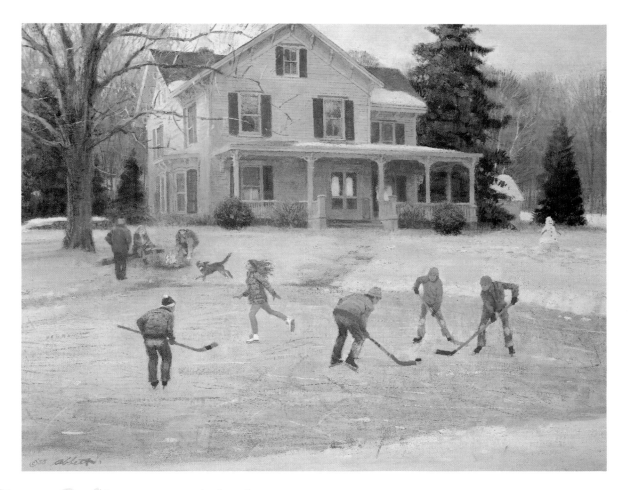

When we were kids, if you found a girl attractive, you showed your affection by stealing her hat or scarf and skating off with it. (Hopefully, we later matured enough to learn better ways of communicating our feelings.) We also worked hard at keeping the ice clear of snow, even though shoveling our own sidewalks seemed an unreasonable chore.

My point of entry for this painting was the old house, and hockey seemed a fitting activity to enhance the scene. Surprisingly, though, some viewers of the print said their interest was centered on the hockey game, not the house.

Skating at Sunset,
Oil, 24 X 30, 1988

*J*im Kennedy showed me the Ruby Anthracite River near Crystal Butte, Colorado. I wanted my painting to convey, among other things, the sparkling clean air and water of that remarkable area. This was one of the first paintings done in my (then) new Arizona studio. Whether as a result of the subject matter or the brighter light in the Southwest, several of my amateur critics noticed a difference between the pure colors and contrast of *The Corner Pool* and those of my earlier works.

This painting was exhibited at the 1982 Artists of America Exhibit sponsored by the Denver Rotary Club.

———

The Corner Pool,
Oil, 18 X 24, 1982

———

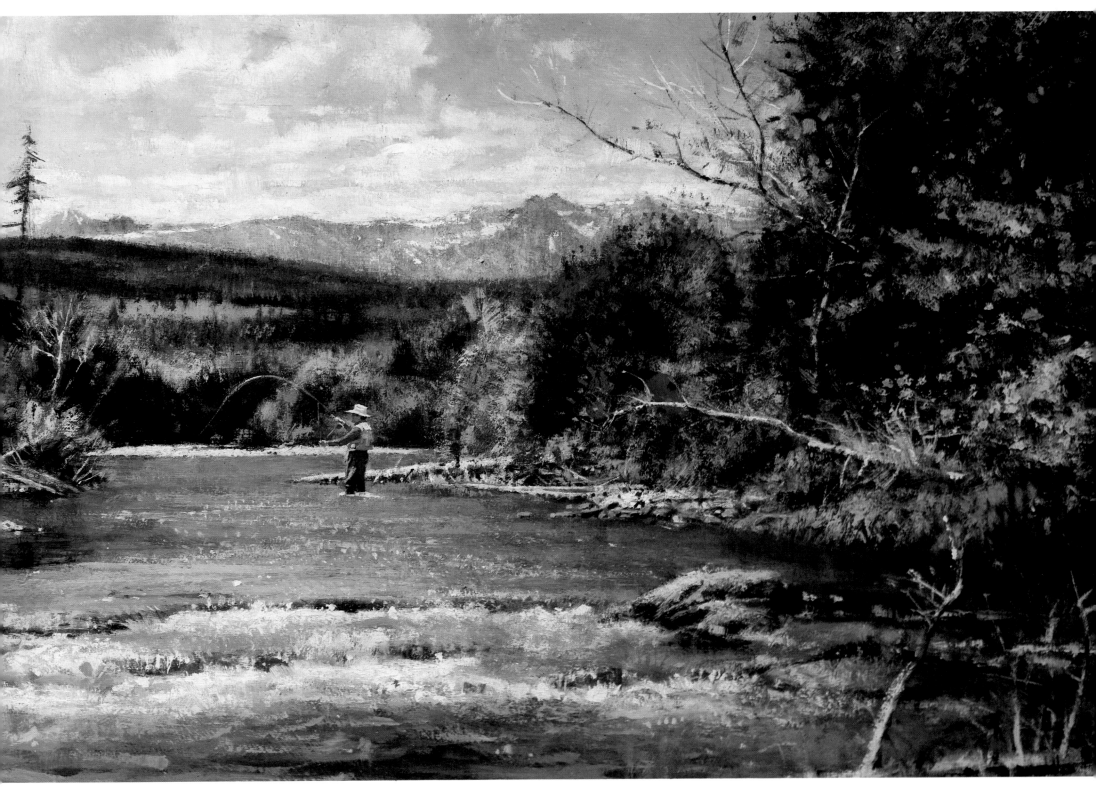

INDEX OF PRINTS

RELEASE DATE	TITLE	INITIAL PRICE	EDITION SIZE	PUBLISHER
1973	Downwind	$ 50	500	Crossroads of Sport
1974	Bobwhites and Pointer	65	1,000	Greenwich Workshop
	Gray Water	50	500	Crossroads of Sport
	Luke	50	500	Sportsman's Edge
	Windfall	60	500	Sportsman's Edge
1975	First Season	65	1,000	Greenwich Workshop
	German Shorthair & Grouse	85	1,000	Greenwich Workshop
	Ringneck and Setter	65	1,000	Greenwich Workshop
1976	New Fields	65	1,000	Greenwich Workshop
	Partners	70	500	Sportsman's Edge
	Ringneck Pheasant	65	1,000	Greenwich Workshop
	Setter and Woodcock	70	500	Sportsman's Edge
	Yankee Drummer	75	500	Sportsman's Edge
1977	Fall Fishing	100	300	Theodore Gordon Flyfishers Club
	Irish Setter Family	75	1,000	Greenwich Workshop
	Setter and Grouse	95	500	Sportsman's Edge
	Split Rail Bobs	95	500	Sportsman's Edge
	Springtime	85	1,000	Greenwich Workshop
1978	Close Honor	85	1,000	Greenwich Workshop
	English Setter Family	125	750	Sportsman's Edge
	Fishing the Bitterroot	125	500	Sportsman's Edge
	Holding Tight	125	500	Sportsman's Edge
	Hunting the Edges	125	750	Sportsman's Edge
	Late Day Woodcock	125	500	Sportsman's Edge
1979	Hasty Exit	125	750	Sportsman's Edge
	Training at Hawkeye	125	750	Sportsman's Edge
	Wild Covey	125	750	Sportsman's Edge
1980	Black Lab Head	70	500	Sportsman's Edge
	Bucking Strap	150	750	Sportsman's Edge
	English Setter Head	70	750	Sportsman's Edge
	Golden Retriever Head	70	750	Sportsman's Edge
	Late Summer Beaverkill	75	750	Sportsman's Edge
	Ready to Go	150	750	Sportsman's Edge
	Riverview Quail	150	750	Sportsman's Edge
	Second Season	150	750	Sportsman's Edge
	Yellow Lab Head	70	750	Sportsman's Edge
1981	Black Lab Family	125	850	Sportsman's Edge
	Black Vultures Clay County	100	777	Buzzard Council of America
	German Shepherd Head	75	750	Sportsman's Edge
	German Shorthair Head	70	750	Sportsman's Edge
	Pointer Head	75	750	Sportsman's Edge
	Springer Spaniel Head	70	750	Sportsman's Edge
	The Bridge Pool	125	1,700	Trout Unlimited
1982	Autumn Monarch	125	1,500	Wild Turkey Federation
	Bo and Duke	125	850	Wild Wings
	Brittany Spaniel Head	75	750	Wild Wings
	Broomweed Covey Rise	150	850	Collectors Covey
	Bulldoggin'	125	850	Wild Wings

RELEASE DATE	TITLE	INITIAL PRICE	EDITION SIZE	PUBLISHER
1982	Crossing at Split Rock	$125	750	Wild Wings
	Irish Setter Head	75	750	Wild Wings
	Labrador Retriever Head	105	1,050	Wild Wings
	Mallard Hideaway	125	850	Wild Wings
	Mountain Majesty	125	950	Wild Wings
	Ruffed Grouse	125	1,780	Ruffed Grouse Society
	Shooting the Grand National	125	300	Grand National Quail Club
	Waiting at Hawkeye	125	750	Wild Wings
1983	Fencerow Pheasants	125	850	Wild Wings
	First Go Around	125	600	National Cutting Horse Association
	Golden Retriever Max	100	1,050	Wild Wings
	Gordon Setter Head	75	750	Wild Wings
	Hillside Woodcock	125	850	Wild Wings
	Hunting at Hawkeye	125	950	Wild Wings
	January Thaw	95	850	Wild Wings
	Labrador Retriever Bo	75	750	Wild Wings
	Wood Ducks	95	850	Wild Wings
1984	Autumn Pools	60	600	Wild Wings
	Broken Covey	125	3,900	International Quail Federation
	Morning Orders	125	750	American Military Collection
	Old Road Cover	125	900	National Wildlife Art Collectors Society
	Snack Time	200	100	American Quarter Horse Association
	Team Roping	200	100	American Quarter Horse Association
	The Winning Point	75	950	National Bird Hunters Association
	Third Season	125	850	Wild Wings
1985	Barrel Racing	200	100	American Quarter Horse Association
	Brittany Head II	75	750	Wild Wings
	Duke and Mike	125	650	Wild Wings
	First Time Out	75	300	Wild Wings
	Nowhere Left to Go	175	450	Minnesota Mining & Manufacturing
1986	Chocolate Lab Head	75	750	Wild Wings
	Elhew Pointers	50	350	Elhew Kennels
	Five Mile Pool	125	700	Wild Wings
	Saturday Afternoon	125	650	Wild Wings
	Training at Cedar Ridge	125	650	Wild Wings
	Upwind Setter and Grouse	125	650	Wild Wings
1987	Our House	125	850	Wild Wings
	Saturday Morning	85	650	Wild Wings
	Stalking the Brown	95	850	Wild Wings
	Summer Drummer	125	650	Wild Wings
	The Gatekeeper	85	650	Wild Wings
	The Pups	125	850	Wild Wings
1988	A Day to Remember	125	850	Sporting Classics
	Brittany Head III	85	950	Wild Wings
	Gray Wood Retriever	125	5,300	Ducks Unlimited
	Skating at Sunset	125	2,500	Wild Wings
1989	Afternoon Adventure	125	2,500	Wild Wings
	Dare and Dash	125	950	Wild Wings